CASPAR DAVID
FRIEDRICH
THE SPIRIT OF ROMANTIC PAINTING

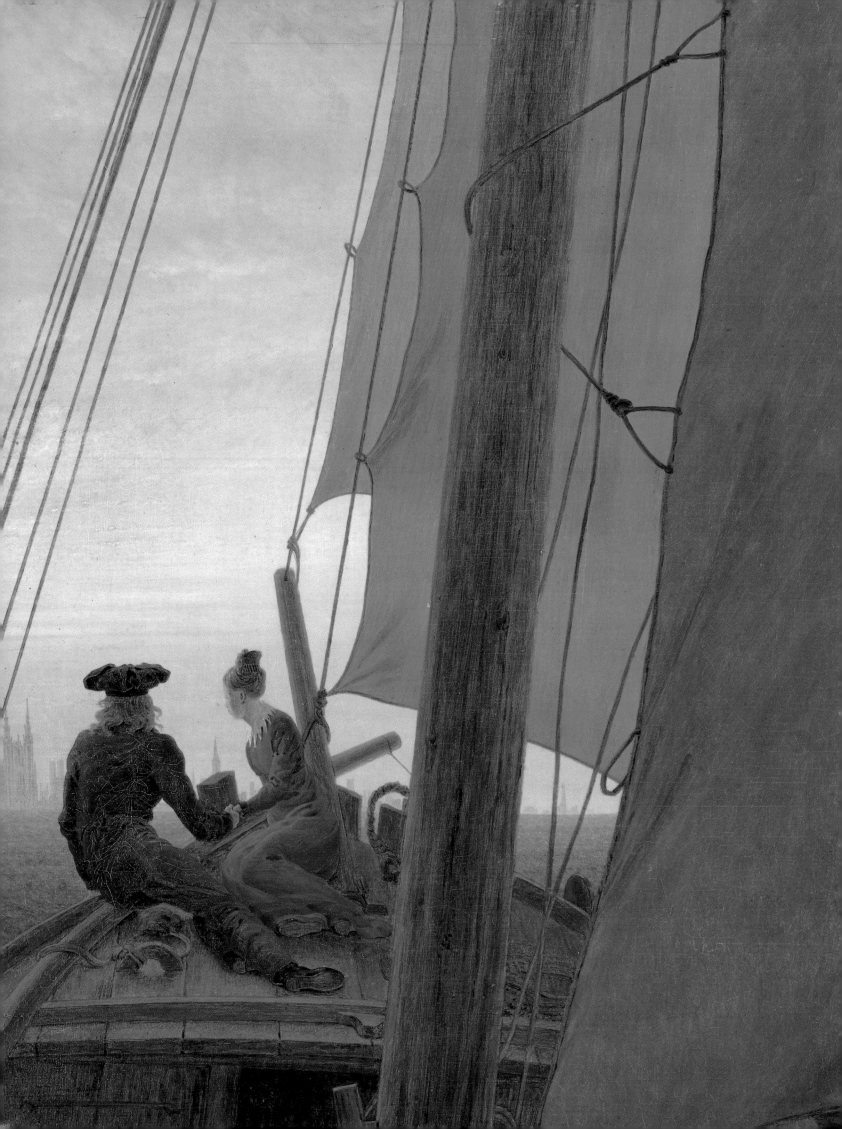

CASPAR DAVID
FRIEDRICH
THE SPIRIT OF ROMANTIC PAINTING

TEXT BY CHARLES SALA

TERRAIL

Cover illustration

CASPAR DAVID FRIEDRICH
Wanderer above the Sea of Fog
1818, oil on canvas,
74.8 x 94.8 cm.
Hamburg, Kunsthalle

Overleaf

CASPAR DAVID FRIEDRICH
On the Sailboat
1819, oil on canvas,
71 x 56 cm.
St. Petersburg, Hermitage Museum.

Opposite

CASPAR DAVID FRIEDRICH
Cross in the Mountains
1812, oil on canvas,
44.5 x 37.4 cm.
Düsseldorf, Kunstmuseum.

Editors: Jean-Claude Dubost and Jean-François Gonthier
Art director: Sibylle de Fischer
English adaptation: Jean-Marie Clarke with Robyn Ayers
Iconography: Claire Balladur
Composition: Graffic, Paris
Filmsetting: Compo Rive Gauche, Paris
Lithography: Litho Service T. Zamboni, Verona

© FINEST S.A. / ÉDITIONS PIERRE TERRAIL, PARIS 1994
A subsidiary of the Book Division
of ⓝ Bayard Presse S.A.
ISBN: 2-87939-092-3
Printed in Italy

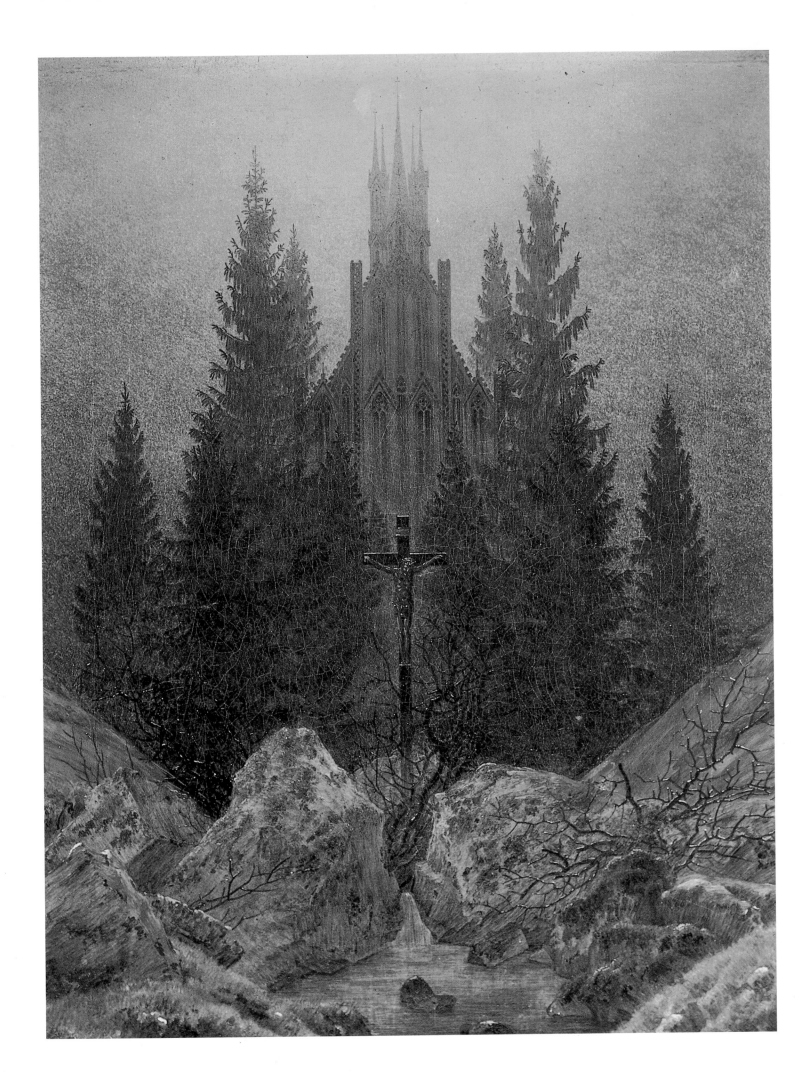

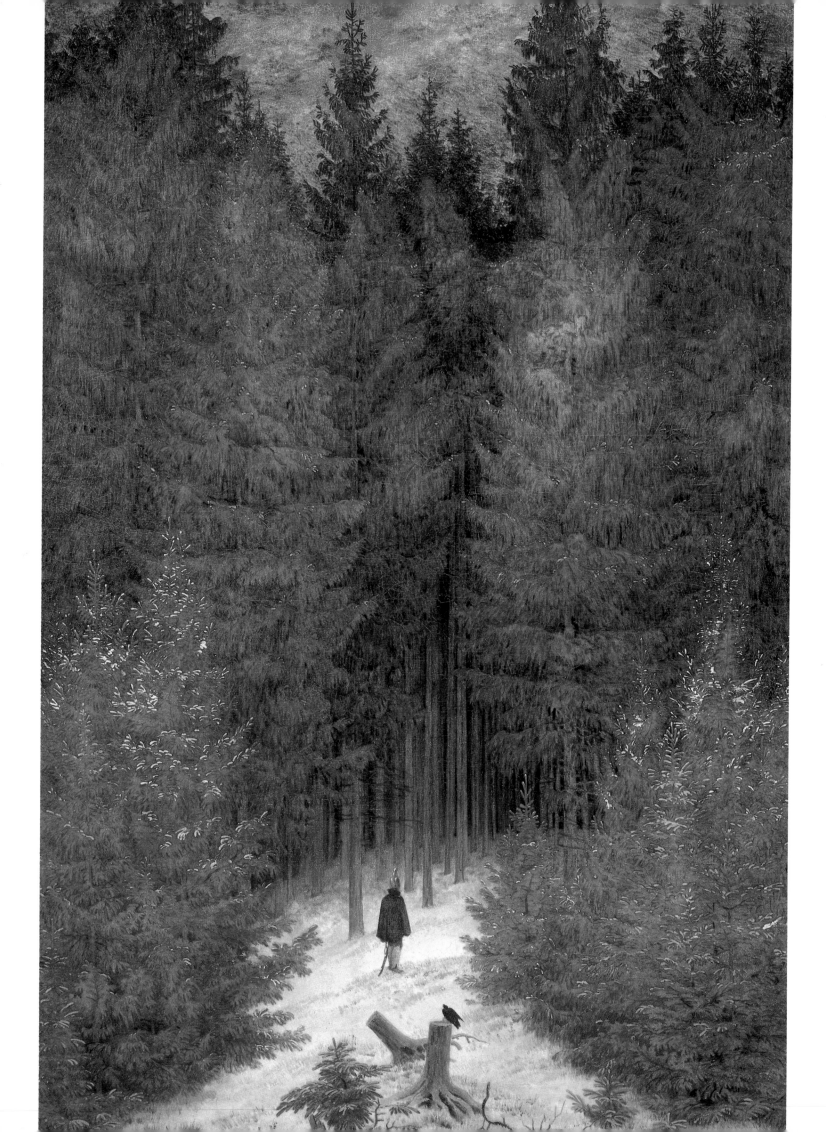

CONTENTS

CASPAR DAVID FRIEDRICH
Chasseur in the Forest
1813, oil on canvas,
65.7 x 46.7 cm.
Private collection.

OBLIVION
AND LATER RECOGNITION

On May 7, 1840, in the same year that Delacroix finished his *Entry of the Crusaders into Constantinople,* Caspar David Friedrich died in solitude and great mental distress. The inventor of the "tragedy of landscape," as he was described by the French sculptor David d'Angers, who had met him, Friedrich had been living since 1835 in a precarious state of health. He was the shadow of his former self; fading away into the bright Nordic mist, like the elusive figures he painted–always shown with their backs turned–contemplating moonlit seas.

Ever more monk-like in his ways, almost confined to his house on the Elbe, he watched as his depression slowly deprived him of his ability to paint landscapes and blunted the edge of his mystic appetite. Art had changed in Germany, as it must, and even Carl Gustav Carus, one of his most faithful disciples and a leading theorist of Romantic painting, seemed to have abandoned him to his fate, leaving him to drift toward an ever-nearer, perhaps devoutly hoped for, infinity.

When Georg Andreas Reimer put the Friedrichs in his collection up for sale in 1842, they fetched surprisingly low prices. This was the fate of the works of a painter who had earned the praise of the leading poets, writers and thinkers of his time, and who could count Emperor Wilhelm III of Prussia among his most fervent admirers.

Despite this high acclaim in his own lifetime, Friedrich was soon forgotten by critics and the public until the end of the century, when the Norwegian art historian Andreas Aubert began compiling a catalogue, and even well into our own century. The one exception to this relative oblivion was the Surrealist Max Ernst. With his usual sagacity and radical ideas, Ernst brought the works of Friedrich and the German Romantics up-to-date for a larger circle of art-lovers.

Max Ernst had known of Friedrich's work for a long time. He had discovered it in Cologne in 1922 and–paradoxical as this may sound–immediately recognized its affinities with his own efforts as a young Dadaist. Ten years later, in 1931, when a fire in the Munich Glass Palace destroyed nine of the Dresden master's canvases, Ernst realized only too well the enormity of this loss. The bombings of Berlin in 1945 took a further toll of Friedrich's works, while in the Postwar period research on the artist never extended beyond the confines of the museums. Only with the 1959 exhibition on the "Romantic Movement" at the Tate Gallery did interest in Friedrich slowly begin to re-awaken.

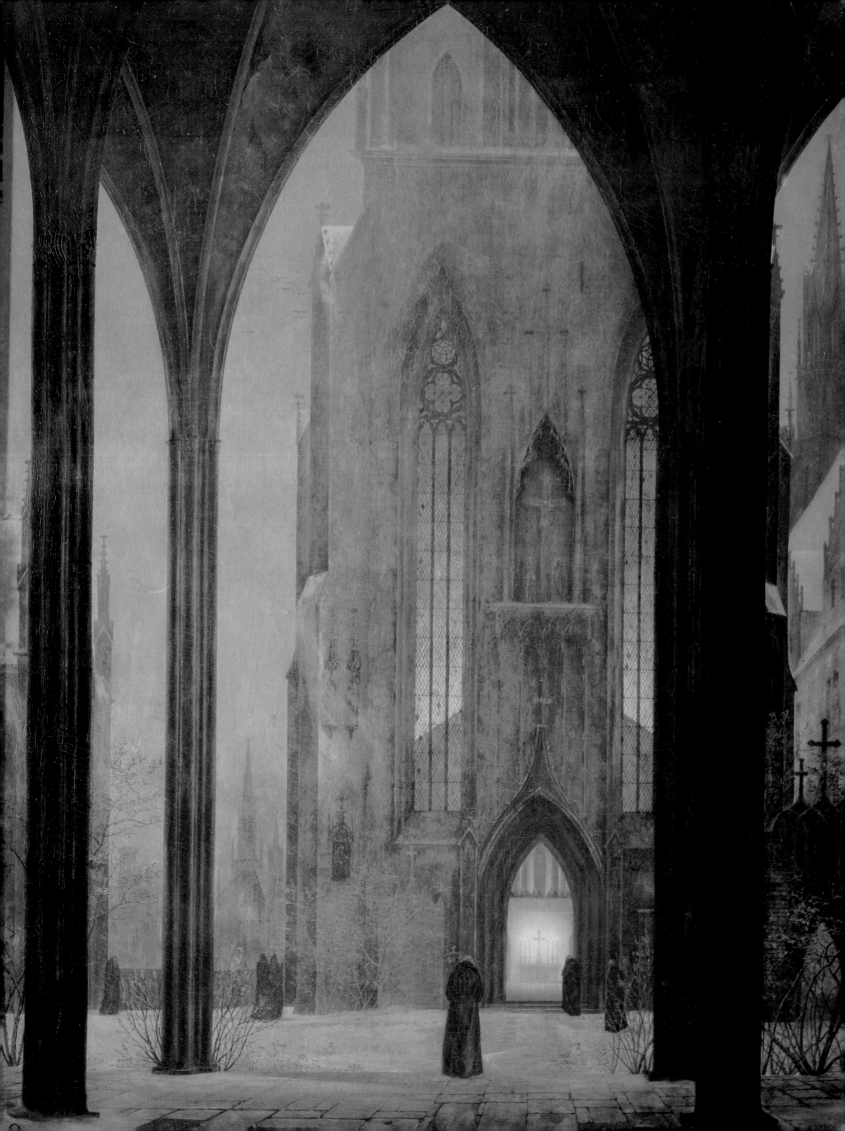

Yet the decisive re-discovery came in 1972, with the major retrospective organized by the Tate Gallery, and was consolidated by exhibitions in Dresden and Hamburg, and then in 1976, with the exhibition on German Romantic Painting in Paris. Thus ended an oblivion that had lasted for more than 120 years–a fate almost unique in the annals of painting.

Caspar David Friedrich was born the son of industrious candlemakers in Greifswald, a small village in Northern Germany, then under Swedish occupation. Sixty-four years later, with his brilliant career already behind him, he died amid general indifference. His early years had been marked by a succession of tragedies: the death of his mother in his infancy, the death of his sisters Elizabeth and Maria–the latter in her adolescence and under frightful circumstances; then the drowning of his brother Christopher while skating on the frozen Baltic Sea.

His religious faith, solidly anchored by his father through daily Bible readings, was assuredly a great comfort to the artist in later life. Although he eventually left the Protestant Church for reasons of personal conscience, it is likely that his Reformed upbringing and its iconoclastic practices played an important part in his creation of landscapes with a marked spiritual tonality.

His personality aside; what role did he play on the Romantic scene in Germany and in Europe in general? What was his relationship to the artists of the past and to those of his time? How can we learn to see and interpret his works today?

ERNST FERDINAND OEHME
Procession in the Fog
1828, oil on canvas,
81.5 x 105.5 cm.
Dresden, Staatliche
Kunstsammlungen
Gemäldegalerie.

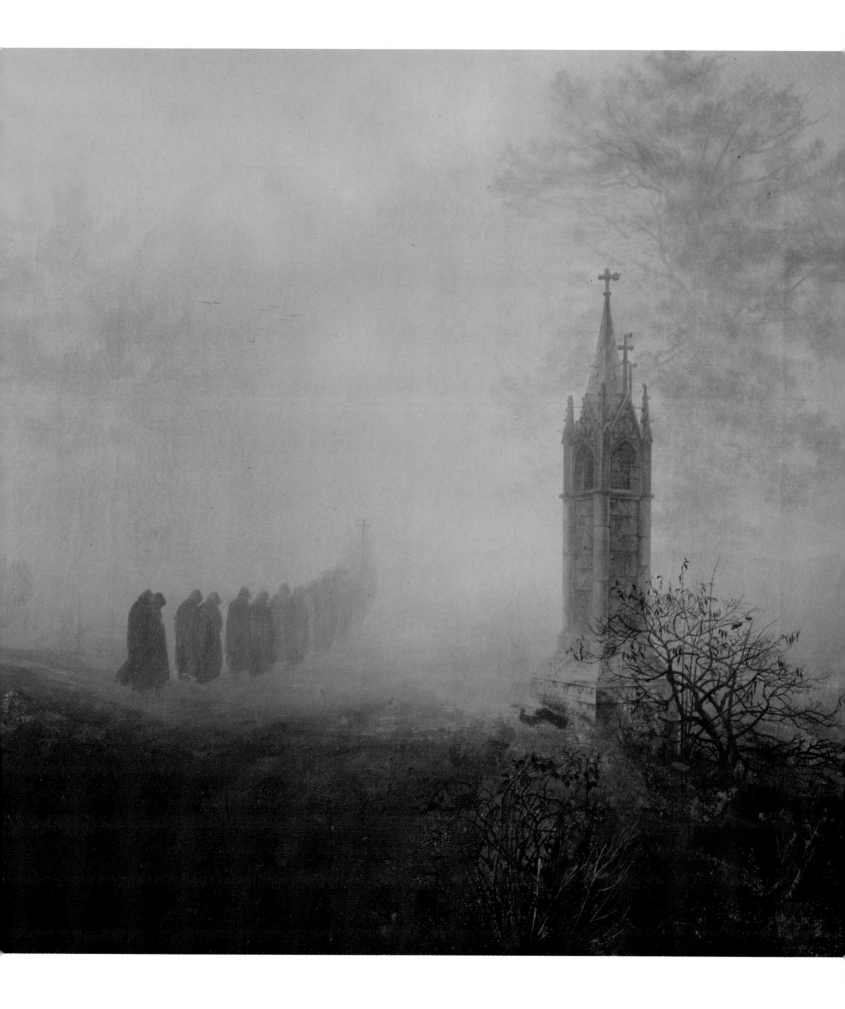

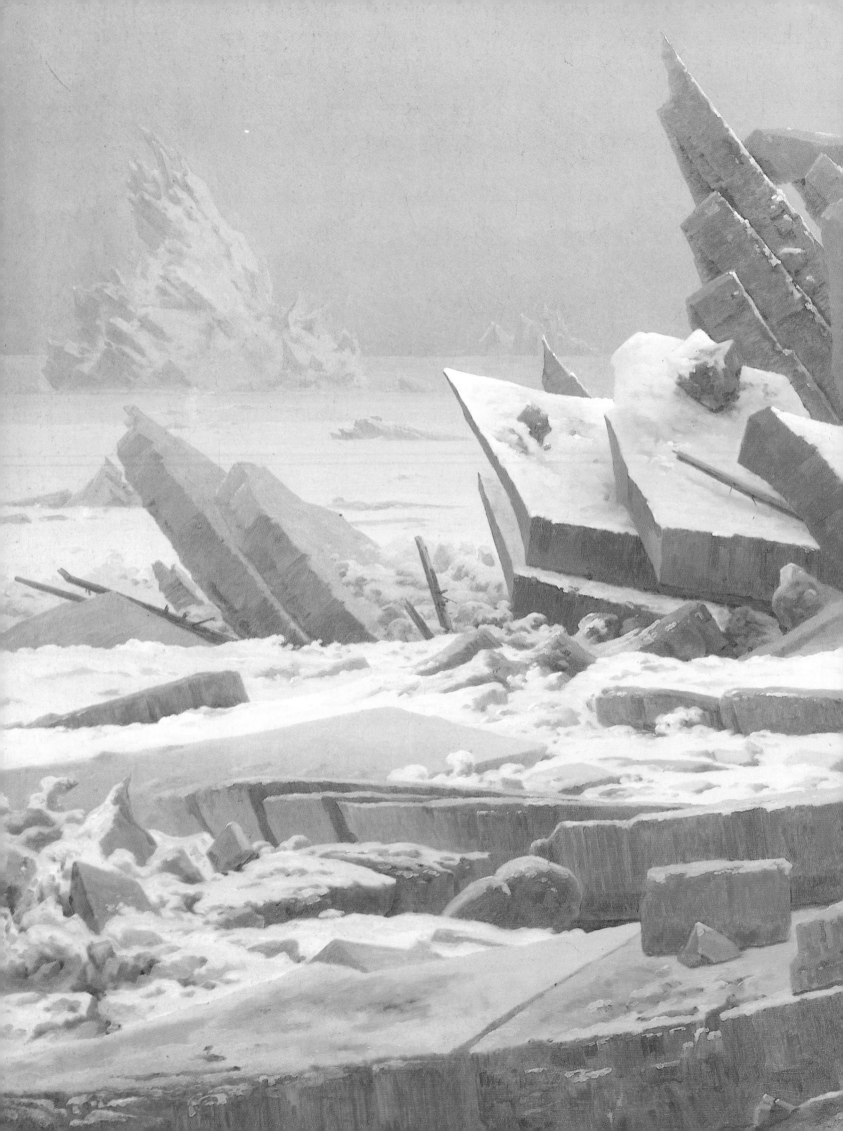

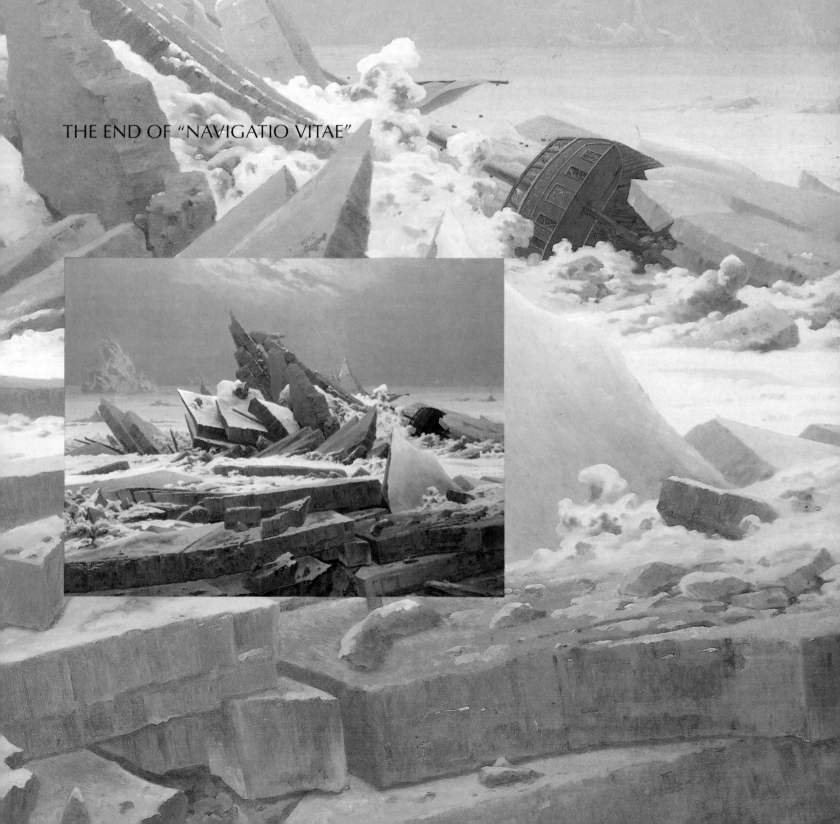

TWO SHIPWRECKS
AND ONE APPARITION,
THE EMERGENCE
OF ROMANTICISM

THE END OF "NAVIGATIO VITAE"

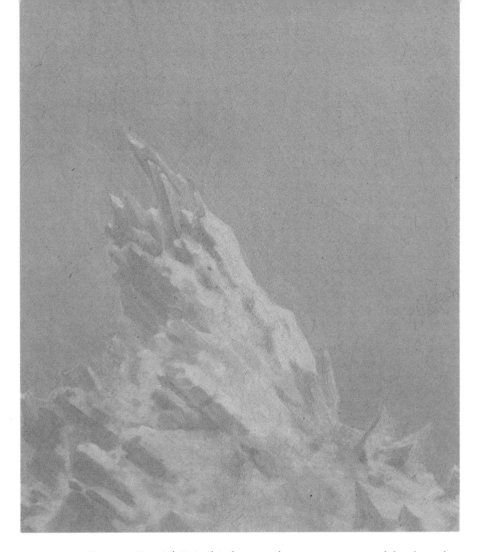

*Overleaf and pages 16,
17 and 19 (details)*

CASPAR DAVID FRIEDRICH
The Sea of Ice
1824, oil on canvas,
96.7 x 126.9 cm.
Hamburg, Kunsthalle.

Caspar David Friedrich was forty-six years old when he received the visit of the future Czar of Russia, the Grand-Duke Nicholas, in December 1820 in his new studio, in Dresden on the Elbe. These were the auspicious beginnings of an imperial patronage which led to the purchase of many paintings. The artist was on the eve of a new phase in his work, inaugurated two years later by a painting that was the antithesis of everything Neoclassical and Italianate in art.

This composition, which has since been lost, was titled *Shipwreck on the Coast of Greenland* and marked the beginning of a series of canvases that contributed much to his return to favour in our own time. The picture had been commissioned by the future Czarina, Alexandra Feodorova, and was intended to represent Nordic nature in all its "fearsome beauty," and also act as a pendant to a work by Martin von Rodhen exalting the generous beauty of nature in Southern climes. Both works were lost, and this particular work by Friedrich, more popularly known as *The Wreck of the Hope,* was long confused with a picture of his that did come down to us, *The Sea of Ice* (1824).

This magnificent composition has unusual features: the wealth of detail, the spatial construction and the overall organisation seem to refer less to the standard pictorial tradition than to the

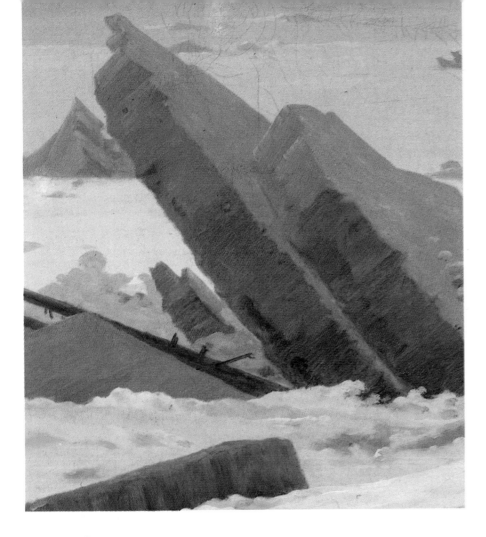

panoramic paintings then in vogue. The foreground, for example, is dominated by huge ice blocks slanted on a diagonal axis. The artist worked from precise studies made of the break-up of the ice on the Elbe at the end of the especially severe winter of 1820-1821.

The crisp, serrated ice-blocks are depicted with such insistent and convincing realism that they seem to be projecting from the two-dimensional surface of the canvas. This treatment is closely related to panorama painting, of course, but Friedrich also applied principles of his own that he later formulated in his writings: give an equal handling to the all the elements, whether primary or secondary, and so unite the great and the small, the part and the whole, together in an overall scheme. But, here, it is a scheme from which the human presence has been banished or excluded: the main protagonists of the tragedy are the icy crags which fully dominate the pictorial stage.

Near the middle of the composition one can make out the prow of a ship trapped in the ice, vaguely biomorphic and skewed in the same direction. A victim of its own temerity, it has been caught and crushed. The wintry scene beyond flattens out into a snowbound expanse punctuated by several more tilting spires of ice. No living presence relieves this wasteland, which merges in the distance with a rosy-blue, wind-torn sky.

The subject of shipwrecks had long interested Friedrich (*After the Storm*, 1817). In Dresden, in 1822, Johann Carl Enslens exhibited a great panorama titled *Winter Camp of the North Polar Expedition*. The following year in Prague, Sacheti, a stage-designer, presented his half-panorama, *Expedition to the North Pole*. Although scorned by mainstream art critics, these panoramas met with tremendous popular success. They consisted of gigantic canvases disposed in a circle over one hundred meters in circumference and some twenty meters high, and were exhibited in specially-built rotundas, at the centre of which was a platform for the spectators. To heighten the illusion, real objects were often placed in the space between the canvas and the viewers. The subject-matter was generally of a military, picturesque or descriptive nature. Last but not least, the polar expeditions of the "Hecla" and the "Gripper," in 1820 and 1824, were abundantly covered by the contemporary press.

These eventual influences, however, were not the decisive factors in the painter's approach, because they are too external. What counts is what he distilled from the raw factual material: a monotonous chaos of ice blocks repeated as far as the eye can see, locked in a solemn immobility. Solitude as a pictorial theme could hardly have been an appealing one for the spectators, orienting them, as it did, in a more meditative, implicitly moral direction. As it was, his contemporaries responded with wonder and uncertainty at the picture's message, evoking parallels between the frailty of the vessel and of human existence, the futility of discovery, if not the vanity of all mortal hope.

David d'Angers described it as "a mountain of ice and the debris of a ship which has been crushed by it. It is a great tragedy–not a single survivor."

This is an evocative description, but the fact is that Friedrich was in no way concerned with creating or commenting on an event, nor with facile allusions to current events. The tragedy that he sought to represent is our mortal journey, the *navigatio vitae*, whose course leads inevitably to death. An idea superbly symbolized by the agony of the ship. It is indeed the wreck of all hope, the foundering of all dreams of discovery, the vanity of all human efforts to attain the divine essence.

An image of failure? Perhaps. But it is a mitigated failure, for this pictorial meditation on human nature and the spiritual quest are in themselves a sort of bridge between despair and its representation. The painting takes on the value of a votive offering:

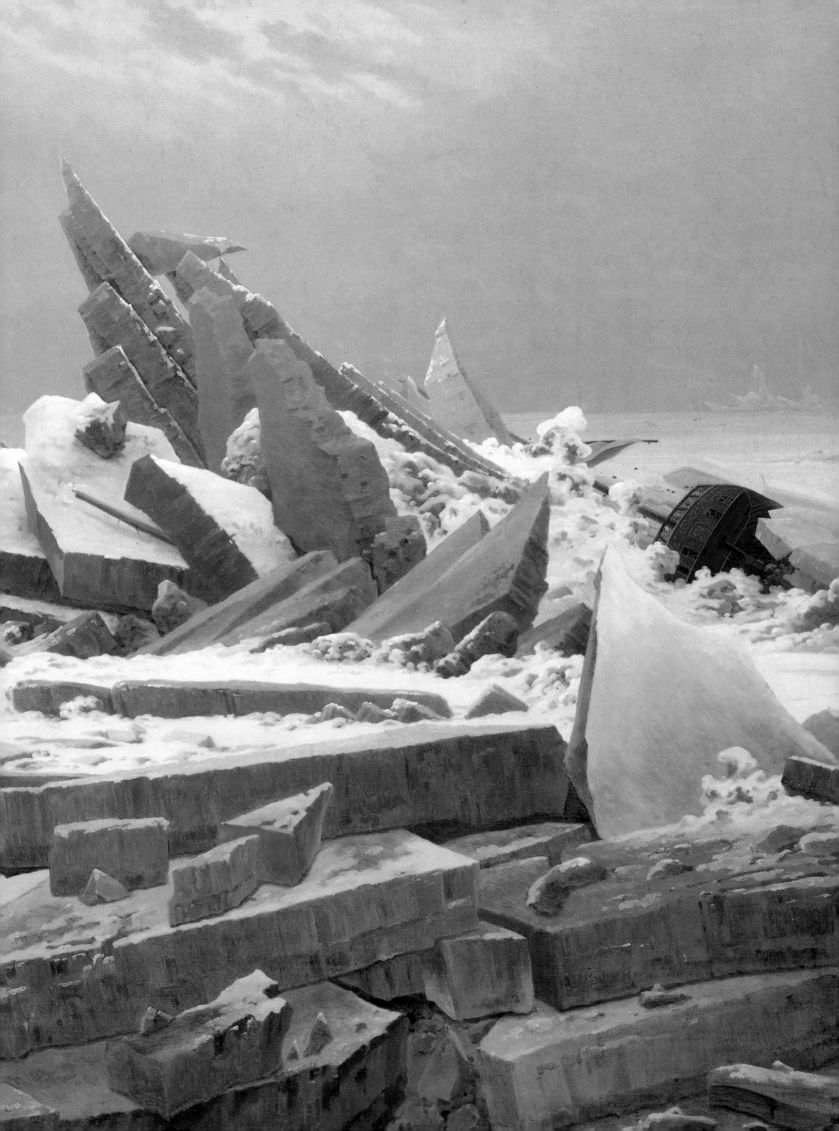

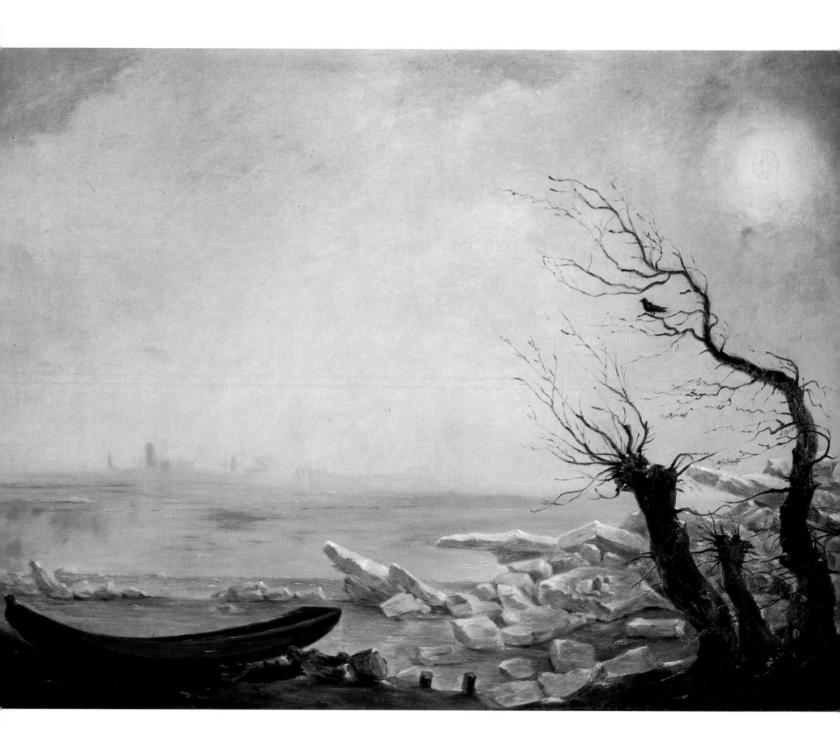

a witness to and affirmation of the pessimism of a man striving to transcend the empty, hostile wastes of extreme experiences.

We should not forget, however, the profound meaning which the annihilation of life in floes of ice must have had for a man who, as a child, had witnessed the drowning of his brother, Christopher, during an ice-skating outing on the frozen Baltic; an accident all the more tragic as the latter died while trying to save Caspar, who had fallen through the ice.

In his silent contemplation of the ship in its wintry shroud, the artist plumbed the depths of a personal tragedy, questioning the injustice of the human condition, which is to be ever faced with death. But the crux of the matter is not to be found in any eventual psychological effects. Rather, it appears in the artist's response: to create a pictorial philosophy which suggests a transcendence, a sublimation of mortal contingencies through the specific powers of the image.

Certain art historians have advanced another, more indirect, interpretation of this picture. According to them, what is represented–in highly coded terms–is the "freezing" of the German political context under the influence of Metternich at the time. With this in mind, it is tempting to compare Friedrich's relatively modest composition with Géricault's monumental *Raft of the Medusa* (1819). There are, however, fundamental differences between the two artists' approaches: where Géricault took a *fait divers*–the incompetence of a Monarchist captain and death on a life-raft–and elevated it to a symbol of freedom and hope (by the appearance of a rescue vessel on the horizon), Friedrich merely reported a *fait accompli*, a one-way journey with no possibility of salvation.

The *Sea of Ice* is an exemplary representative of the Romantic and spiritual landscape created by Friedrich in the first decades of the 19th century. He put his meticulous realism at the service of a profound sense of ethics and more than a little religious symbolism. Hidden and encoded by the painter behind the exact appearances of nature, lies a lesson in life. Action is replaced by silent meditation, and the images turn inwards to face doubts and questions. The painted image is meant to express the Germanic *Weltanschauung*, its concept and vision of the world.

21

CARL GUSTAV CARUS
Boat Trapped in Blocks of Ice
Oil on canvas,
32 x 44.5 cm.
Linz, Neue Galerie.

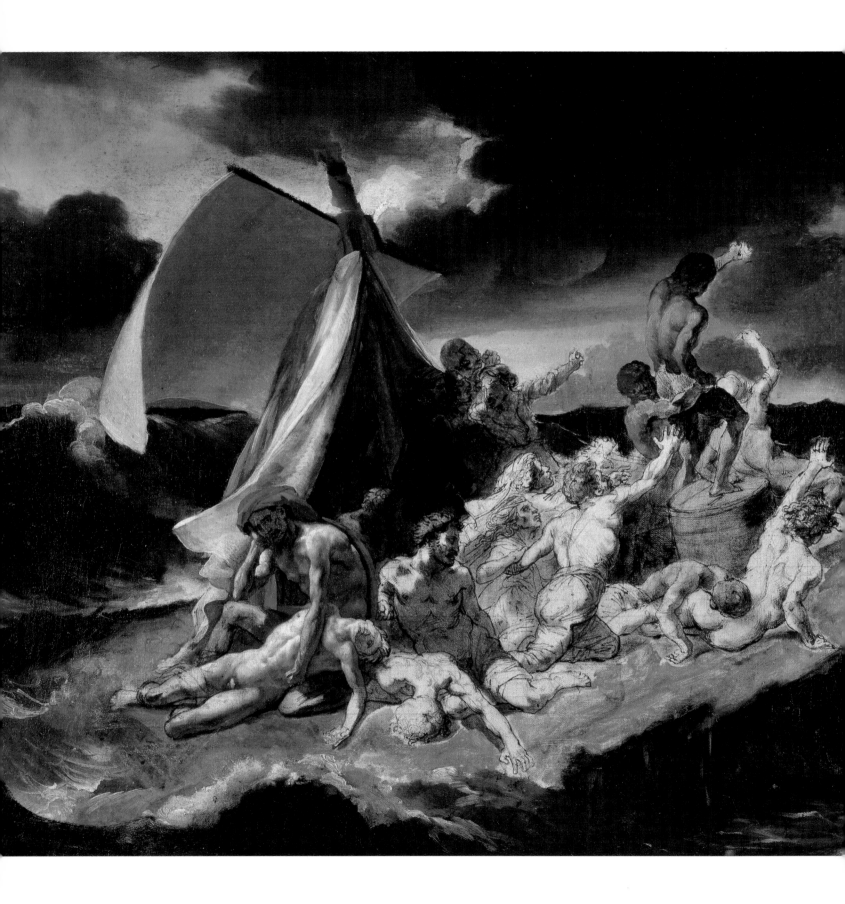

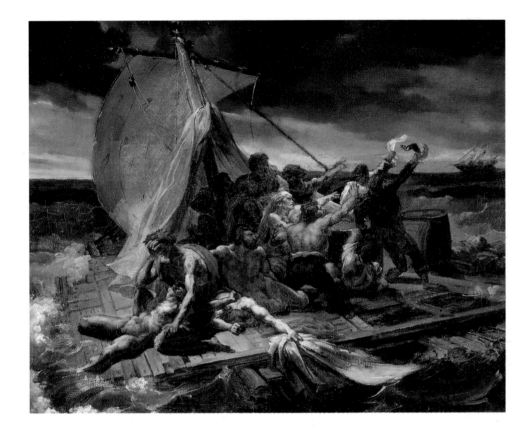

THÉODORE GÉRICAULT
The Raft of the Medusa
1st sketch.
1816, oil on canvas,
37.5 x 46 cm.
Paris, musée du Louvre.

Opposite

THÉODORE GÉRICAULT
The Raft of the Medusa
2nd sketch.
1816, oil on canvas,
65 x 83 cm.
Paris, musée du Louvre.

THE RAFT OF THE MEDUSA
OR THE SINKING OF NÉOCLASSICISM

At the beginning of the 19th century, the theme of the shipwreck, so masterfully illustrated by Géricault, was not an entirely new one in Europe. J.M.W. Turner had treated it before in his 1805 *Shipwreck,* and would return to it again and again, developing it throughout his career.

One name, however, was to be enduringly associated with the appearance of Romanticism on the scene in 1819: that of the "Medusa." Bound for Senegal in 1816, this ship had been given the fateful name of one of the three Gorgons, the dreaded sisters of Greek mythology.

The frigate "Medusa," accompanied by the corvette "Echo," the sloop "La Loire" and the brig "Argus," was part of a small convoy transporting the Governor of Senegal and other colonial administrators. Aboard the "Medusa" were four hundred passengers and crew members. The ship had been placed under the command of Hugues Duroy du Chaumareys, an émigré and an inexperienced naval officer who had not sailed in twenty-five years. In the early afternoon of July 2, the vessel foundered one hundred and twenty kilometers off Cap Blanc on the coast of Senegal. The lifeboats were pressed into service and a makeshift raft was constructed to carry one hundred and fifty people, mostly military personnel. The raft should have been towed by the lifeboats, but the cables were cut and the hapless craft was cast adrift on the open sea. In a romantic drama fit for the tabloids, nature suddenly turned into a deadly foe, unleashing in the men their lowest instincts.

The tragedy that ensued on this frail stage measuring only seven by twenty meters lasted thirteen days and was of both the most ferocious and the most ordinary kind.

Almost immediately, prodded by hunger, thirst and alcohol, the struggle between the men began, and within only a few days, half of the original hundred and fifty survivors were dead. The others slowly wasted away, decaying both physically and morally, only to be devoured by their own shipmates, half-crazed with hunger. By the 11th of July, all that remained were

Opposite and following pages (details)

THÉODORE GÉRICAULT
The Raft of the Medusa
1819, oil on canvas,
491 x 716 cm.
Paris, musée du Louvre.

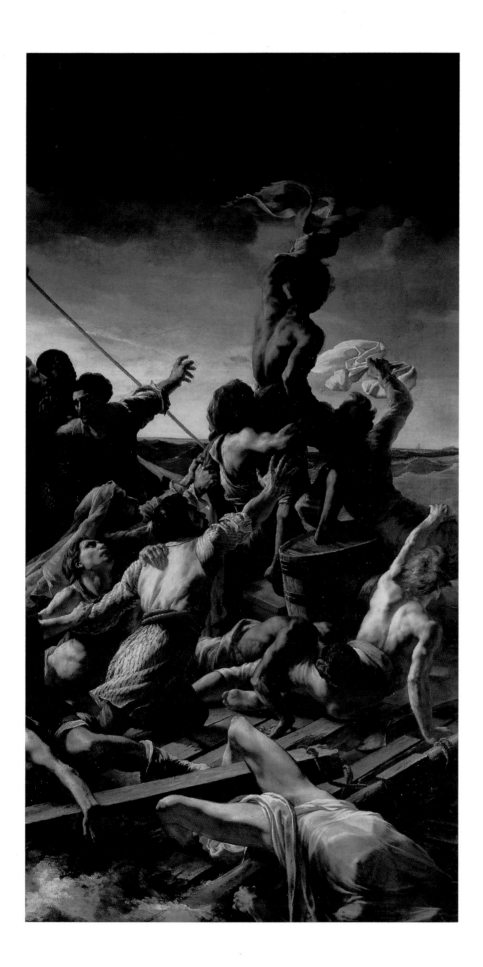

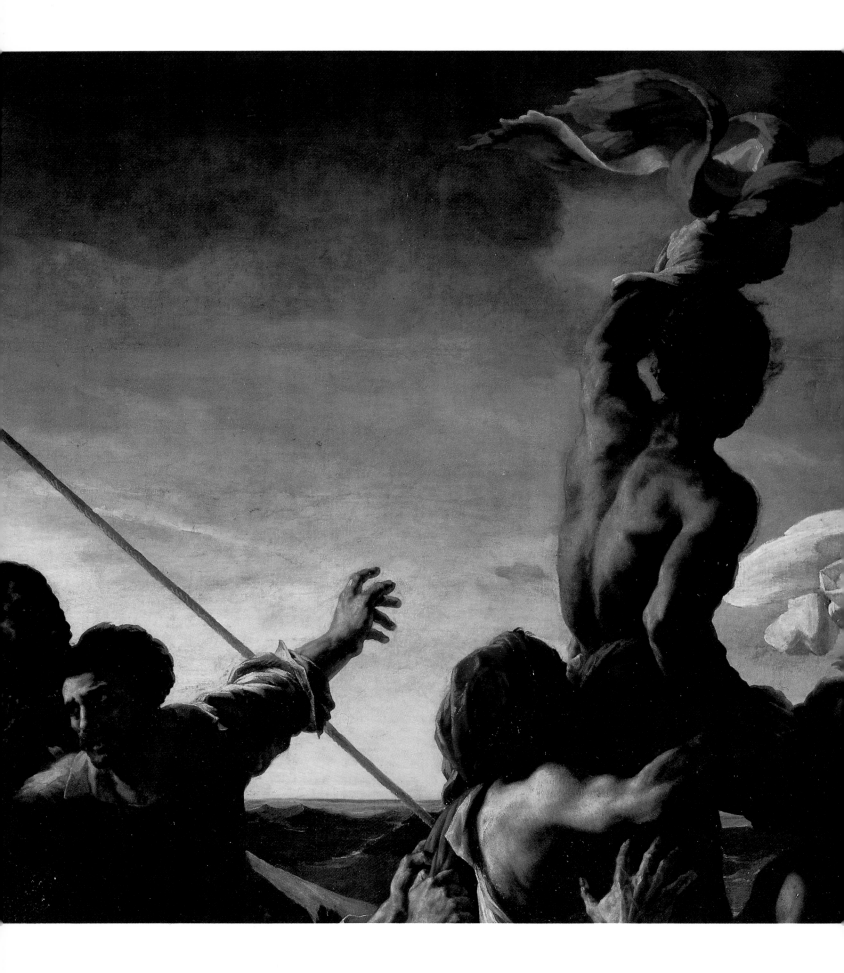

fifteen haggard shadows, hovering between life and death. Class and age differences had been abolished in a community of nakedness, suffering, filth, disease and murder. A state of complete equality had been achieved, yet only those with a deep faith and a strong cultural base could face their fates with dignity and maintain a spark of hope. On July 17, with morale at its lowest level ever, a sail was spotted on the horizon, heaving into and out of sight. What the rescuers from the "Argus" finally found on this improbable floating morgue were fifteen men in an unimaginable state of depravity.

The captain of the "Medusa" was tried by a court of justice in Rochefort and sentenced to loss of rank and three years' imprisonment. The trial quickly took a political turn as the liberal opposition transformed the "Medusa" tragedy into a symbol of Monarchic incompetence and Royalist decay. In that same year, two survivors, the engineer Corréard and the surgeon Savigny, published their personal accounts of the disaster. Their tale became an inspiration for Théodore Géricault, a young, unknown painter just back from a journey to Italy and Rome.

Seven years older than Delacroix and a former pupil of Guérin, Géricault sensed in this human drama the seeds of a new epic; a historical backdrop for a great pictorial "machine" that would stage the dynamic and varied dimensions of death, human otherness, and the responses–ranging from madness to stoicism–displayed by men suddenly at odds with nature and their destiny.

The first question was: which moment of this atavistic saga to depict? From his sketches, we see that the artist long hesitated between the rescue–which he considered too descriptive–the mutiny of the soldiers–considered too fierce–and the acts of cannibalism that would have dramatized the depths of savagery to which they had stooped.

He was very thorough in his research, interviewed Corréard, Savigny and other survivors, and built a scale model of the raft. In the autumn of 1818, feeling the need to withdraw from the rush of his Parisian social life, he secluded himself in a house in the Faubourg du Roule. He believed that solitude and a monastic-like existence would create the moral conditions necessary for him to relate to the event and develop a new aesthetic of cold horror.

Working on a scale as vast as his subject, he slowly put the protagonists of this modern tragedy into place. He used his friends as models, Eugène Delacroix among them, and also

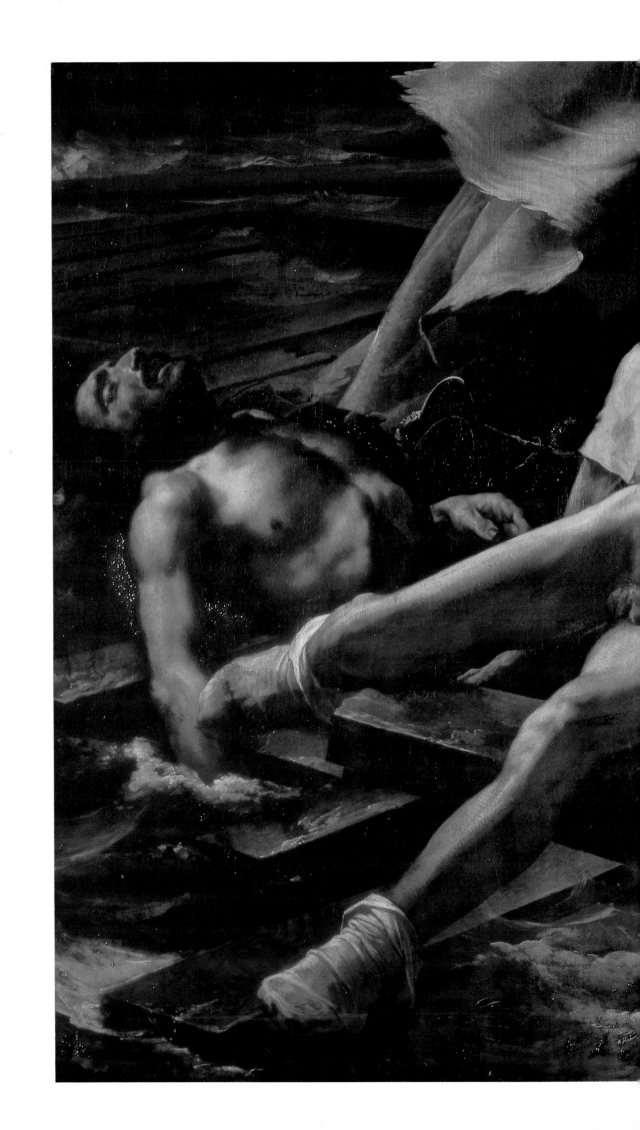

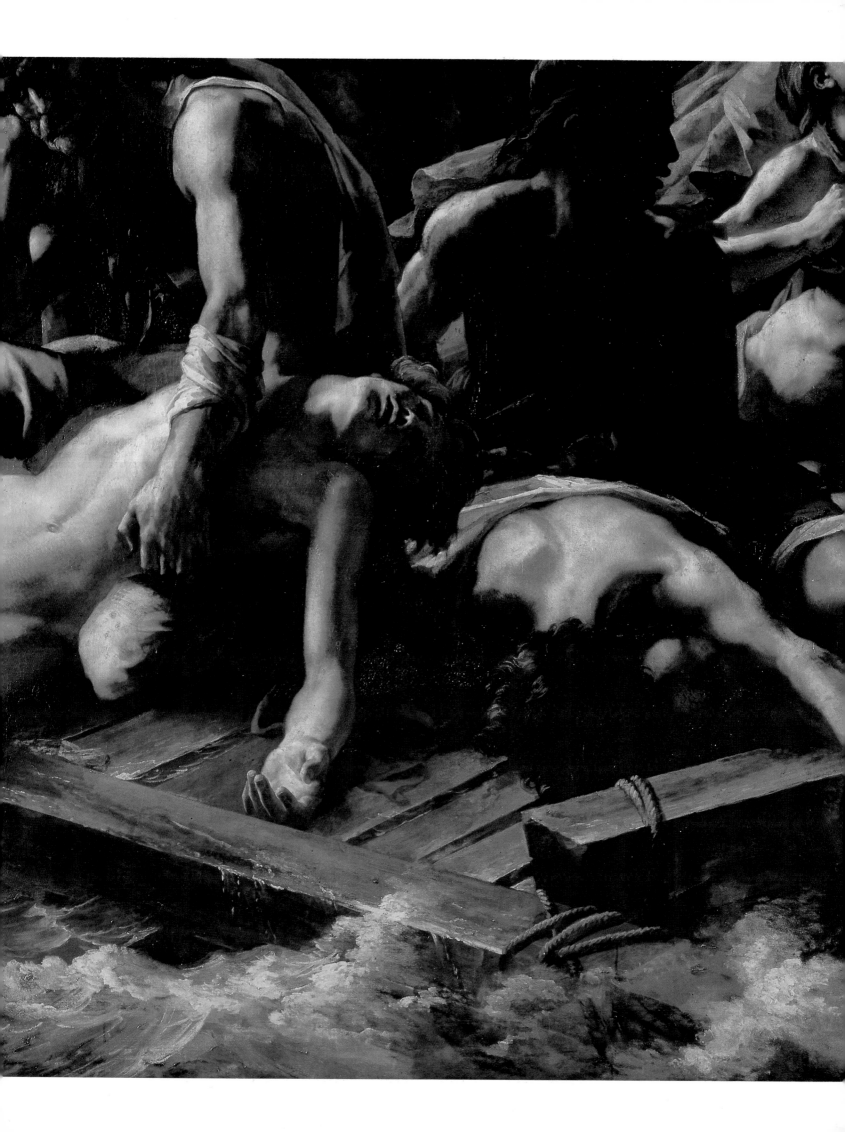

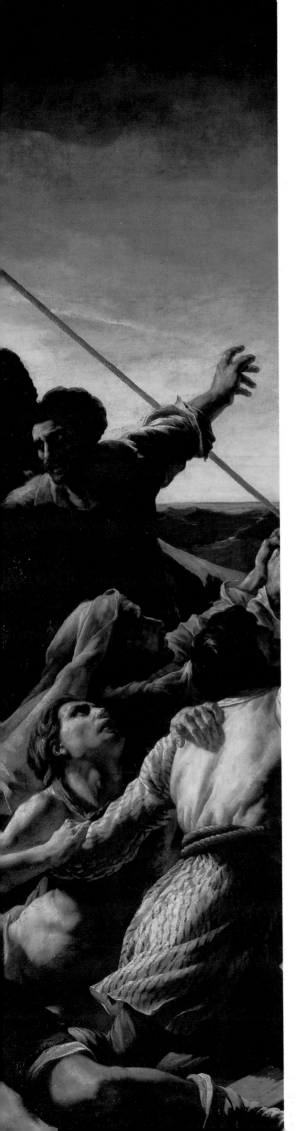

Corréard, Savigny, the negro Joseph, and former soldiers of Napoleon's army. Still not satisfied, Géricault went on to compose uncanny still-lives of actual human remains salvaged from the Beaujon Hospital nearby. For the sake of absolute realism, he even brought dead bodies into his studio and posed them.

The moment he finally chose was the climax of this *symphonie funèbre*: when the ghoulish survivors finally catch a glimpse of hope in the form of the brig "Argus," rising providentially above the horizon like a star. This peak moment was intended to be a metaphor for the precarity of the human condition. Although under full sail, the "Argus" appears impossibly small in the distance, at the apex of despair, the only grace note in this drama.

The composition is Neoclassical in its language, but modern in its message. In the foreground is the lozenge-shaped raft, a makeshift construction of beams and planks. The pictorial space is spanned by an imaginary diagonal rising from left to right, creating a moral axis ranging from despair to hope. The result is two human pyramids, with the one on the right culminating in the figure of a negro waving a white and red cloth. The theme of hope was linked, in Géricault's mind, with the struggle against slavery. The sea is full of looming, wind-lashed waves, under a lowering sky brimming with the threat of storms to come. The craft groups nineteen figures, both living and dead.

In moral terms, the pyramid on the right represents life, the upward surge of life, reinforced by the view of the "Argus" in the distance, however minute. Next to the mast, with outstretched arm, Corréard indicates the horizon to the surgeon Savigny. The left side of the composition is the realm of death; sitting among the corpses is the stoic figure of an old man, a quotation from *Marcus Sextus* by Géricault's teacher, Guérin.

The poses and muscular bodies are fully in keeping with the "academies" of the Beaux-Arts curriculum, while the chiaroscuro treatment derives from the tradition of Caravaggio. Nonetheless, the artist performed the amazing feat of raising a sensational current event to the same level as the great historical compositions of Gros, who celebrated the Napoleonic epic. But there are no enemy camps here, for the battle is against fate and a forbidding nature. The details may be realistic enough, but the artist suffused the scene with an emotional, heroic, almost abstract energy. In this way the obsession with death is transfigured into a symbol of fate assumed, the struggle to regain human dignity.

The critics were anything but subdued by this unusual "pictorial machine" when it was presented at the Salon of 1819, and their comments ranged from anathema to cautious praise. This may have been a momentary setback for the nascent Romantics, but it was a triumph for the painter, who was suddenly the focus of public sensation and aesthetic attention. In any event, this pivotal composition marked the true demise of Neoclassicism and formed the necessary foundation for the innovative approach of Eugène Delacroix.

THE DESCENT INTO HELL OR THE OBSCURE ITINERARY OF A YOUNG ROMANTIC

Around 1821-1822, Delacroix's work underwent a fantastic transformation, making this other former pupil of Guérin the true founder of French Romanticism, not long after Friedrich's first experiments in Germany.

His friend Géricault, critically injured after falling twice from a horse, died two years later, after struggling against fate in the best Romantic fashion.

In 1821, Delacroix began a large composition titled *Dante and Virgil in Hell,* a subject taken from the *Divine Comedy* (Inferno VIII) by Dante Alighieri, which his friend Pierret often read in the studio. The boat is being steered on a lake in Hell by Phlegias towards the city of Ditae. This recalls the maritime theme of *The Raft of the Medusa,* but the subject is treated in a completely different manner, based on a different conception of space, mood and the imagination.

The outstanding feature of this picture is its finality: there is no trace of the anecdotal, none of the literalism of an illustration. On the contrary, the scene comes across like a clairvoyant dream, a not-impossible apparition, and far removed from traditional illusionism. This was a deliberate choice on the part of the twenty-four-year-old artist.

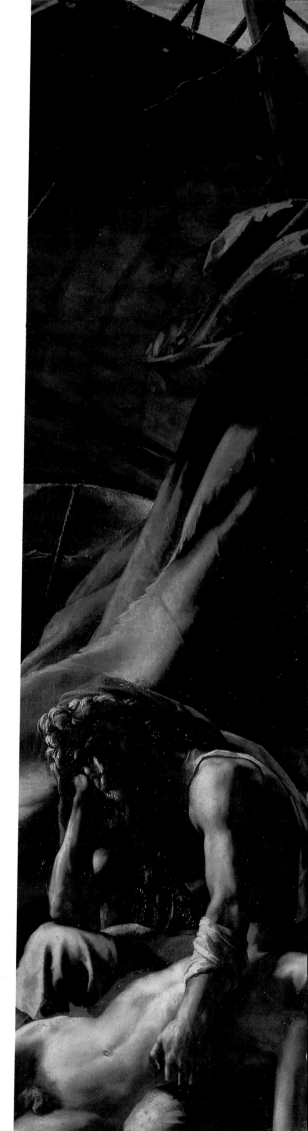

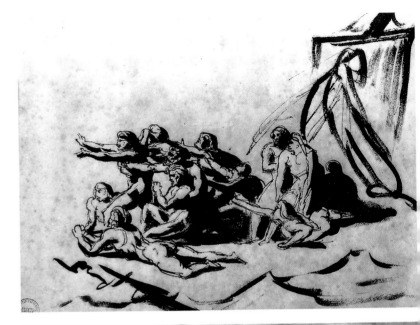

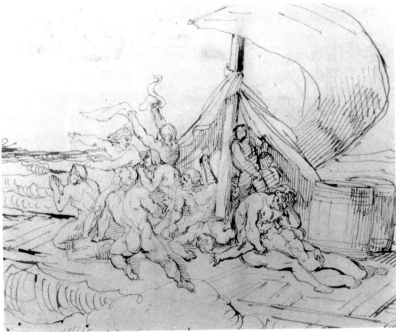

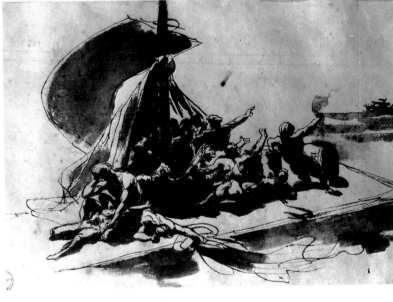

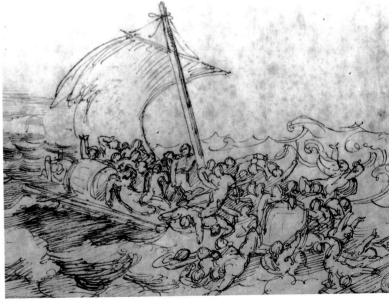

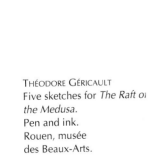

THÉODORE GÉRICAULT
Five sketches for *The Raft of
the Medusa*.
Pen and ink.
Rouen, musée
des Beaux-Arts.

THÉODORE GÉRICAULT
Torso of a Negro Male
Study for *The Raft of the Medusa*.
1818-1819, oil on canvas.
Montauban, musée Ingres.

For sure, Dante, Virgil, Phlegias and the souls of the Damned are all in their places, ready to play the Romantic drama. All concern for realism has been replaced by an amazing aesthetic of ambiguity. Space seems to be in suspense, composed of thousands of particles of the most diverse substances: water, mist, fire, clouds. The time in Hell is night, when light has an obscure resonance, it is the dark light of nightmares. Not a real night, but a night of the interior: the horror of facing evil and its punishment, felt by Dante himself as he gropes for Virgil's guiding hand.

"O the winds! Beware the winds of night!" Victor Hugo would write several decades later. What we have here is an aesthetic of fear combined with fascination, a state shared by all the German poets and painters of the period (Novalis, Tieck, Friedrich). An abyss had opened at the feet of Western Rationalism. The poet and the artist were drawn into a place of tribulation where the damned devour each other.

There is nothing innocent about Delacroix's choice of Hell: we are all guilty of hearkening to the flames, to some dark horror. He sees himself in Hell with the eyes of the artist, of the medieval bard and of the Latin poet. Where is Beatrice, that positive feminine image? Surely she does not appear in the aspect of this muscle bound woman crammed against the boat, a not-too-distant relative of the Sybils and nudes of the Sistine Chapel? Hers is an anatomy conjured up and corrected by Rubens, to whom Delacroix dedicated his art in a double homage to the past. He was a great admirer of Michelangelo and Rubens, the leading artists of the 16th and 17th centuries, both of whom were known for their peculiar treatment of the human figure.

Apart from man's (and the artist's) horror at the unspeakable reality of divine punishment, Delacroix expressed here another basic position: Romanticism was to be a dynamic of passions in space. Good and evil meet and clash; two vital elements clearly embodied by the figures, the atmosphere and the setting. Nothing is stable, nothing is anchored to the ground: water dissolves into smoke which shades the colours and merges with the clouds. Even the fierce ballet of the Damned appears suspended on the waves. Everything could suddenly disappear again at the end of the nightmare, at the end of the vision set down by the painter.

It was a way of warding off the dark and infernal realms of Antiquity with a Christian edge. The realms of internal, subjective darkness which threaten the painter, the poet and the Romantic individual. An active and dark power surrounds the two

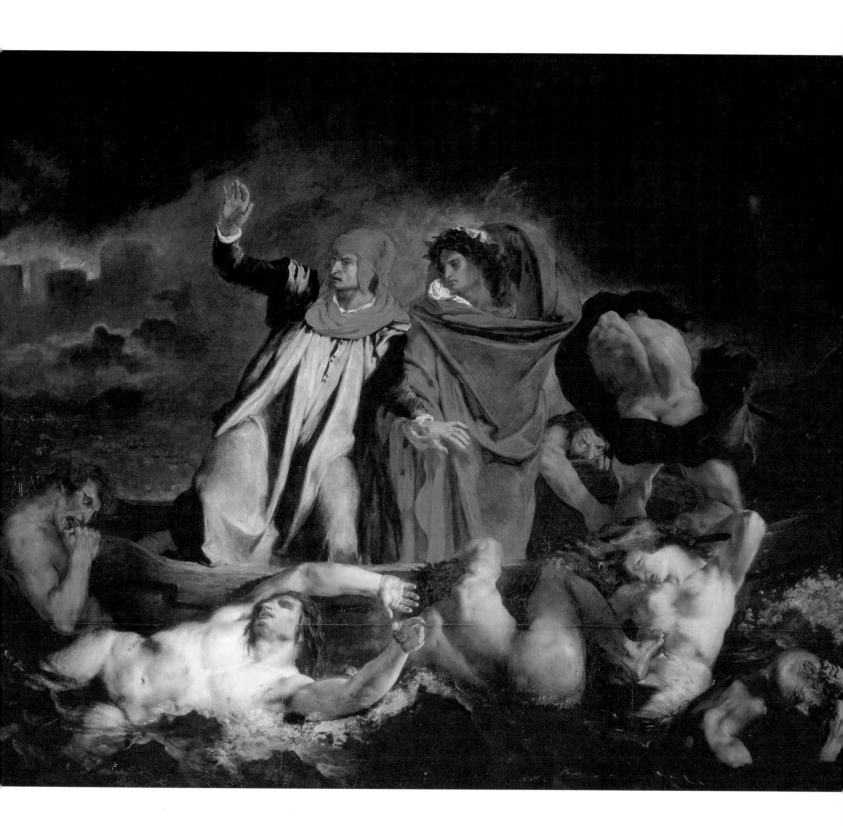

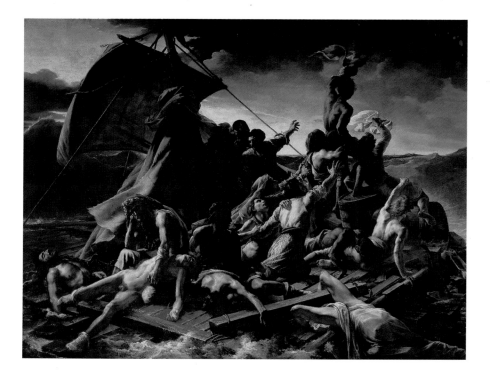

travellers in their infernal journey, which, in Dante's *Divine Comedy,* eventually leads to the heavenly light of Paradise.

Critics retorted with accusations of "smudging" and "incorrection," oblivious to the fact that the Romantic approach concerned the spatial and pictorial conception of the painting as a whole. Death, aggression, sensuality, the rites of passage and individual tragedy against the backdrop of collective distress. After two and a half months of furious labour in his studio, Delacroix emerged as the leader of this new type of painting.

The theme of the shipwreck appears in Friedrich's *Sea of Ice* as the precisely-detailed staging of an extreme natural situation, yet devoid of all picturesque or anecdotal emphasis. A metaphor of human existence, an image of the futility of voyages of discovery, a meditation on the fragility of existence. Géricault treated the subject in a large-scale composition in which Neoclassical vigour verges on a dialectic of the extremes of hope and despair, playing dynamically with the internal forces of the theme: realism and its transcendence. Delacroix, following the lead of the poets, broke through to the obscure realms of the irrational, transforming the function of space, of the figures and of the subject.

Where Friedrich gave himself over to meditative abstractions, the French artists expressed the shock of the individual's encounter with personal or collective history, if not destiny.

THÉODORE GÉRICAULT
The Raft of the Medusa
1819, oil on canvas,
491 x 716 cm.
Paris, musée du Louvre.

LANDSCAPE PAINTING
IN EUROPE

SEARCH FOR THE SUBLIME

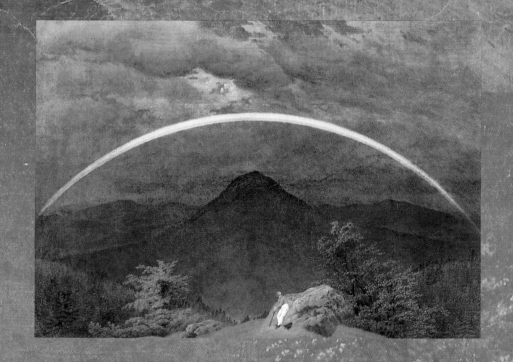

Let us turn back a few years to the time when landscape painting and its function were undergoing a remarkable transformation. Already in the second half of the 18th century, in Europe, outside France, there appeared a pictorial vogue that was mostly foreign to Neoclassicism and that expressed itself in a wholly different register. It manifested itself in a taste for the sublime, and brought with it a new iconography of mountains and evocative rock formations.

The painters who cultivated this tendency aspired to a transformation of the role of perspective, an expansion of space; imperceptibly, they gravitated towards a mystical naturalism, a sort of geological sublime, that had never been seen before. Remember that Edmund Burke's influential *On the Origins of our Ideas of the Sublime and the Beautiful* appeared in 1757, and Immanuel Kant's even more significant text, *Observations on Our Sentiment of the Beautiful and the Sublime,* in 1764. The German philosopher's reflections on Aesthetics anticipated to a surprising extent the shape which painting of the natural sublime would take in Europe at the end of the 18th century, and in Germany in the early 19th century– primarly in the Romanticism of Friedrich and the Dresden School.

Kant established a qualitative difference between feelings of the Sublime and of the Beautiful, pointing out that "the view of a snow-covered mountain peak rising above the clouds" may have its charm and appeal, but it also inspires awe, and this dual reaction is exactly what characterized the essence of the natural sublime. He also noted: "Towering oaks and lonely shadows in a sacred wood are sublime," "day is beautiful, the night sublime," "Beauty charms, the Sublime moves."

The discovery of the Alps was a relatively recent phenomenon in the history of European sensibility. In the late 18th century, the high mountain fastnesses, with their glaciers, precipices and desolate passes inspired horror and dread. The Alps, long ignored, began to attract scientists and the curious after Balmat and Paccart made the first ascent of Mont-Blanc in 1786. In 1788, the naturalist Horace Bénédicte de Saussure made the climb and recorded his experiences, mentioning among other things: the elevation of the soul, the broadening of spiritual horizons, and the secret voices of Nature.

Painters also began to discover the inner forces of the Alps; Turner, an Englishman, and Wolf, a Swiss, scoured valleys and glaciers in search of the secret powers enshrined in the stark monumentality of the rocks.

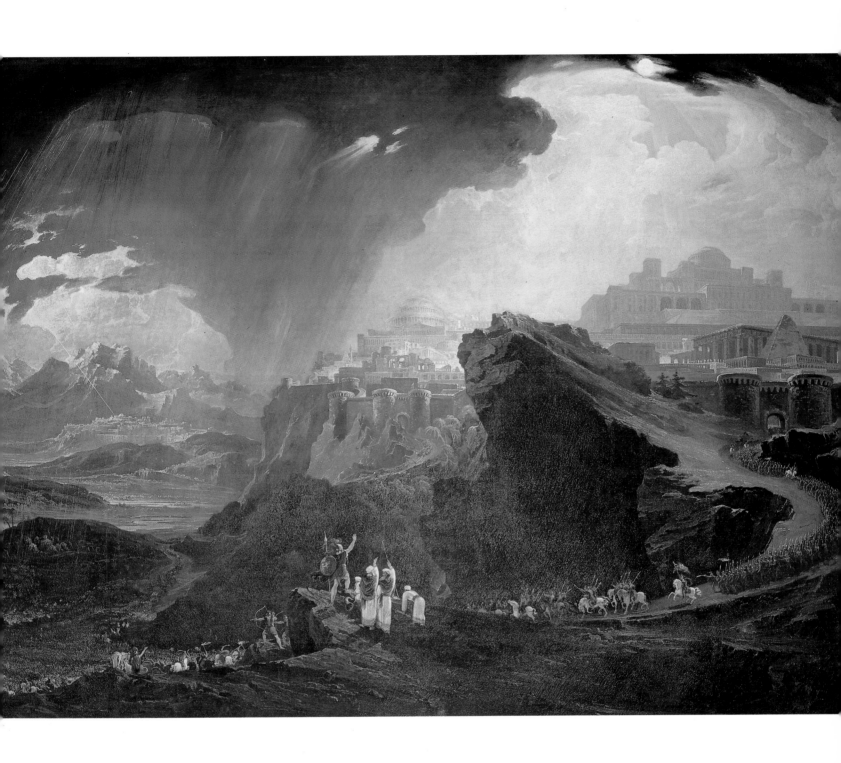

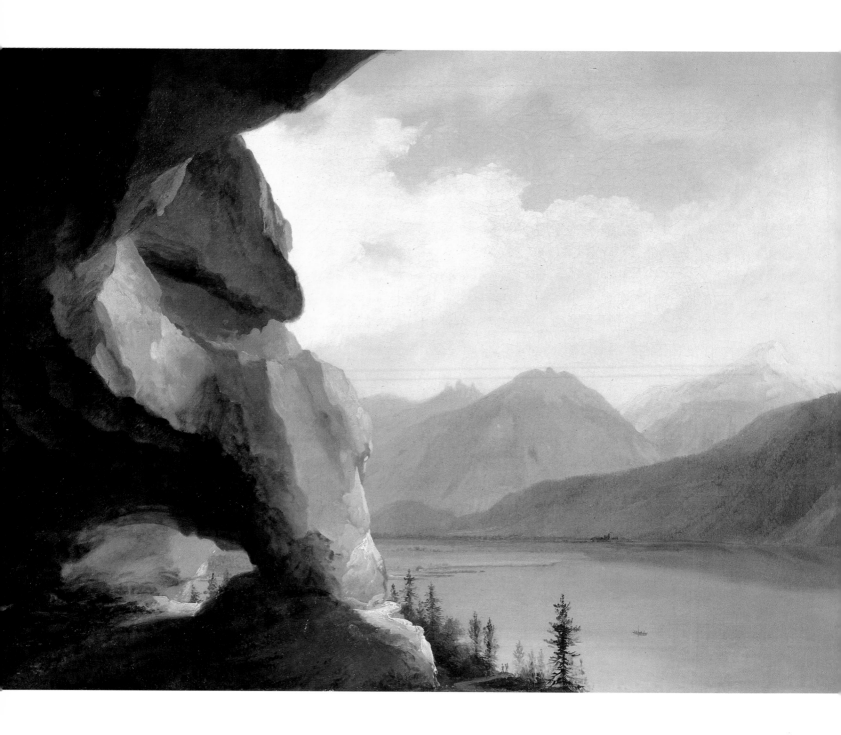

This communion with the elements and quest for telluric powers is particularly evident in the work of Caspar Wolf, one of the leading precursors of the Romantic landscape. Born in Muri in 1735, the painter spent many years making documentary views for a publisher in Bern, exploring the Alps high and low, searching in every nook and cranny. His technical skills made for a flawless depiction of the natural spectacle, but what fascinated him the most were the mysterious and lyrical aspects of the mountains.

His overt goal was the objective, topographical exploration of little-known sites, but his pictorial vision often led him to indulge in sublime reverie, oblivious to all other concerns, letting nature overpower with its immensity the human creatures who timorously skirt its unfathomable depths. Wolf thus created a new type of landscape view which culminated in works like *The Lake of Thun and Mount Niesen Seen from the Grotto of Saint-Béat* (1776), in which the minuscule human figures seem to be no match for nature, which is both stunning and disquieting in its perfection. The left foreground, dominated by the mighty arch of the grotto and accentuated by strong contrasts of light and dark, leads the eye towards the sketchily-indicated lake and the mountains beyond. It seems clear that, through this stark confrontation, the artist sought to give form to a natural cosmic power. This notion is powerfully expressed in *The Grotto of Saint-Béat Seen from the West* (1776), in which he repeated the theme of dark and remote reaches, and of the solitary wanderer faced with a spectacle which takes on the appearance of a total artwork, a sort of gigantic sculpture, in which he acts only as a sort of double of the painter or of the spectator.

The theme of the grotto or cave in modern times, treated by Wolf in such an unusual manner, goes back to the Italian Renaissance, where it was developed by Leonardo da Vinci and Mantegna in such famous compositions as *The Virgin of the Rocks*, or *The Adoration of the Magi*.

But it was with such artists as Wolf that the grotto became a major and significant theme. In the latter's work there is a subtle shift from the documentary intention toward a pre-Romantic atmosphere. Wolf seems not to have disliked certain contradictions: contemplative serenity is experienced at the same time as a *horror vacui*. His technical mastery is often counterbalanced by a fascination with death.

This dynamic and contrapuntal vision of the spiritual landscape is also evident in his *Alpine Landscape with Rainbow*

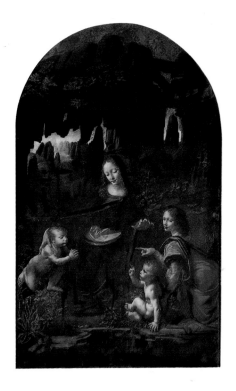

LEONARDO DA VINCI
Virgin of the Rocks
Oil on canvas,
199 x 122 cm.
Paris, musée du Louvre.

Opposite

CASPAR WOLF
View of the Lake of Thun and Mt. Niesen from the Grotto of St. Beat
1776, oil on canvas,
Aarau, Aargauer Kunsthaus.

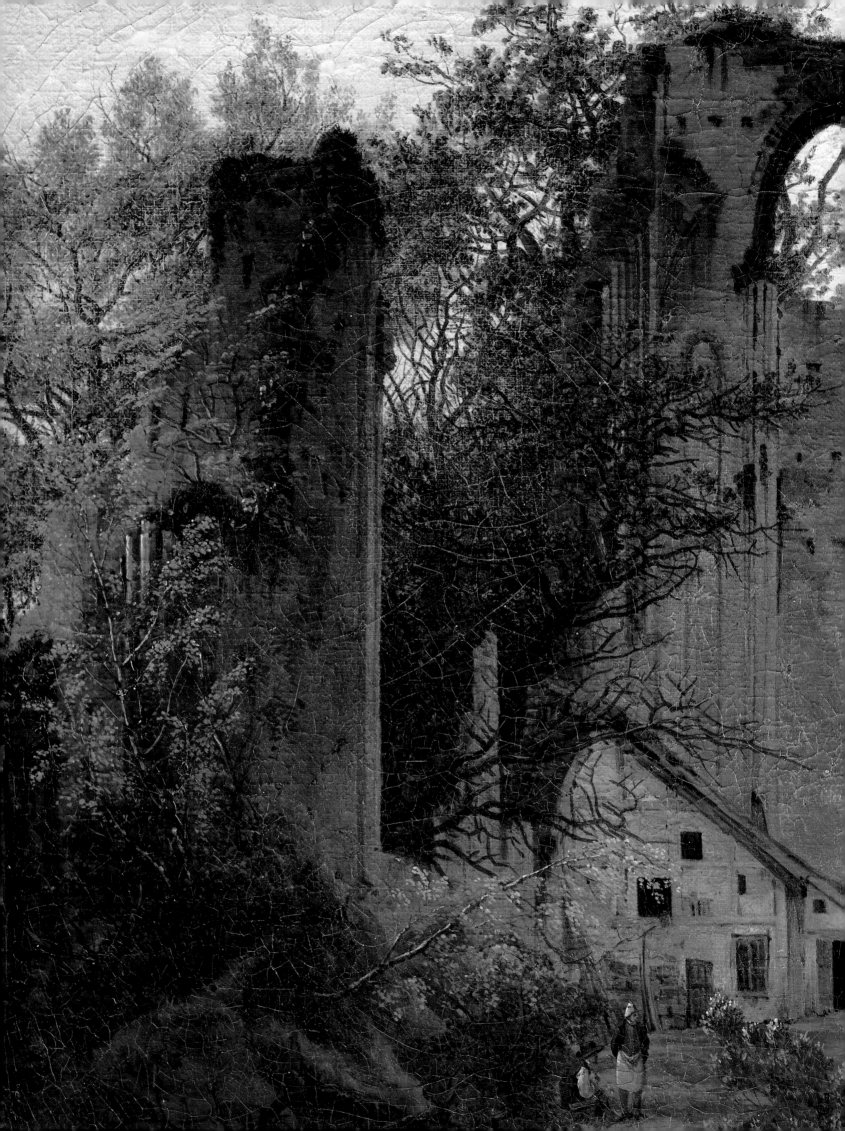

(1778). The vertical accent imparted by the format further enhances the opposition between above and below, between the sharp foreground and the hazy distance. Spanned by a rainbow, an ancient symbol of the new covenant between Heaven and Earth, the lower register becomes the focal point of the composition. Also, by extending the mountains towards the upper edge of the picture, the artist created a flattening effect, effectively reducing the scene to two dimensions. This abolishes the reassuring feeling of progression: nature confronts us like a "Gothic" rampart which calls not for action, but for meditation.

THE IMAGERY OF THREATENING NATURE

Overleaf

CASPAR DAVID FRIEDRICH
The Ruins of Eldena
1825, oil on canvas,
35 x 49 cm.
Berlin, Nationalgalerie.

Opposite

CASPAR DAVID FRIEDRICH
Landscape with Solitary Tree
1822, oil on canvas,
55 x 71 cm.
Berlin, Nationalgalerie.

This tendency to bring out the menacing expressivity of natural shapes and volumes was a feature of both English and German painting at the end of the 18th century. Other painters of the Sublime strove to break through the bonds of Neoclassicism, to go beyond surface appearances and penetrate the hidden realms of the universe. Theirs was a spiritual quest, oriented more towards symbolic than descriptive values.

These painters advocated a kind of diffuse empathy, an effective identification with the natural elements, an approach which anticipated almost all the qualities of the German Romantic landscape to come. Such motifs as dark caverns, lonely crags, rock formations jutting upright in the landscape like question marks, or trees poised in precarious balance, were no longer used as simple stylistic effects, but became the means to intellectual and spiritual ends. John Robert Cozens' watercolour titled *Near Chiavenna, in the Grisons* (ca. 1781) forcefully expresses these new principles. For Cozens, painting the Alps was more than just a picturesque exercise; he stressed the enormous masses of rocks,

L. Tourne. del
1781

N.º 53

letting them fill up the pictorial field and create an oppressive atmosphere. The tiny human shapes never quite manage to establish a reassuring scale. Amid the sharp and broken forms of this natural chaos, man is no longer master, but rather more of an intruder. And nature is no refuge at all: it is fragmentary, disorganized and powerful. Cozens accentuated these effects in another watercolour titled *Entrance to the Massif of the Grande-Chartreuse* (1783), in which the hesitant light in the distance does nothing to offset the powerful verticality of the pine-covered rocks.

The majestic and disquieting Alps, their jagged crests and iridescent light seeming to obey only hostile laws, attracted the attention of other painters like Francis Towne and Thomas Girtin. Working at the end of the 18th century, both artists combined a near-obsessive rendition of detail with vertical compositions, creating a novel and suggestive depiction of the spectacle of nature (Francis Towne, *The Source of the Aveyron* 1781).

In his view of *Bamburgh Castle* (1797), Thomas Girtin created a monumental composition in which ruins and rocks distract the spectator from the tiny figures of a shepherd and his animals. The upward thrust of the rocky promontory and the stark play of light and shade once again reduce the human presence to complete insignificance, confirming the pre-Romantic sentiment of the cosmic and unrivalled power of Nature.

Joseph Mallord William Turner, one of the leading English artists of the 19th century, was to adopt a number of the aesthetic and compositional principles of the natural sublime. Turner made a trip to the Alps in 1802 and was struck by the evocative quality of certain details. The drawings and watercolour studies that he brought back to England were often used in his later elaboration of paintings in oil.

The watercolour titled *The Great Falls at Reichenbach, in the Hasli Valley, Switzerland* (1804) was based upon a sketch made at the site. Through the jumble of dead and broken trees in the foreground, we can glimpse a couple of goats carefully picking their way through the devastation. In the middle-ground we see a group of frail human figures huddled around a campfire, counterbalanced to the left by a shepherd and his herd. From there, the background rises vertically in the misty distance. The fearsome aspect of this "sublime" setting is highlighted by the brisk and nervous brushwork, and by the insistent alternation of light and dark. The subject is seen and presented as a sort of archaeology of nature.

CASPAR WOLF
Cascade in Winter
1778, oil on canvas,
82 x 54 cm.
Winterthur, Museum
Stiftung Oskar Reinhart.

Opposite

FRANCIS TOWNE
The Source of the Aveyron
1781, pen, ink and
watercolour,
42.5 x 31.1 cm.
London, Victoria and Albert
Museum.

A similar intention may be detected in a further alpine view titled *St. Gotthard, the Devil's Bridge* (1804), which is fully dominated by the vertiginous and devastating aspects of nature. The bridge itself stands less as an affirmation of the great works of Man than as a questioning of the vanity of his presence. Instability and a dynamic nature, typical of Turner's approach, characterize this large watercolour and other works like *The St. Gotthard Pass* (1804), an oil painting based on two watercolour studies done from life. Overwhelmed by the site and the hostile appearance of the landscape, the artist set down his impressions in his sketchbooks. In this canvas he exaggerated the narrowness of the gorge, creating an effect which, along with the cutting off the summit and the bottom of the gorge from view, creates a dizzying feeling of instability and claustrophobia. A tiny cross at the end of a path keys the picture in a spiritual mode, a feature later to be found in many of Friedrich's works.

The theme of a menacing nature transformed into an instrument of divine vengeance inspired the painting of another English artist of the early part of the century: John Martin. Possessed of an irrepressible need to express pictorially man's powerlessness in the face of divine wrath, Martin composed grandiose scenes in which an unbridled nature precipitates man to his doom, a victim of his own guilt. His works are characterized by a fantastic elemental imagination, if not a rather negative vision of human destiny. The picture titled *Sadak Searching for the Waters of Oblivion* (1812) caused a sensation when it was shown in London. The public was deeply unsettled by this vision of towering and burning rocks crushing all the efforts of the hero. An opium smoker, John Martin demonstrated an amazing mastery of pictorial space and created works of masterful scope, like *Joshua Ordering the Sun to Stop in its Course* (1818), in which the interpenetration of a turbulent sky and an overbuilt earth expresses an apocalytic vision of the Holy Scriptures. His propensity at composing scenes of wild and natural wonders may also be seen in *The Bard* (1817), which bears a close relation to the Ossian pictures of Ingres, Gérard and Runge.

The Day of His Wrath (1854) stands as the spiritual testament of this artist passionately attached to a vision of the Absolute, but also to the scientific exploration of the Universe.

Opposite and following pages (detail)

JOHN MARTIN
The Bard
1817, oil on canvas,
215 x 157 cm.
Newcastle-upon-Tyne,
The Laing Art Gallery.

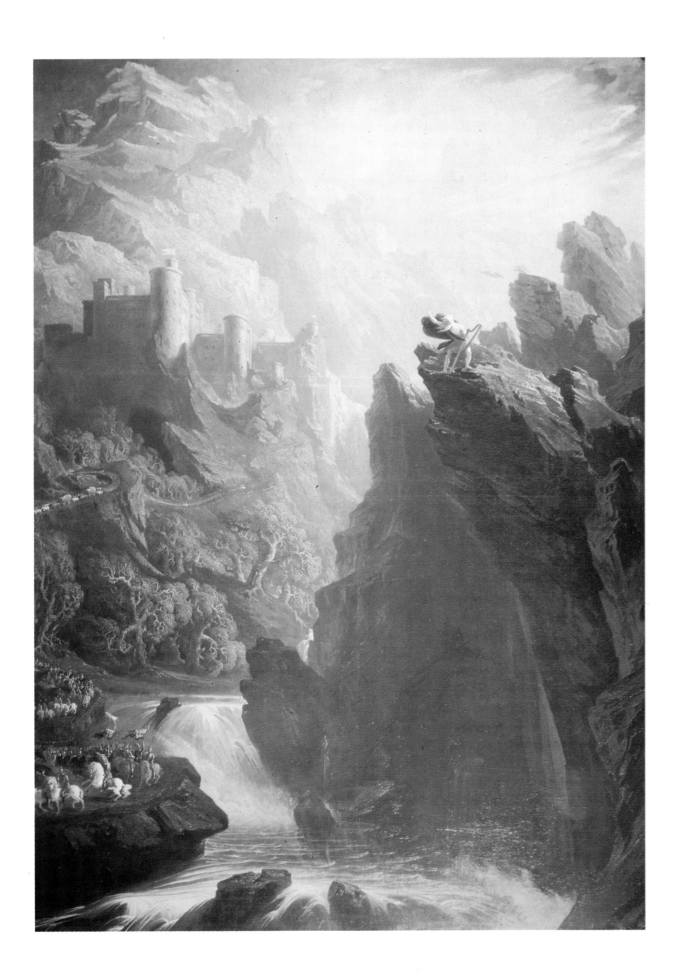

TURNER AND FRIEDRICH

PARALLELS AND DIFFERENCES

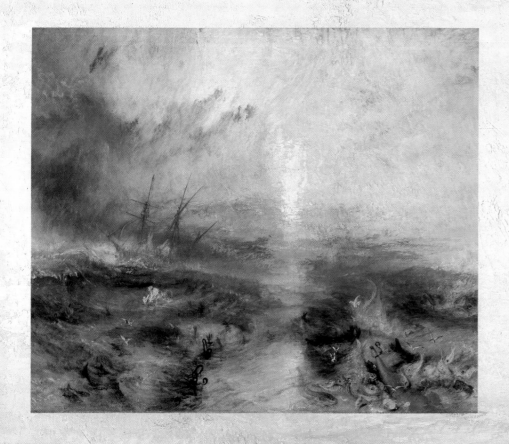

At the end of the 18th century, England discovered the charms and delights of landscape painting, a genre that clashed with the then-prevailing antiquarian and Neoclassical vogue in art. This new imagery may have originated in Italy, but it was in the Swiss Alps that the English painters first awakened to the sublime effects of rockscapes and began to create highly evocative compositions. John Robert Cozens, as we have said, cast the landscape into an altogether new mould, one unthinkable a few decades before, combining precise observation with imaginative volumes to produce a powerful pictorial tension. After him, Thomas Girtin brought a new freedom to watercolour painting and to the application of colour. His compositions, made up of numerous light areas and broad coloured patches touched up with small, brisk brushstrokes, became the formal foundation upon which the young Turner elaborated his own technique. With Turner, watercolour stopped being a mere tinted drawing and was elevated to a new status.

So essential is the role of landscape in Turner's work that it is worth digressing to define the relationships and divergences between his style of painting and that of Friedrich, his elder by one year. Indeed, Turner's achievement in the art of landscape was so decisive that their respective approaches—parallel in time and intention—are quite comparable, even if they differed ultimately in their development.

Born the son of a modest London barber, Joseph Mallord William Turner (1775-1851) was apprenticed to architects and print-dealers before gaining admittance as a student in the Royal Academy in 1789. He mastered graphic techniques and achieved considerable success as a topographical draughtsman, and was granted an associate membership to the Academy in 1799. In the course of these pursuits he discovered the vital presence of the Thames and the atmospheric intensity of the seascapes at Margate, while he no less passionately searched out old houses, ruined castles, Gothic churches, etc. He then wandered throughout England, roaming through the countryside and exploring towns and sites of all kinds, storing up impressions and memories that were to nourish his painting for the rest of his life.

In 1802, after a stay in Paris, he made a trip to the Alps, and this, as we have seen, inspired in him a sense of the sublimity of nature. Several years later, in 1807, he was appointed as a professor to the Academy, an activity which led him to work more intensively on colour theory. During this period, and in the

Previous pages

JOSEPH MALLORD WILLIAM TURNER
The Slave Ship
1840, oil on canvas,
91.5 x 122 cm.
Boston, Museum of Fine Arts,
Henry Lillie Pierce Fund.

Opposite

THOMAS GIRTIN
**Bamburgh Castle,
Northumberland**
1797-1799, oil on canvas,
45 x 55 cm.
London, Tate Gallery.

years to come, Turner was particularly appreciated for his compositions, which had a clear affinity with those of Claude Lorrain. The particular works on which his reputation was founded depicted historical subjects with suggestive classical architecture, stunning atmospheric effects and complex trees. Starting in 1823, however, seascapes appeared more and more often in his work: using transparent "veils" of colour, the artist masterfully rendered the relationship between sky, water and light particles suspended in the air.

In 1830, and in the face of bitter criticism, he inaugurated a new manner of painting which heightened and expanded the art of landscape in a radically new way, doing away altogether with the Claude-style classicism that had played such a major role in his earlier efforts. The space in these new compositions was divided into several zones of light of alternately concave and convex shape, crossed by beams or "corridors" of light which, although seemingly realistic, were often the product of his powerful imagination. This was the colour beginning which marked the break between the Classical and Romantic phases of his career. It was an ultimate liberation through colour and light used to dissolve forms and suggest space without defining it. In his later period, after his meeting with Ruskin in 1840, he devoted himself to a remarkable series of watercolours, many of which were overtly non-figurative, and too far ahead of their time even to be shown.

But, coming back to the works inspired by the spectacle of the Alps, it may be said that his intentions and subjects were quite closely related to those of the Dresden School, and to those of Friedrich in particular. Turner's travels in 1802 had taken him to Savoy, the Piedmont, the Saint Gotthard Pass and Mont-Blanc. Charmed by the sights and contrasting features of the alpine landscape, he was especially attentive to those tragic accents in which nature displayed a beauty both awesome and sublime; without, however, denying himself the luxury of invention. Back in his studio in England, he used the many sketches and watercolours done from life as starting points for his flights of imagination.

Works from this period repeatedly offered spectators the sight of formidable rock formations. Yet what Turner looked for in these highly picturesque motifs went far beyond the appeal of mere novelty: he was searching for the inspiration that would make him transcend the merely descriptive and endow his paintings with more meaning and scope.

JOSEPH MALLORD WILLIAM TURNER
View of an Alpine Valley, probably the Val d'Aosta
Watercolour.
Private collection.

CASPAR DAVID FRIEDRICH
**Mist Rising in the
Riesengebirge**
1820, oil on canvas,
54.9 x 70.3 cm.
Munich, Neue Pinakothek.

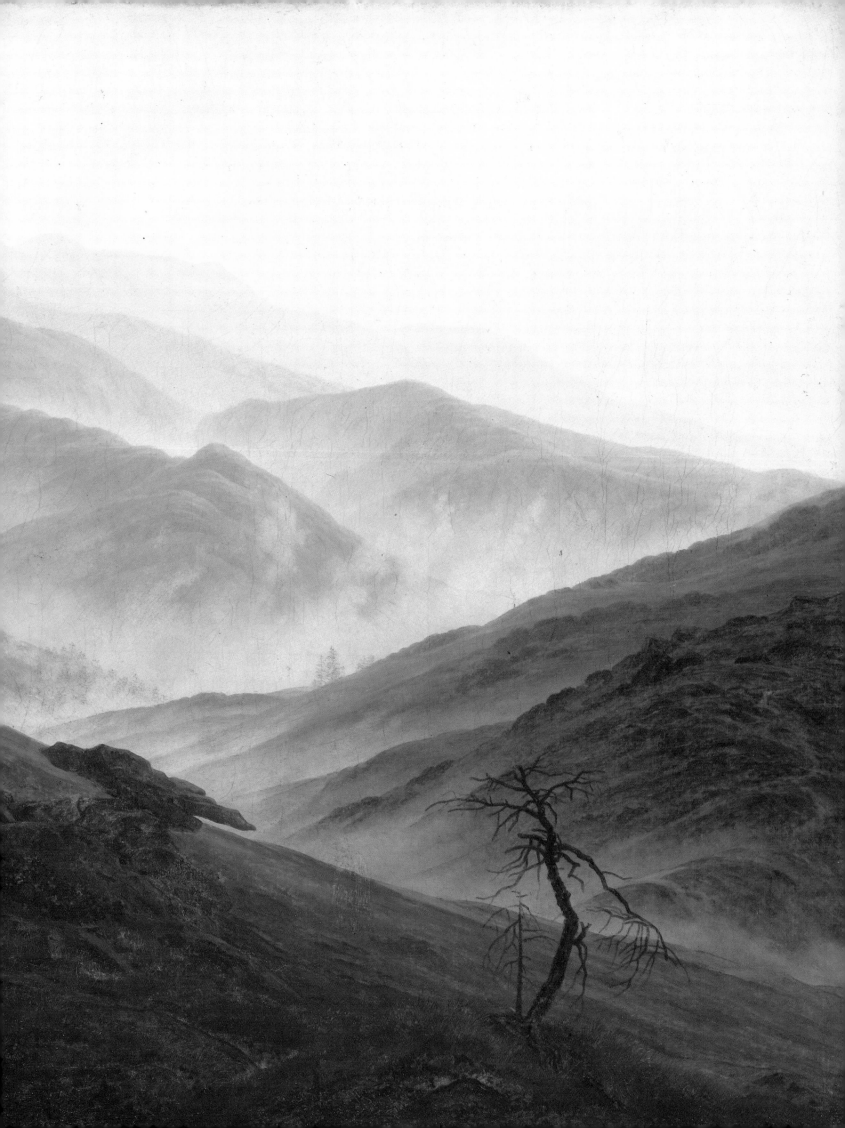

Like quite a few other European artists, this peaceful British *petit bourgeois* strove above all to invert the balance between Man and his natural environment. He sought to define new relationships, new concepts that expressed one of the leading subjects of Romanticism: the physical and spiritual journey that provides the painter with a dramatically enhanced space elaborated both from his direct impressions and by the active participation of memory.

From one work to the next, whether in watercolour or oils, nature emerged transmuted into myth or divinity, transcending its former limits to assume a quasi-religious function, something on the order of a diffuse Pantheism. In this sense, Turner's vision is very much in line with the one adopted by the German Romantics of the first decades of the 19th century. What both trends shared was the obstinate and anxious quest for an ideal and visionary dimension in nature. It was a perpetual, often quixotic quest for a coveted goal that all too often slipped out of reach, as in a dream.

Nature sublimated in this way became the springboard for ventures into the infinite; surely a necessary impulse, but one which was all too often undermined by the frailty of the human condition. The expression of this dialectic, however, was the ultimate goal of the Romantic artist. During this same period, Turner's work was marked by another feature, noteworthy from an intellectual and pictorial point of view: the presence of the human figure, although often reduced to a mere silhouette, a near-abstract sign which, divested of its former stature, no longer succeeded in counterbalancing the preponderant might of nature. Reduced to an infinitesimal spot, and caught in the dual trap of his dread and fascination, the human creature faced a world of hostile elements which conspired ultimately to annihilate it.

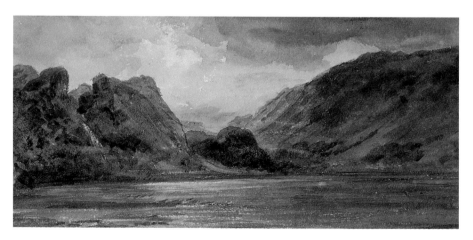

FROM REAL LIGHT
TO IMAGINARY LUMINISCENCE

After his travels on the Continent in 1802, Turner produced works deeply impressed by the natural sublime, and so prefigurative of the German Romantics. But after this first phase devoted to Alpine landscapes, the English painter was to develop further and very rapidly. All the while pursuing his study of the various aspects and expressions of nature, he directed his efforts more and more to the chromatic analysis of light.

While there was definitely a convergence of intention betwen Turner and Friedrich in the preceding phase, the two artists now diverged in their respective approaches to the rendering of light. In Friedrich's work, light had a symbolic function linked to Christianity, and he used it as a means of definition and construction. In Turner, light was decomposed and became a prime agent in the dislocation of the landscape and its transformation through a strong internal radiance.

A work like *Ulysses Mocking Polyphemus* (1829) might be related to the Classical tradition by its subject-matter, but it pointed to an entirely new distribution of areas of light. The various elements of the scene are precisely articulated; we can make out the two protagonists, one perched on the mast of a ship, and the other evanescent, blinded and clinging to the mountainside. The ships are precisely depicted, and forms become less and less distinct as they recede in the distance, according to the conventions of pictorial tradition and of 19th-century history subjects. What has changed is that spatial organisation and the role of light have been charged with new significance.

His choice of subject-matter notwithstanding, Turner did not restrict himself to the literal and tangible elements of the episode, but subverted them instead through a very free handling of colour.

The alternation of concave and convex spaces creates an independent rhythm, interconnecting the light and dark parts, and abolishing the limits between sea and sky. On the right of the

Opposite

JOHN CONSTABLE
**Lake Derwent with
Evening Storm**
Watercolour, 33.5 x 38 cm.
London, Victorian and
Albert Museum.

Next pages

JOSEPH MALLORD WILLIAM
TURNER
The Slave Ship
1840, oil on canvas,
91.5 x 122 cm.
Boston, Museum of Fine Arts
Henry Lillie Pierce Fund.

picture, the glow of the rising sun is rendered by a thick, coloured impasto which shades off imperceptibly into the surface of the sea below and the vault of the sky above, activating the opposition between clarity and imprecision.

Starting in 1823, marine subjects became ever more frequent in Turner's painting, developing over the next years into a predominant theme. This was a further divergence from the practice of the German Romantic painters.

Two works in particular testify to the significance of the sea in Turner's inspiration and show the full extent of his pictorial development. The first, from 1840, is known as *The Slave Ship* and is probably one of the most representative works of this period. The subject is linked to the anti-slavery campaign actively being conducted in Great Britain at the time. Accounts had been published of a crossing made in 1783 by the slave-ship "Zong" during which the captain ordered the crew to throw sick slaves overboard in order to collect insurance for losses at sea.

The artist of course intended to express a moral judgment of the event, but instead of describing it in terms of anecdotal details, he created an entirely new and original spatial construction. The reddening sky and vermilion-flecked sea are shot through with a powerful luminosity.

In the foreground, on the surface of the sea, there is a clash of birds and fish, some of which are attacking a human form. Located on the right, this figure catches our attention, draws us into the composition, and then–in a horrible blend of indirect eroticism and pictorial singularity–we realize that it is a woman's torso and that the legs are still bound in chains.

There is no stable element to anchor this composition, the main subject of which is less the slave ship than the chromatic clashes and transformations between the sea and the sky, where the formidable rising curtain of yellows and reds is brought to its highest pitch. Light surrounds the forms and penetrates them, making them ambiguous and evanescent, such that the original and morally edifying subject is dissolved, or drowned, so to speak, in the process of formal elaboration.

The literal reading of the subject becomes wholly secondary to the sheer optical effect, the almost purely retinal dimension of the picture. These bloodstained waters and this natural apocalypse are nothing less than the death knell of history painting; every effort at description is discouraged by a luminous haze. This picture further highlights the differences which would

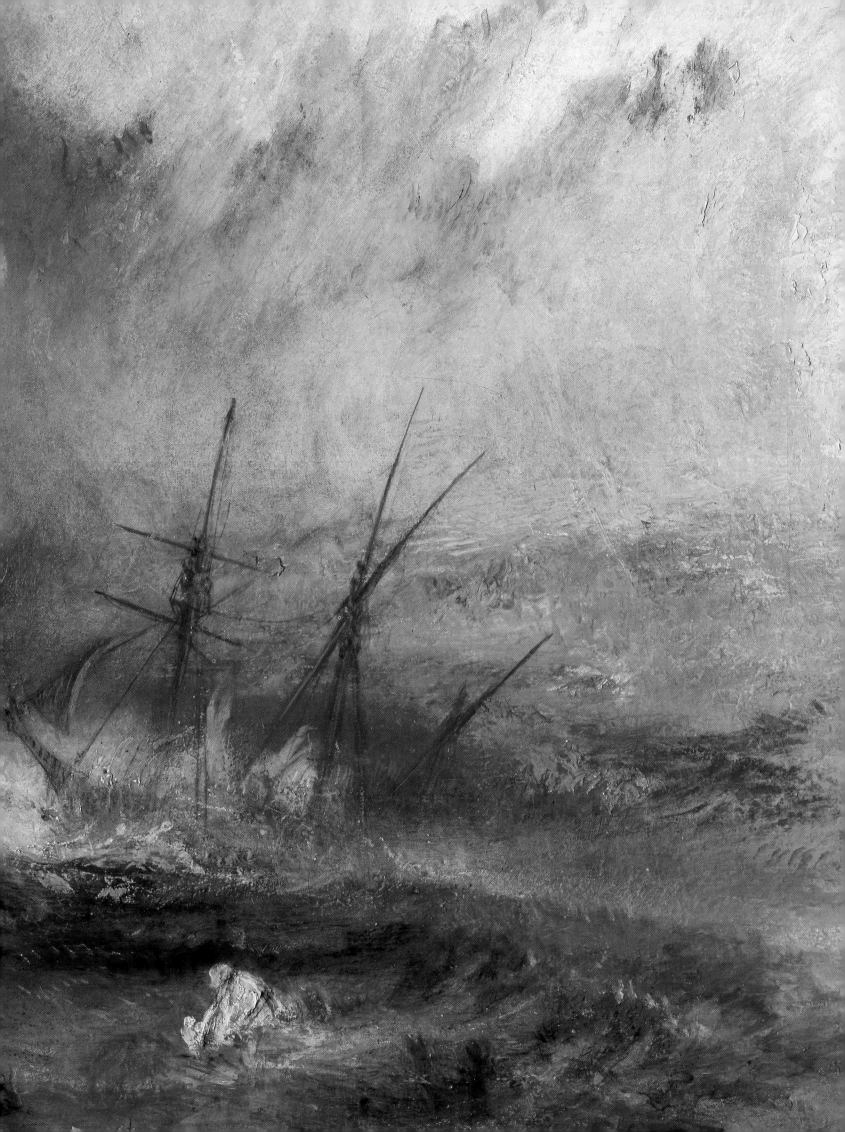

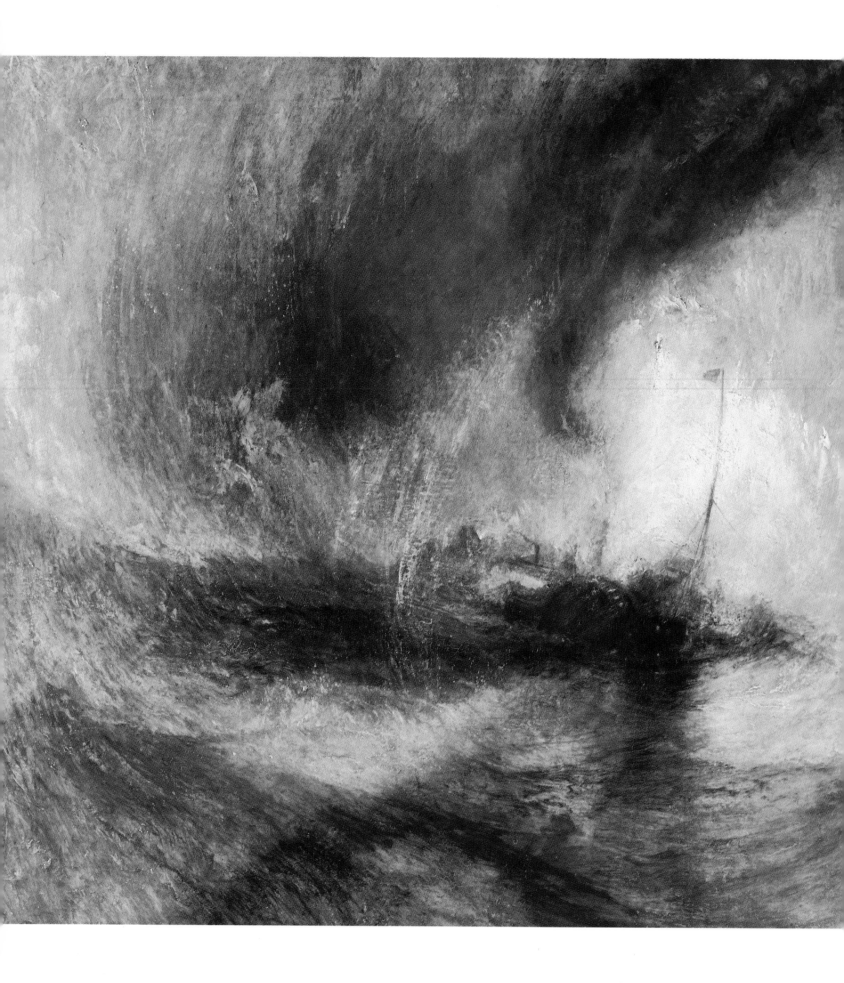

henceforth set off Turner's painting from the precise, realistic and symbolic works of the Dresden School.

Rockets and White Lights from 1840 presents us once again with a seascape transformed into an explosion of matter developed into a spatial sequence. No doubt the painter had had strong emotional experiences during his Channel crossings, but biographical fact is of less import here than the artistic approach and formal depiction of the event. Once again, the composition is spanned by a sharp diagonal which separates the horizon and the sky from the land. The beach and the sea in the foreground interpenetrate as two luminous spirals, while the twin vortices of smoke and fog in the background connect the sky and the sea in an emphatic rising movement. The slight human figures in the foreground timidly contemplate the aggressive surges of nature. The brushwork is brisk, distinct and thick in spots; a manner of building up the image that speaksmore to the spectator's eye than to his powers of analysis.

Here too, Turner did not restrict himself to the realistic components of the event; he used the anecdotal facts as visual detonators to spark an intense formal experience.

Friedrich's attitude during this same period was diametrically opposed to that of Turner. In the English painter the formal aspects, the purely retinal expression, superceded the realistic and figurative intention; light served to dissolve the hard edges of things. In the German painter, on the other hand, light was used in the traditional way, even if it was charged with symbolic resonances. Friedrich only partially renounced the stability of the image, striving always to achieve perspectival depth and a minute description of the landscape in all its majesty.

Joseph Mallord William Turner
Snowstorm. Boat at the Harbour Entrance
1842, oil on canvas,
146 x 237 cm.
London, Tate Gallery.

TURNER,
IMPRESSIONNISM AND MODERNITY

One composition from Turner's late period shows even more clearly the break which separated his work from the German painters of the Romantic landscape around 1840. *Rain, Steam and Speed* (1844) is a scene directly inspired by the Great Western Railway and depicts a train speeding across the Maidenhead Viaduct over the Thames, near London.

This type of subject would normally have lent itself to a celebration of technology and modernity, but, in Turner's hands, it took an entirely different direction. The Thames is shown from a point near the railing of the viaduct, a dizzyingly high viewpoint which draws the spectator's eye inexorably into the thick of a frightful storm, a luminous swirl of rain and wind which acts both to dissolve the solidity of the forms and to unify the pictorial space. Soaked in gusts of rain vaporized by the wind, the elements of earth, air and water interpenetrate in a cataclysm of truly biblical magnitude.

Under these circumstances, the train and locomotive with its red signal lantern seem scarcely capable of holding their own against the unbridled elements, much less of overcoming them. Lashed by lightning, the engine advances unsteadily, emitting puffs of steam that are clearly no match for the apocalyptic forces in play. Another picture by John Martin, a friend of Turner, casts the railway in the role of an inhuman instrument of damnation (*Last Judgment*, 1854). In the middle of Turner's ambiguous space, two diagonals extend toward the horizon–the viaduct itself and an arched bridge sketchily shown on the left–yet these perspectival indications are themselves swallowed up by the luminous void. Fishermen in a boat staunchly make their way towards a group of white forms on the opposite shore. More incongruous still, a peasant ploughs his field on the far right. Turner touches here upon a very delicate and modern problem: indeterminacy as the main theme of a work of art.

JOSEPH MALLORD WILLIAM TURNER
Rain, Steam and Speed.
The Great Western Railway
1844, oil on canvas,
91 x 122 cm.
London, National Gallery.

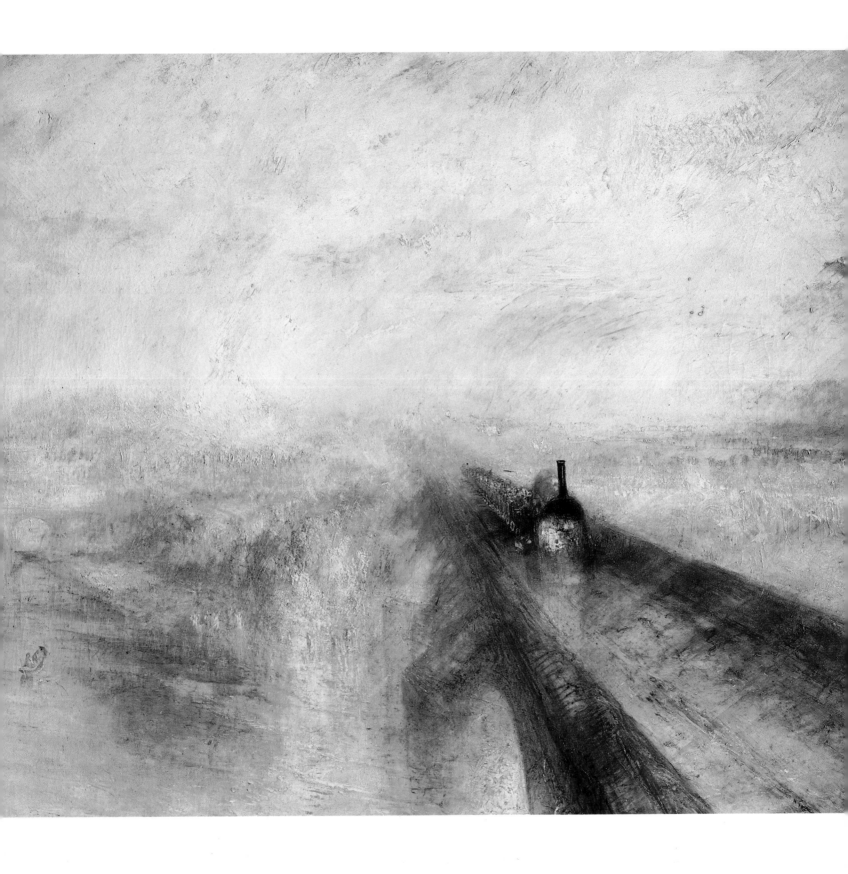

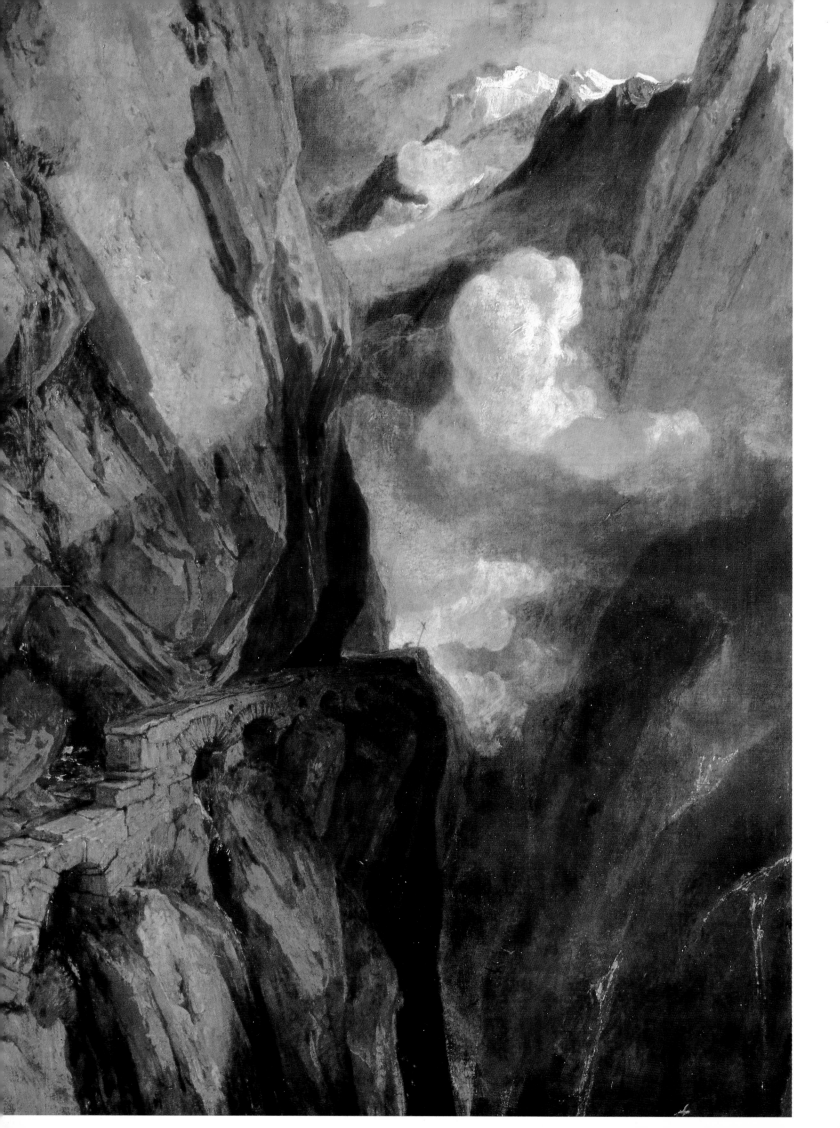

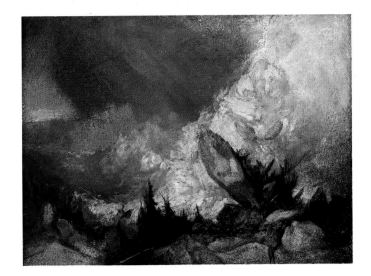

Monet and Pissarro, two young French painters in exile in London during the 1870-1871 Franco-Prussian War, were indelibly marked by such works which so brilliantly advanced, as their basic premise, the dissolution of the subject.

While we do not know exactly which of Turner's works the two painters were able to see during their stay, in their inaugural group exhibition in 1874, the Impressionists paid a tribute to the English master in the form of an etching after *Rain, Steam and Speed* by Bracquemond. We know that Claude Monet, although he retreated to a more nuanced position in his later years, considered this work as a veritable "icon". It makes perfect sense to think that, along with Manet, Courbet and Boudin, Turner exerted a decisive influence on the young Monet during these formative years.

The transparency of overlapping atmospheric "veils," divided brushstrokes, strongly saturated colours, the quasi-obsessive quest for the element of light, were some of the aspects of Turner's works which must have positively fascinated young artists searching for ways to overthrow the tyranny of the subject.

Thus Turner, who in the early years of the century had explored aspects of the natural sublime so close to the concerns of the Dresden School, at mid-century anticipated the efforts of the future Impressionists who, like him, were enthralled by the retinal qualities of light.

JOSEPH MALLORD WILLIAM TURNER
Avalanche in the Grisons
1810, oil on canvas.
90 x 120 cm.
London, Tate Gallery.

Opposite

JOSEPH MALLORD WILLIAM TURNER
The Saint Gotthard Pass
Around 1803-1804,
oil on canvas,
80.6 x 64.2 cm.
Birmingham, City Museum and Art Gallery.

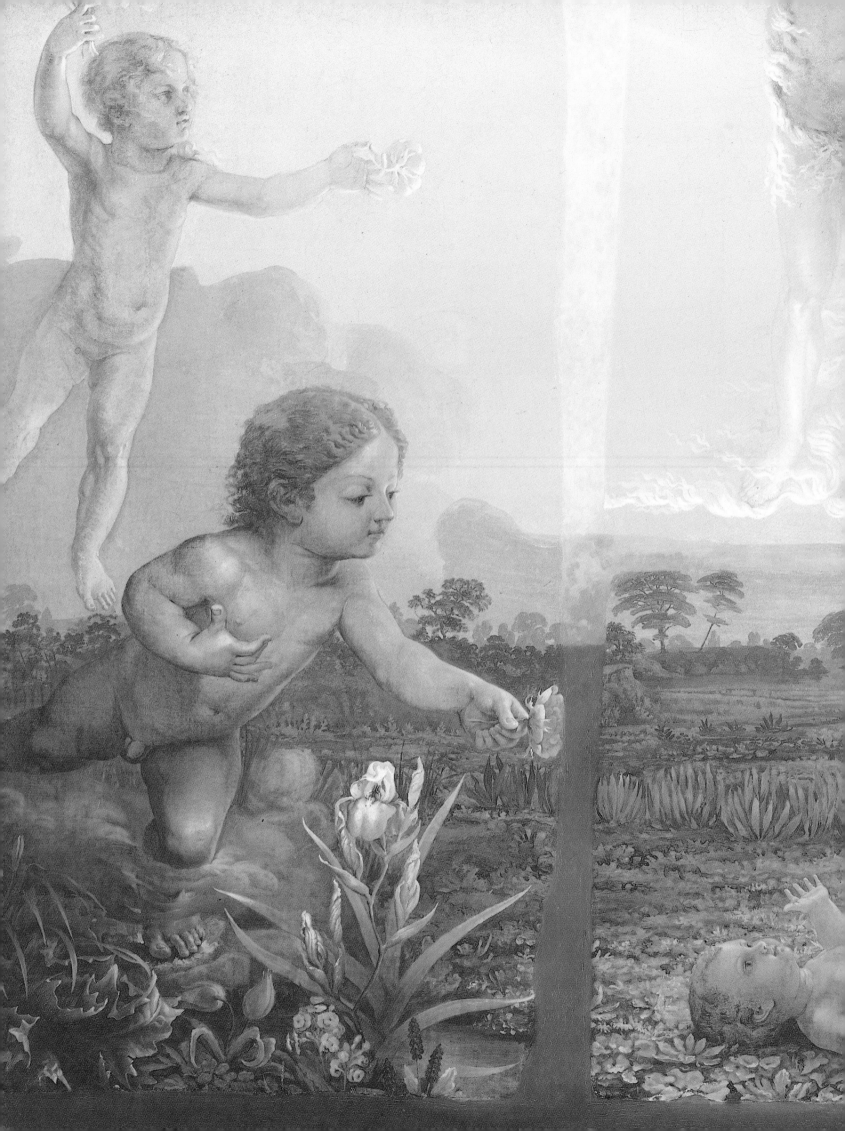

GERMANY :
BETWEEN TRANSFORMATION
AND NOSTALGIA

Above and opposite (details)

CARL GUSTAV CARUS
Memorial Monument to Goethe
1832, oil on canvas,
71 x 52.2 cm.
Hamburg, Kunsthalle.

The context out of which German Romanticism developed was both unique and complex. The German character was not entirely receptive to certain ideals of the 18th century, especially those concerning the primacy of Reason. Un-encumbered by Jacobin ideology, the seeds of pictorial Romanticism had sprouted in the fertile terrain of the natural sublime, a trend that gained a foothold first in England and in Switzerland.

Moreover, the Greco-Roman mythology which had triumphed in Neoclassicism was replaced in Germanic countries by a painstakingly reconstituted Nordic variety. These same countries were also profoundly attracted to medieval forms and to the mystical aura associated with churches and Gothic buildings. The religious spirit of the Middle Ages, embodied in the cathedral, was to be one of the major sources of inspiration for the Dresden School. Scholars, painters and art-lovers strove to rebuild the ruined edifices in the name of an exclusive cult which served both Nationalistic and Romantic ideals. The Cathedral of Cologne, which stood unfinished for centuries before finally being completed in 1880, had become a fitting symbol for the fate of the German people: the incomplete design of a national destiny.

THE ADVENT OF ROMANTICISM

German Romantic painting does not present itself as a coherent school, with a clearly outlined programme, but rather more as a diffuse sensibility, an overall conception of the role of art and of the artist. It was characterized, both for the Nazarenes and for the Dresden painters, by a pronounced affinity for meditative introspection, and a penchant for psychological and spiritual exploration embodied in apparently traditional forms.

Where French painters had a predilection for paroxystic action, their German counterparts clearly opted for the silence and non-action of reflection, for images involved with their inner meanings.

In the case of the Germanic culture, of particular importance was the elaboration of a *Weltanschauung*, a general ethical conception of the world, which, at the beginning of the 19th century, was given expression in philosophy, poetry and literature.

Thus while Delacroix, following his own impulses and taste for exoticism, travelled to the Orient of 1832, Runge and Friedrich searched for metaphysical meanings, for a vision of infinity simply glimpsed in the geological features of their homeland. Delacroix stressed the solitude of the individual before History, Friedrich that of Man in front of Creation. The artistic differences were even more far-reaching, for French Romantic painting brought about certain technical innovations that would be taken up and developed by a formalist tradition extending from Delacroix, through the Impressionists, and eventually to Seurat.

German painters, ever respectful of the rules transmitted over the centuries, rarely strayed from convention as far as composition, pictorial space and the representation of the human form were concerned. Where the goal of French painting was a renewal of the subjects and their formal expression, German painting strove instead to preserve the traditional manner, all the while endowing it with a profound new meaning.

Then, the political context was vastly different in the two countries. In France, Paris had played a centralizing role in

the arts since the 16th century. Germany, on the other hand, was composed in the 18th and 19th centuries of a large number of principalities, a situation which led to the creation of a large number of widely-scattered, and often opposed, cultural centres, of which Berlin, Munich, Dresden, Hamburg and Düsseldorf were the only ones of any artistic import. It is there that German Romantic painting, breaking away from Neoclassicism, gradually came into being during the first decades of the 19th century.

At the end of the preceding century, men like Oeser, Winckelmann and Mengs had formulated a new aesthetic ideal which had its ultimate source in the art of Antiquity. Between 1790 and 1810, the school of David had a widespread influence outside France. By the turn of the century, artistic sensibility developed more in depth, and the foundations of this renewal were laid by writers, poets and philosophers, by men of a more unfettered imagination than the painters. The field of poetry was astoundingly rich in new creations.

In 1800 Novalis published his *Hymns to Night*, Friedrich von Schlegel his remarkable *Dialogue on Poetry* in 1803, and Hölderlin his *Night Songs* in 1805. The new Romantic poetry and literature fundamentally called the role of art into question. We know that Friedrich read the basic texts of the early Romantics and that he particularly admired three of the leading figures of this tendency, all of whom lived in Dresden. These were von Kleist, whom he knew personally and who lived nearby, von Schubert, a friend and admirer, and Tieck, a noteworthy critic and theorist.

Heinrich von Kleist was a complex personality who lived in splendid isolation and was subject to violent crises. Overly concerned with formal considerations, he strove to cultivate an inner voice, his unique guide in composing poems and plays of profound originality. Obeying the demands of a strict aesthetic, he expressed himself in a lucid, yet complex style. His essays veered sharply away from objective reality to concentrate on the specifically human situation: deprived of Paradise, Man lives in a circular dimension, ever in search of a new grace, which may be granted by the unconscious, a dream, or a new unfolding of the personality.

Gotthilf Heinrich von Schubert was a tormented soul, but his anxiety motivated a tireless cultural quest which led him to investigate the most diverse fields, from medicine and the natural sciences, to theology and history. He settled in Dresden and gave

remarkable lectures on such subjects as *The Nocturnal Aspects of the Natural Sciences*. Kleist and Madame de Staël were among his many admirers. In 1814, he published a book on dream symbolism in which he attributed a decisive importance to dreaming: "In dreams, and already in this delirious state which precedes sleep, the soul seems to express itself in a language all its own." According to him, the statements of dreams were innate, natural and superior, because independent of the dictates of time.

Ludwig Tieck was another writer who was deeply interested in dreams. His characters seem to renounce reality in favour of a world in constant change and flux: "We grow up," he wrote, "and our childhood is a dream woven within ourselves." His seriousness and authenticity was best expressed in his Märchen, fairytales full of magic forests, and all manner of symbolic stones and flowers. He transmitted to Friedrich a taste for fluid, musical and metaphoric landscapes in the moonlight.

The most important influence on painting, however, came from the ideas of the philosopher Schelling published between 1802 and 1805: lying hidden beneath the surface appearance of nature is a spirituality waiting to be revealed by the painter and poet. This powerful philosophy of art was augmented in 1810 by Goethe's key work on *Colour Theory*, according to which all natural phenomena obey a general conception which the human mind can penetrate and decipher. His insistence upon the idea that colours speak more to the soul than to the eye must surely have found a ready audience in painters like Friedrich and Runge.

RUNGE : THE LANDSCAPE
AS SPIRITUAL HIEROGLYPH

Opposite and pages 72-73

PHILIPP OTTO RUNGE
Morning
1809, oil on canvas,
152 x 113 cm.
Hamburg, Kunsthalle.

Philip Otto Runge was born in a well-to-do family of shipbuilders. In 1798, deeply impressed by Tieck's novel *The Peregrinations of Franz Sternbald*, he decided to undertake an artistic career. It was in this activity that he found what he was looking for: that blend of real dreams and insidious uncertainty, that magic state which skirts realms of unspeakable fears and invites the loss of self. A dreamlike blend of certainty and fantasy, in which everything is ever on the brink of metamorphosis. As Tieck wrote: "Everything around us is real–but only up to a certain point."

At the Copenhagen Art Academy, he was influenced by Abildgaard, the same teacher who attracted Friedrich, and between1801 and 1803 he studied at the Academy in Dresden. Friedrich was among his friends, as was Goethe, with whom he corresponded on his colour theory. His reading of Boehme and Tieck led Runge to find not only new subjects, but also a new pictorial form in which to express them.

For him, landscape painting, so long neglected until then, was the best suited medium for the new visions heralded by the poets and philosophers. Runge considered landscape as a kind of poetic hieroglyph that provided the spectator with the keys for a religious interpretation of nature.

In his efforts to renew Christian art, Runge painted *Dawn* in 1808, a work which brilliantly exemplifies the spiritual scope of Romantic painting. In this stunning symbolic synthesis of nature, plants and humanity, light and colour play a decisive and expressive role.

In a sky gilded by the rising sun, above a white lily–symbol of virginal purity–a group of three cherubs surrounds the Morning Star. Several more angels playing music hover below, while the figure of Venus-Aurora-Mary advances in a blaze of light, her head at the exact centre of the composition. At the bottom, four more cherub-like figures frame a newborn babe reminiscent of the Christ Child. The child symbolizes the

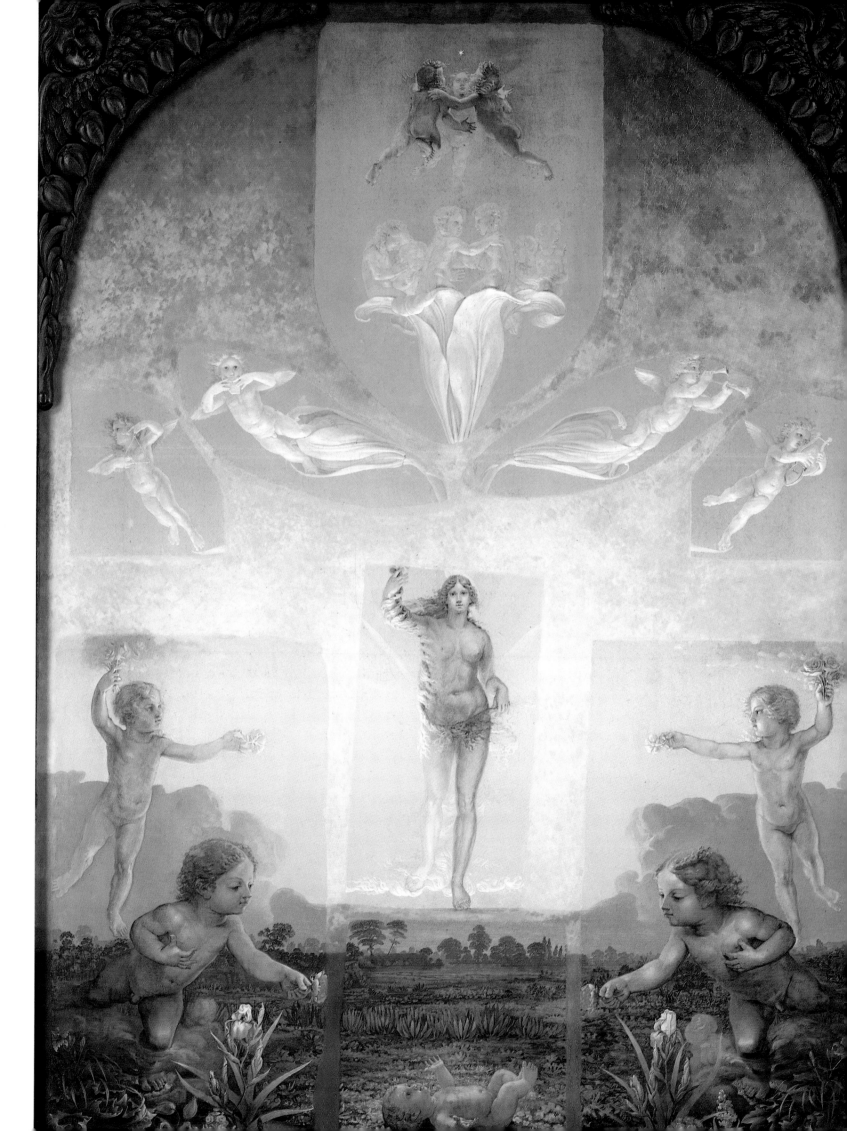

Opposite and page 86

PHILIPP OTTO RUNGE
**The Hours of the Day.
Morning**
1808, watercolour,
83.6 x 62.7 cm.
Hamburg, Kunsthalle.

beginning of all things–of the day, of spring, of life, of the creation of the world.

This was one of Runge's first attempts at founding a new religious art, and it combined Christian and pagan features (the Nativity and the Triumph of Venus), as well as a hint of Pantheism. The whole is based upon a constantly curving line, creating an arabesque of living and sensual bodies, which are subject, however, to a rigorous, almost excessive symmetry.

Although the two painters were friends, there are few analogies here with the use of light in Friedrich, where it is not so overtly symbolic, even though it also has a generative function. The use of the human figure as a prime support of Christian symbolism is specific to Runge, but the metaphysical resonances of the colour and light are common to both.

The basic content of Runge's work is the Romantic idea that divinity is an original force, ever-present and ever-renewed in the Cosmos, and that it is the painter's task to decipher and reveal it. The work of art is therefore a symbolic expression of the organic unity which constitutes the totality of the divine power, from the smallest plant to the orbits of the planets. Runge's chromatic syntax and his love for complex arabesques and curvaceous forms, were to reappear in the Symbolist and Art Nouveau movements of the late 19th century (consider, for example, certain compositions by Jan Toorop and Edvard Munch). His metaphysics of light and his colour theories were also taken up to some extent by the Blaue Reiter group.

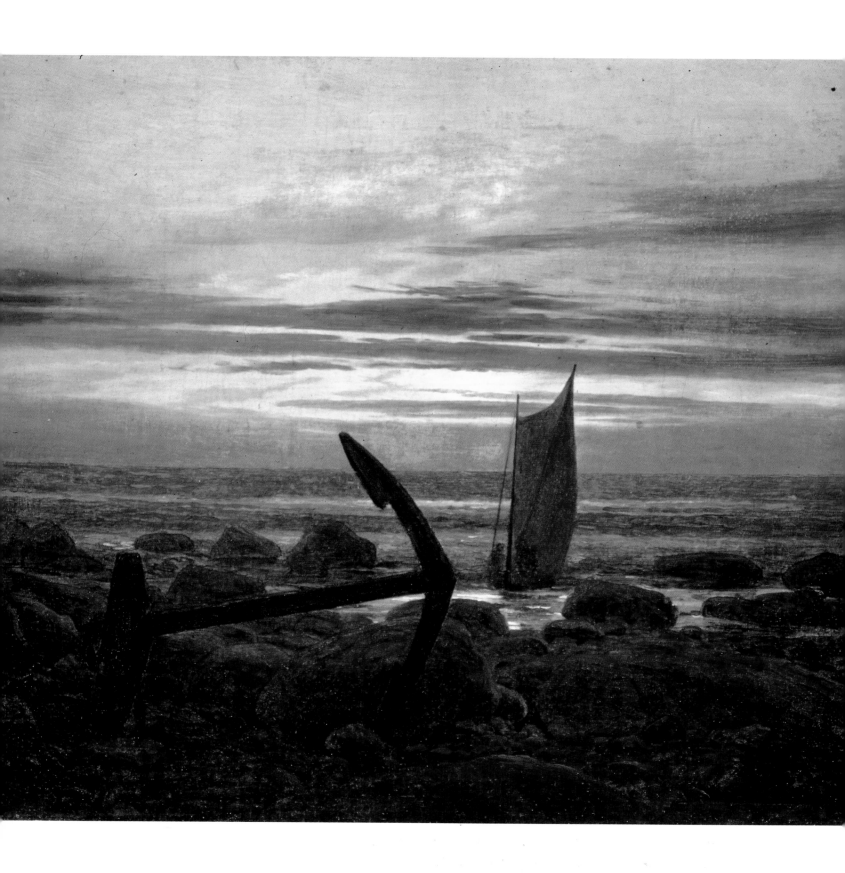

FRIEDRICH : BEYOND REALITY

Runge's death from tuberculosis at the age of thirty-three put an early end to his bold projects and speculations, and his ideas about symbolic landscape were not to have an immediate following. Yet this pioneer effort was to be taken up, albeit in another register, by his compatriot from North Germany, Caspar David Friedrich.

Friedrich moved to Dresden in October 1798. What the two young artists shared at the time was a similar *Weltgefühl*, a sense of the cosmic unity of Creation, which each tried to work out in pictorial terms in the first decade of the 19th century. They were also both moved by a determination to create a specifically German spiritual landscape, deliberately turning their backs on Italy, which, along with the Greek world, was the traditional homeland of the arts and the main source of pictorial inspiration.

Runge expressed the need to let the inner life unfold, to follow in art the path which led from the depths of being to personal consciousness, and, in a similar vein, Friedrich wrote: "The painter should paint not only what he has in front of him, but also what he sees inside himself. If he sees nothing within, then he should stop painting what is in front of him."

This inward gaze, this return to the inner world of the psyche, or spirit, is precisely what characterized the literary and pictorial Romanticism of Northern Germany, even if it was developed mostly at the Saxon court in Dresden. Around 1800, this city was a focal point for the young Romantic writers, and with the results of Friedrich's first efforts, it was to witness one of the most significant achievements in Romantic landscape painting.

Yet Friedrich was not a landscape painter in the traditional sense, even if his working method consisted in the precise observation of nature and its phenomena, which he reproduced with what could pass for typically Flemish exactitude.

While he may have sought to explore the manifestations of nature in all their variety, nothing was further from his intentions than the simple, direct and spontaneous transcrip-

CARL GUSTAV CARUS
Night Scene on Rügen
1820, oil on canvas,
38 x 47.5 cm.
Dresden, Staatliche
Kunstsammlungen
Gemäldegalerie.

Opposite

CASPAR DAVID FRIEDRICH
**Moonlit Night with Boats
on the Baltic Sea**
1818, oil on canvas,
23 x 31.5 cm.
Obach bei Schweinfurt,
Georg Schäfer Collection.

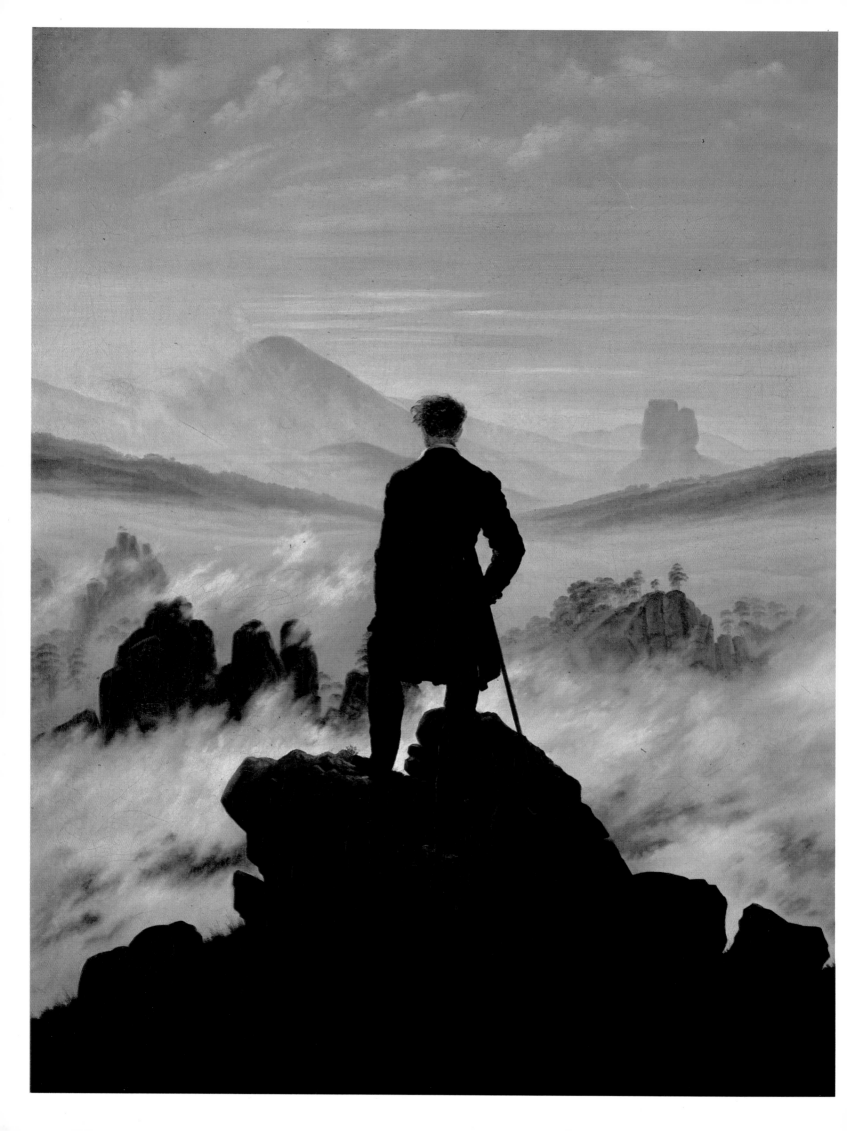

tion of his visual impressions. Instead, he deliberately limited his choice of subjects: these natural motifs were meant to express more than just descriptive, surface appearances, but also hidden values.

With great persistence, he transposed on to the canvas only the essence of what he had noted in his drawings from life, motifs that he could later re-work and recombine in his studio, softening the contrasts, regularizing the shapes and contours. In this way he could integrate the multiplicity of nature into a figurative discourse which was often subtle, symbolic, and at times excessively encoded. For, despite the near-obsessive precision of the forms and the rather conventional treatment of the composition, nature in his hands was transformed into a metaphor of the mortal world and charged with spirituality. The painter was involved in more than the straightforward repro-duction of nature; his art partook of the dialectic between reality and symbol. This precise quality seems to have unsettled a number of his contemporaries, Ludwig Richter among them.

Like no one else before him, Friedrich studied the specific features of his native Baltic coast, and then of the mountains of Saxony, Bohemia and Silesia. He had a passion for atmospheric phenomena, scenes with clouds and mist created by the hourly and seasonal changes of the Nordic elements. Still, his was not a search for the descriptive or the picturesque: on the contrary, his thousands of drawings from life were just the visible foundations, the outer framework of a secret language which pointed far beyond what was so precisely and sensually presented to the eye.

Friedrich, like Schelling and the other philosophers of Romanticism, considered the visible and tangible phenomena of nature to be manifestations of the invisible and ineffable, like shadows of God. Progressively, in study after study, his landscapes appear as fragments of the monologue of a lonely man dealing with the fundamental questions of life, and in particular the relationship between Man, Nature and God. This was in itself an overwhelming task, next to which "mere" pictorial representation counted for very little.

In specifically pictorial terms, these spiritual intentions were expressed through a compositional construction that tended toward geometric simplification. Friedrich was not one to indulge in the sensual aspects of form, or in colours that called attention to themselves too loudly. His major deviation from the traditional systems of composition consisted in the elimination of the middle-

CASPAR DAVID FRIEDRICH
Wanderer above the Sea of Fog
1818, oil on canvas, 74.8 x 94.8 cm. Hamburg, Kunsthalle.

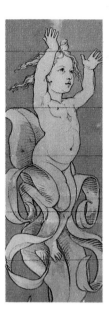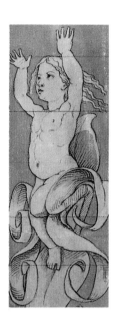

ground. Friedrich's pictures indeed present a sharp contrast between the foreground, which is often detailed and dark, and the background, which fades out of reach, lost in a luminous haze.

The artist wanted above all to symbolize the realm beyond the senses, that place of serenity which he never tired of seeking. If Friedrich's landscapes have a Protestant quality about them, this was as much because of his way of life as because of his working methods. The dark greys of his studio walls echo the varied and subtle monochromes of his paintings. His favourite time of the day for lighting was at twilight.

Around 1810, after years or unremitting efforts, he reached a radical, and significantly concise conclusion: faced with the ineffable power of nature, the only recourse for the mere mortal was meditation. Painting thus became an exercise in asceticism, with spiritual concepts being hidden behind the externals of a relentlessly precise pictorial technique.

In his _Nine Letters on Landscape Painting_, Carl Gustav Carus (1789-1869), painter, physician, botanist, _naturphilosoph_, and friend of Friedrich, brilliantly summarized this new philosophy and set down the new practices by which painters could orient themselves. In essence, he said that in contemplating the crushing power of the natural landscape, the artist performed not just an aesthetic exercise, but participated in a mystic quest. By realizing his limitations and relative insignificance, the painter should experience a feeling akin to the Pantheistic intuition that God is in all things, and that the complexity of the landscape is but another reflection of his presence. Consequently, the only saving pictorial and spiritual grace could come from the "loss" of the artist's individuality in the flowing infinity of nature.

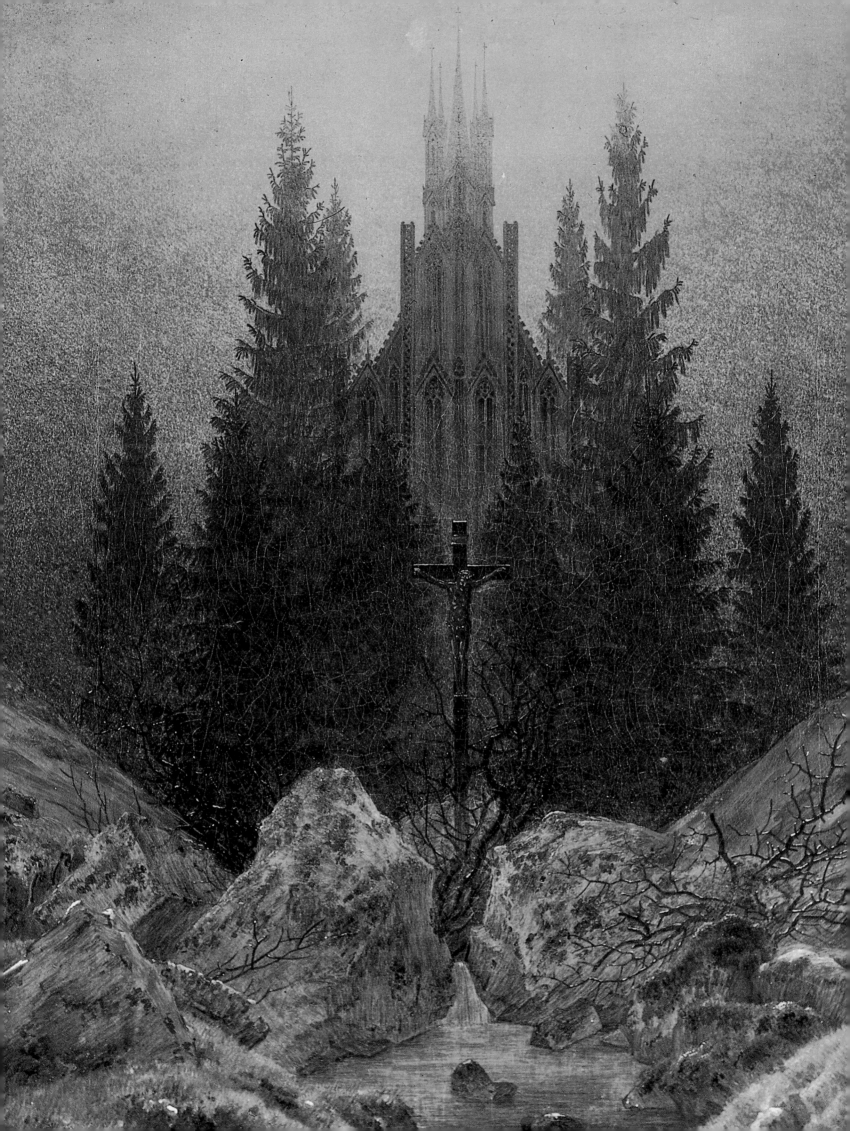

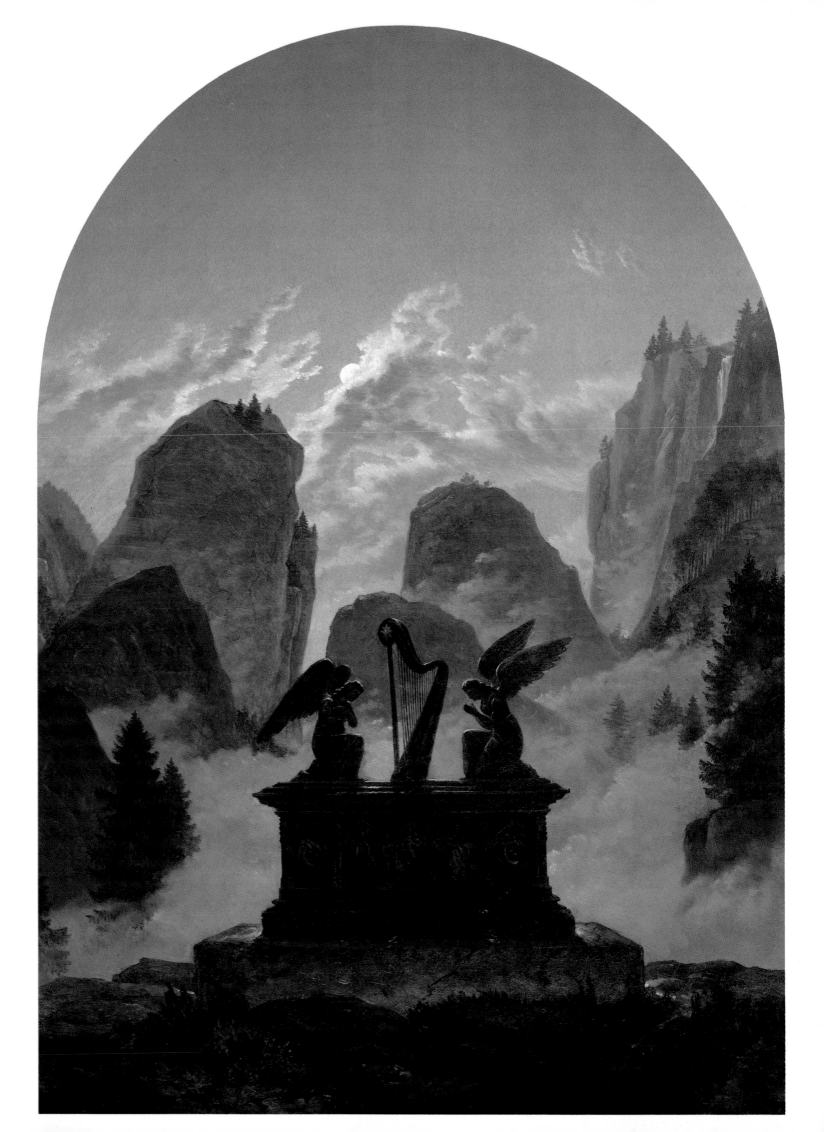

By dispensing with his individuality, the artist lost himself in nature, but, in its absolute clarity, the picture he creates will bear witness to this internal perfection. He will have captured it and brought it to the surface of his consciousness. In other words, this communion with nature is not a real loss, but rather an initiatory process through which spirit becomes accessible, by step, to the physical senses. The painter will finally be able to see the fundamental unity of Creation in the work which it helped being into being. Seen in this way, the Romantic painter in Germany was a man with a mission: to develop a new, specifically German type of landscape distinct from all the other European schools. This approach could be compared to Chinese landscape painting, which was both realistic and mystical in scope, or to the spiritual endeavours of Fra Angelico.

Friedrich based his work on similar intellectual foundations, and very soon his visual experience of nature was transformed into a radically mystical experience of uncommon expressive power.

Who was this Carl Gustav Carus, who so masterfully combined the talents of a painter, naturalist and theorist? Although a respected master and close friend until the very end, Carus' character was the opposite of Friedrich's. He was a man of calm and steady will, classical serenity, and an unbounded curiosity for the sciences. He wrote books on Symbolism of the Human Person, Psyche, a remarkable work on Goethe, and an amazing, fourteen-hundred-page autobiography. Carus was not one to shun honours or the society of his peers. He lived in Dresden, teaching gynecology, serving as official physician to the Court of Saxony, and frequenting the great naturalists.

He soon became the pupil, and faithful friend and supporter of Friedrich. Like his master, he worked in a polished and meticulous technique, and often chose very similar subjects, so much so, in fact, that their works were often confused in the 19th century. Paintings like *Night on Rügen* (1820) and The *Cemetery at Oybin* (1828) display subjects typical of Friedrich. Others, like *Allegory on the Death of Goethe* (1832) and *Memorial Monument for Goethe* (1832) are characterized by completely different options based more on classical allegories: the poet's lyre, the rainbow symbolizing the union of Heaven and Earth, the Arch of the Covenant (Exodus 25:17). All of this, however, against landscape backgrounds that owe everything to Friedrich.

CARL GUSTAV CARUS
Memorial Monument to Goethe
1832, oil on canvas,
71 x 52.2 cm.
Hamburg, Kunsthalle.

THE QUEST
OF INFINITY

PAINTING, MIST AND HOPE

In 1802, when Friedrich visited the island of Rügen for the second time in short succession, he had not yet formulated his aesthetic and conceptual goals. He wavered between the precise rendering of natural forms (*Hut and Well on Rügen,* 1802) and another approach to painting, in which the atmosphere shaded imperceptibly into an allusive or allegorical mode (*Fog,* 1807).

A picture like *Summer* from 1807, reminds one irresistibly of the landscapes of Nicolas Poussin. The ordering of the three registers in this composition is perfectly classical. The gaze progresses from flower to flower, from tree to tree, toward the hazy, bluish-tinted distance in imitation of the timeless manner of Leonardo da Vinci. There is such a wealth of floral detail in *Summer* that one is tempted to settle for the pleasures of a purely descriptive, naturalistc and literal reading.

But there is more than meets the eye in this picture. The embracing lovers in the foreground and the two white doves perched in the foliage key the subject to a more allusive register: this is the image of an idyll and the fullness of Creation. The sensual abundance and variety of natural details can be read both as an allegory of mortal love and as nature sublimated in paint.

Who was Friedrich in 1807? The artist who would one day assert that "a work is not made, it must be felt," was still only a young beginner who had been awarded a prize by Goethe and the Weimar Friends of the Arts Circle in 1805 with *Procession at Sunset,* a sepia painting profoundly imbued with mysticism. Following the lead of the Schlegel brothers and Schelling, he worked to sharpen his awareness of landscape and its power to the point where it became a personal asceticism and a metaphorical transposition of the mortal journey.

Friedrich was acutely sensitive in his reactions, and in 1806 he was in a nervous state of prostration because of the fate that his homeland was suffering at the hands of Napoleon's armies. He found refuge and inspiration in his exploration and walks around Neubrandenburg, Greifswald–his birthplace–and

Overleaf

CASPAR DAVID FRIEDRICH
Hut and Well on Rügen
1802, watercolour,
13.8 x 21.5 cm.
Hamburg, Kunsthalle.

Opposite

NICOLAS POUSSIN
Spring, or Adam and Eve in the Earthly Paradise
1660-1664, oil on canvas,
117 x 160 cm.
Paris, musée du Louvre.

Next page

CASPAR DAVID FRIEDRICH
Summer
1807, oil on canvas,
71.4 x 103.6 cm.
Munich, Neue Pinakothek.

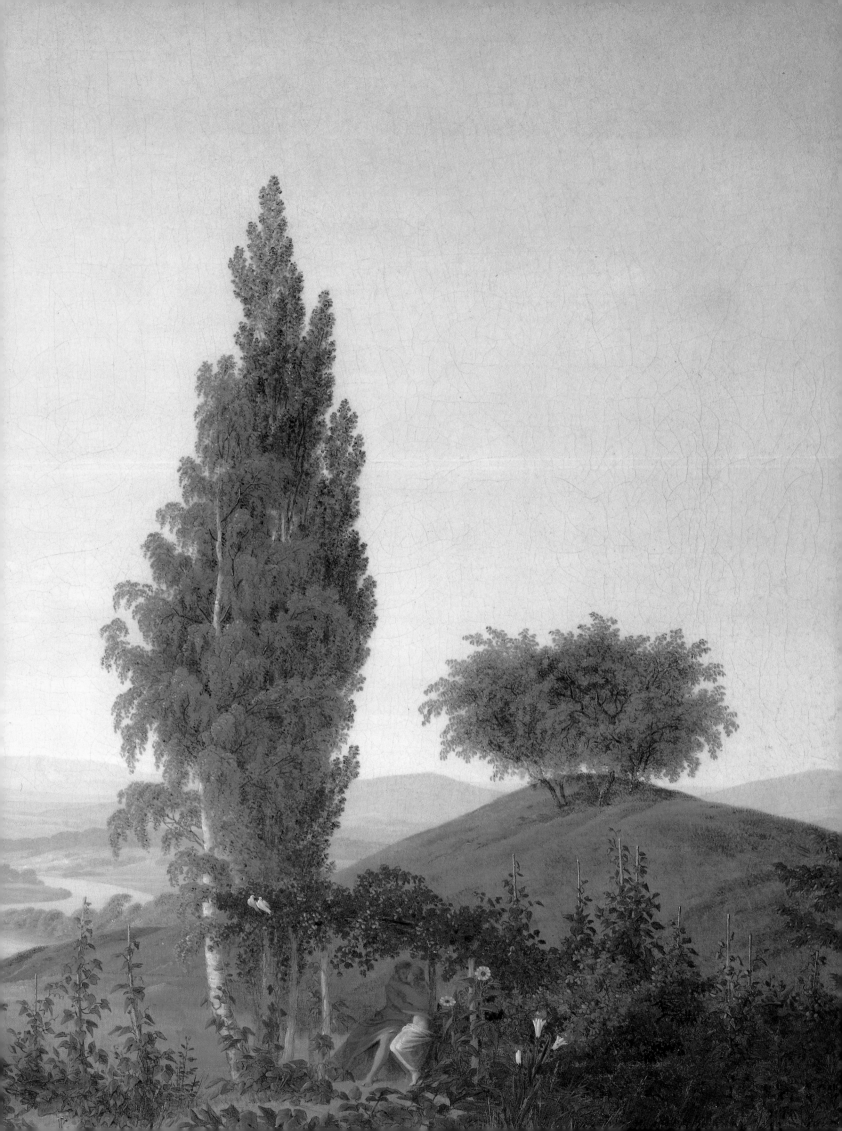

CASPAR DAVID FRIEDRICH
**Self-portrait, Head Resting
on Hand**
1802, pencil, pen and ink,
26.7 x 21.5 cm.
Hamburg, Kunsthalle.

Opposite

CASPAR DAVID FRIEDRICH
Self-portrait
1802, pencil and ink wash,
17.5 x 10.5 cm.
Hamburg, Kunsthalle.

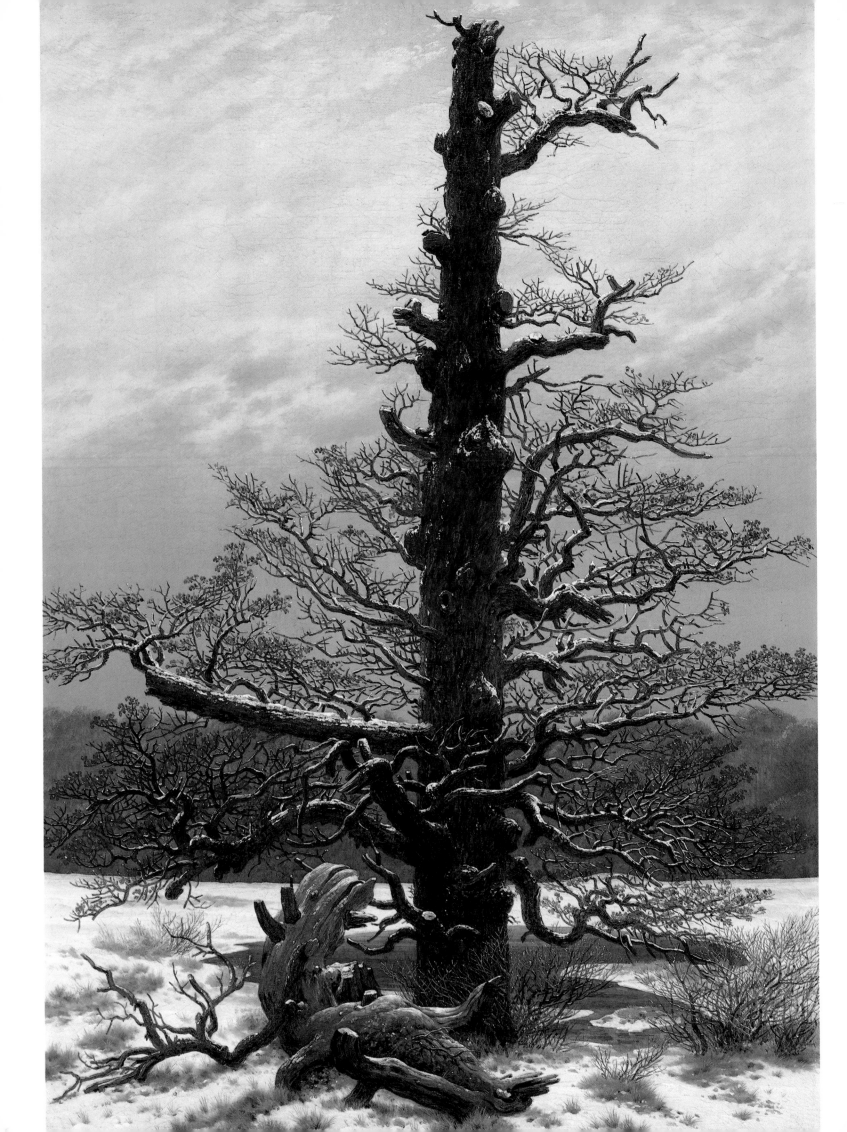

Rügen. This island famous for its white chalk cliffs provided him with subjects and details which he studied time and time again in meticulous drawings.

Fog was painted in 1807, in a pivotal period just before Friedrich painted the compositions that would make his fame. This picture seems to be charged with a hidden meaning. Because of the elimination of the middle-ground–a significant step in itself–the eye of the spectator is led, after pausing on the shore and rocks in the foreground, toward a world transfigured by the uncertainty and almost diaphanous obscurity of the coming dawn. The lush organic life that filled *Summer* is gone, and the idea of happiness with it. The stone anchor in the immediate foreground is related to Early Christian symbolism: as a cross, it is a symbol of the eternal life, of the hope of heavenly bliss in the afterlife.

The scene is wrapped in fog, plunged in a conspicuous absence of movement. A lone rowboat seems to be leaving the shore and heading towards a sailing ship, probably intended to be an allegory of death as departure, associated with dawn and the coming of hope as light. Although charged with symbolic meaning, this canvas strikes us first by its pictorial qualities, and may be compared to certain works by Turner, Oehme and Carus, Friedrich's talented pupil.

This picture also marked a major break which opened on to a new period. In the classical landscape, everything was subordinated to the progressive mastery of spatial clarity. Here, however, the fog is overall, and with it Friedrich introduces a principle of total uncertainty. Here we see rather the principle of atmospheric confusion, the deconstructive effects of fog suppressing the contours of things and preventing a precise spatial orientation.

According to certain 18th-century theorists, fog meant separation from God and aimless wandering, an interpretation to which Friedrich wholeheartedly subscribed, writing in his notes: "landscapes wrapped in fog seem more vast, more sublime; fog stimulates the imagination and reinforces expectation, like a woman dressed in veils. The eye and the imagination are generally more attracted to the hazy distance than to what may more clearly be seen close up."

CASPAR DAVID FRIEDRICH
Oak Tree in the Snow
1829, oil on canvas,
71 x 48 cm.
Berlin, Nationalgalerie.

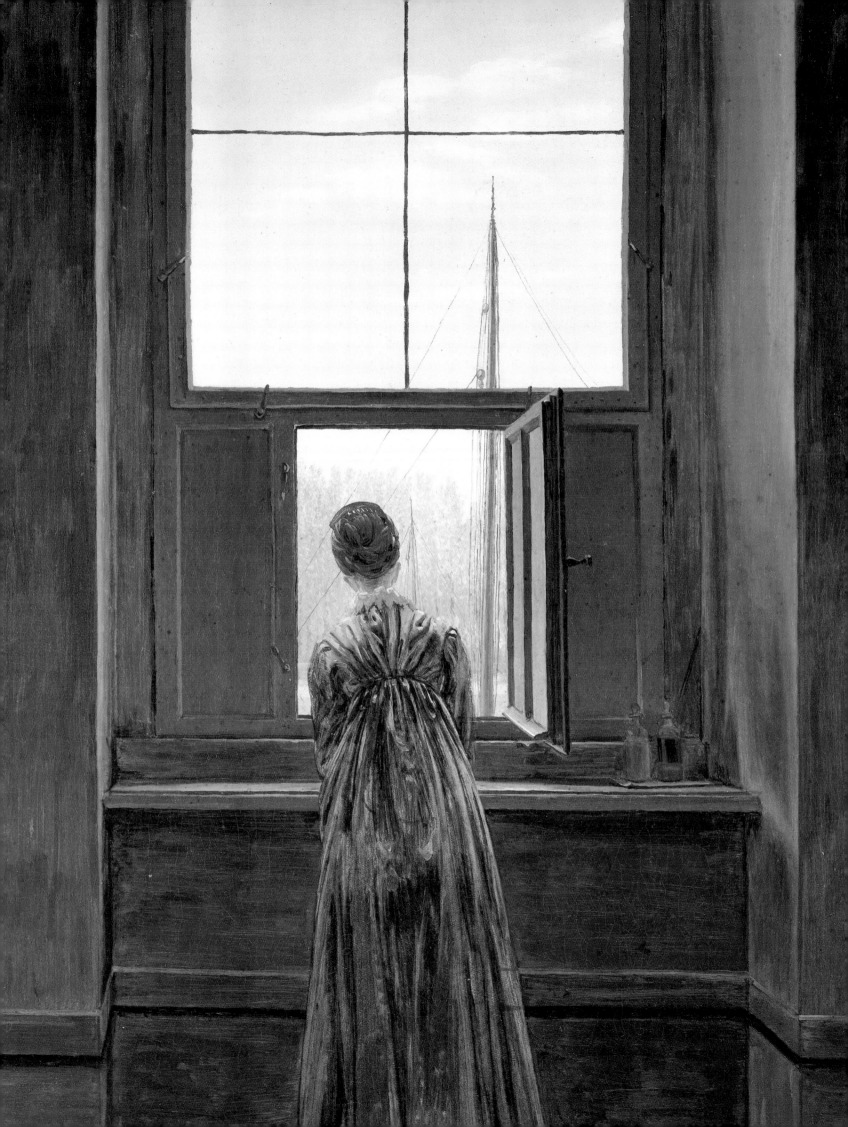

AN ARTIST, A STUDIO, A PICTURE

There is no doubt a correspondence, a spiritual symmetry between Friedrich's daily life and the deeper structures of his paintings. This close relationship was also apparent in his way of life: extreme simplicity, generosity toward others, and a love for nature as the ultimate refuge. He lived his life far away from the agitation of the crowds, so much so that certain contemporaries described his home as being like a monk's cell.

Two sepia drawings from his hand, *View from the Studio, Left Window* and *View from the Studio, Right Window,* both from 1805, not only confirm these eyewitness descriptions but also display a marked taste for geometric simplification. Everything is orthogonal, precise and essential. This ascetic vocation of the home is a feature of the famous canvas titled *Woman at the Window* (1822), which shows his wife Caroline from the back, looking out of a window at the Elbe. Her face is invisible and the painter underscores the symbolic relationship between the "here" of the studio and the luminous "beyond" of the landscape, with boat masts and distant poplars visible through the window. Two remarkable portraits showing Friedrich at work and executed by Georg Friedrich Kersting, a close friend of the artist, have come down to us: *Friedrich in his Studio* (1811) and *Friedrich Working in His Studio* (1819). These contemporary depictions of the painter confirm the basically ascetic notion that Friedrich had of space and his inner world.

In the version which shows Friedrich standing in front of his easel, Kersting emphasized his intellectual activity and extreme concentration by establishing a special image of creative intensity. The rectangle of light formed by the window is echoed by the dark rectangle of the canvas, shown from the back. The moment of meditative observation expresses the indissociable unity of nature (the sky) and art (the canvas), a union for which the painter, equipped with his palette and mahlstick, acted as witness and scribe. In this version, the window on the right is shuttered, while the one on the left is partly obscured at the bottom to reduce the intensity of the raking light, rendering the bareness of the room all the more impressive.

CASPAR DAVID FRIEDRICH
Woman at the Window
1822, oil on canvas,
44 x 37 cm.
Berlin, Nationalgalerie.

Above

CASPAR DAVID FRIEDRICH
**View of the Artist's Studio,
Left Window**
1805-1806, sepia,
31 x 24 cm.
Vienna, Kunsthistorisches
Museum.

Opposite

CASPAR DAVID FRIEDRICH
**View of the Artist's Studio,
Right Window**
1805-1806, sepia on paper,
31 x 24 cm.
Vienna, Kunsthistorisches
Museum.

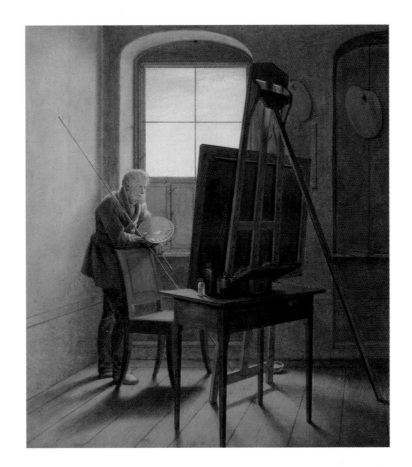

GEORG FRIEDRICH KERSTING
Friedrich in his Studio
1812, oil on canvas,
53.5 x 41 cm.
Berlin, Nationalgalerie.

Opposite

GEORG FRIEDRICH KERSTING
Friedrich Painting in his Studio
1811, oil on canvas,
54 x 42 cm.
Hamburg, Kunsthalle.

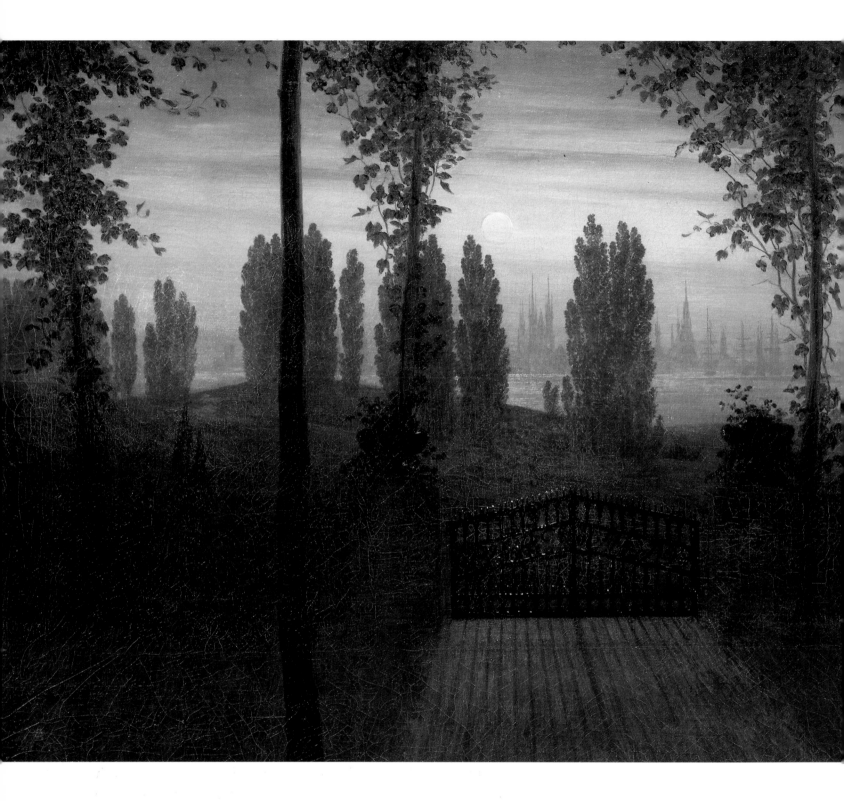

CASPAR DAVID FRIEDRICH
Epitaph
for Johann Emanuel Bremer.
1817, oil on canvas,
43.5 x 57 cm.
Berlin, Staatliche Schlösser und
Garten, Schloss Charlottenburg.

The other version, which shows Friedrich seated in front of his canvas, displays a more descriptive intention. The painter's studio–or rather, cell–appears so irremediably empty that one is tempted to say that the absence of life is the real subject of this picture. Friedrich's work habits were in keeping with this image. We know from an account by Gerhard von Kügelgen that there were no other objects in the studio when he worked and that he kept his painting accessories in another room near by, as if these presences from the outer world threatened to disturb the gradual emergence of images in his consciousness.

In Kersting's compositions, however, we notice also a rather prosaic spittoon and some rulers and palettes. The light is bottled up, as it were, controlled and deviated by the windows and shutters. The sparseness of the studio and the stark geometry of the room dominate the whole, like a Protestant church bare of images and plunged in semi-darkness.

Positioned on an oblique axis, like the incoming light, the painter is shown seated with his legs crossed, painting a waterfall in a landscape. More than an image of the artist at work, what is exalted here are the very conditions of painting such as Friedrich conceived them. It is painting characterized by solitude, the foundation of all pictorial endeavour. This total and deliberate isolation brooked no intrusion from the outside world, whether affective or social, nor for more than the simplest material or daily needs. In the pictorial production from this period, no other work displays so concentrated an atmosphere, with the possible exception of Carl Gustav Carus's famous *Studio in Moonlight* (1826), in which there is a mood of deep and suggestive nocturnal solitude.

As we have already pointed out, Friedrich himself often represented windows, a subject which evidently fascinated him,

for he treated it in his early drawings and throughout his career. A pencil drawing with sepia washes titled *Window with a View of the Park* (1806-1811) combines two co-extensive but completely dissimilar worlds. The window-frame appears to act as an imaginary border between two aspects of reality: the inner–austere, geometric, the ascetic projection of moral simplicity–and the outer–both multifarious and more complex. The view of the park is placed in opposition to the view indoors: nature here shows its luminous side, alive with the sinuous shapes of the trees and plants. This deliberate and emphatic duality confronts us with the difference between the world of tangible things, and the world of the imagination and the spirit, represented here in dialectic opposition.

CHRIST IN THE MOUNTAINS

CASPAR DAVID FRIEDRICH
The Tetschen Altarpiece
1808, oil on canvas,
115 x 110.55 cm.
Dresden, Staatliche
Kunstsammlungen
Gemäldegalerie.

Two years later, Count Franz Anton von Thun-Hohenstein was to be captivated by the impressive Tetschen *Altarpiece* (1808), an ambitious work which sealed Friedrich's commitment to painting in oil. This particular composition marked a profound change in the artist's aesthetic and iconographic course. Under circumstances not entirely known to us, Count von Thun-Hohenstein–very likely at his wife's prompting–bought the Altarpiece for his castle at Tetschen, on the Elbe. This was independently of any specific religious application, for the castle had no chapel. Adverse criticism obliged Friedrich to describe and explain the work himself in a commentary of precious historical and artistic value.

First of all, the religious and allegorical intent are clearly stated, and the symbols are both typically Christian and part of his personal iconography. In the foreground, the artist transcribed details of the terrestrial world and the major symbolic

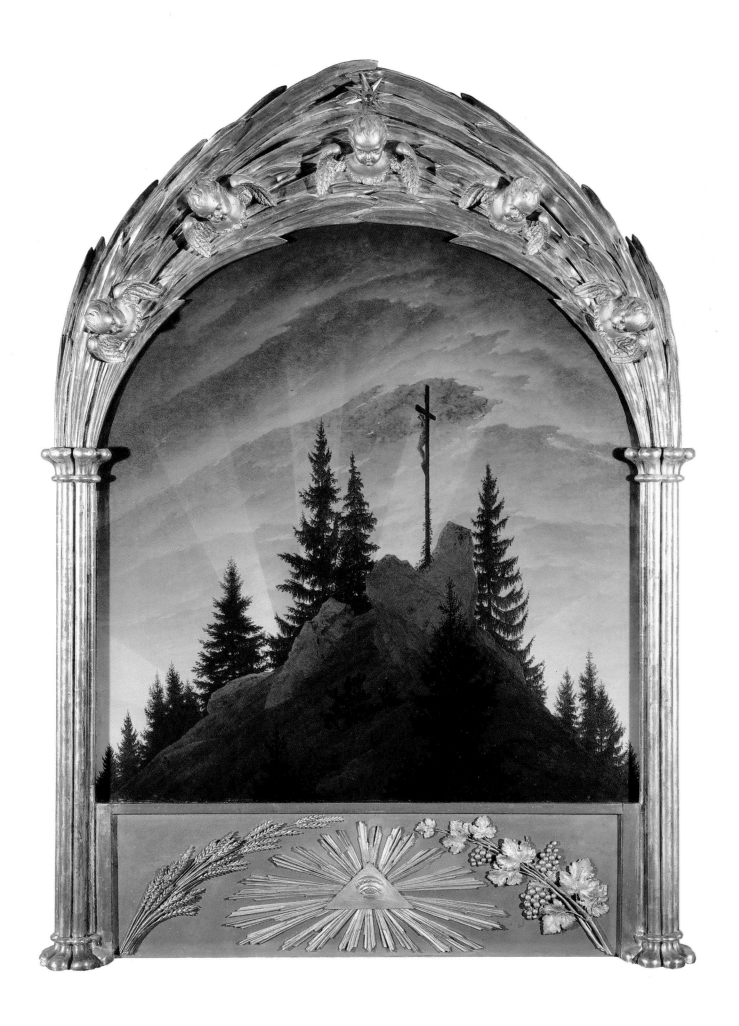

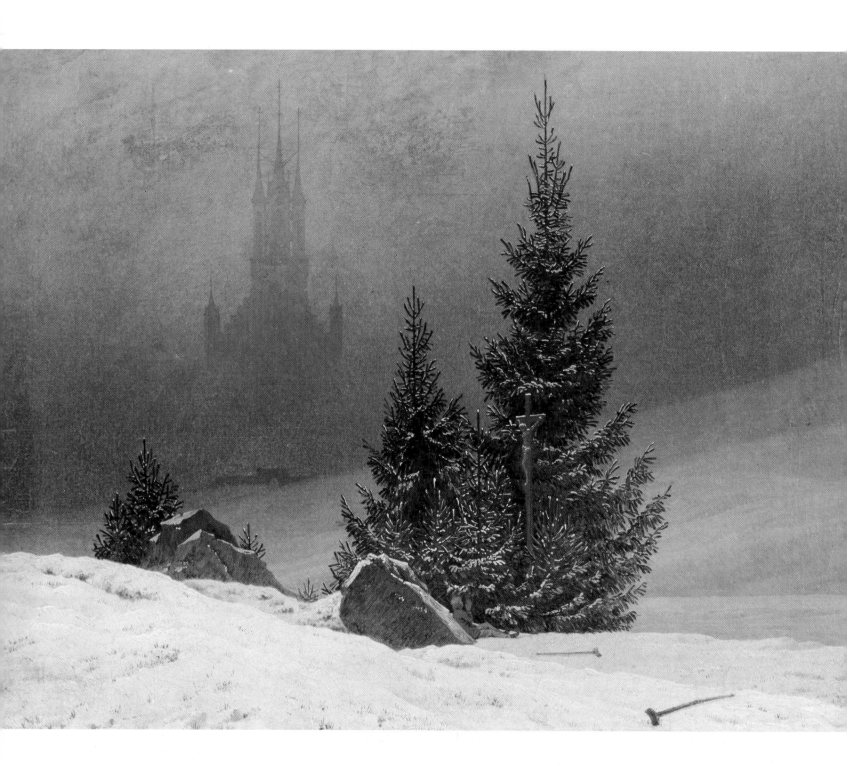

components: rocks, pine trees, cross, ivy. The space reserved for the sky, with its spiritually evocative luminosity, extends beyond the terrestrial realm: ablaze with the light of the setting sun, it is a symbol of the Eternal Father. Christ on the Cross is facing this light, His body almost dissolved by its mighty radiance. The frame, carved by Gottlieb Christian Kühn in accordance with Friedrich's ideas, clearly reasserts the Christian symbolism. The five broad rays of light in the picture are echoed by the five angels on the frame, which is composed of palm fronds curved into a Gothic arch. The lower part acts as a sort of predella decorated with sheafs of wheat and grapes on a vine–evident symbols of the Eucharist–flanking a Trinitarian symbol emblazoned with the all-seeing eye of Jehovah. Although the *Tetschen Altarpiece* heralds the birth of the spiritualized landscape, this novel approach at first had little following in Germany itself.

Friedrich's choice of subject-matter in this work–which he first exhibited in his studio around Christmas 1808–was duly noted by the public, but greeted also with outright hostility. The painter and writer Wilhelm Basilius von Rahmdor published a disapproving critique in which he not only questioned the opportunity of transposing landscape into the religious sphere but also gave vent to some particularly severe judgments. He spoke in terms of a willful mystification of nature, of an artistic concept that could only lead to pathological emotionalism. Friedrich answered with a long article that was printed in *Journal des Luxus und der Moden,* while other painters, like Gerhard von Kügelgen and Ferdinand Hartmann, rallied to his defence. This first critical reception was only the beginning of a standing debate that would last throughout the painter's career.

Several years later, Ludwig Richter, one of the best-known painters in Germany, set down a very harsh critique of Friedrich in his own diary. He was also of the opinion that the Dresden artist's pictures were imbued with an unwholesome melancholy and that they exerted a no-less healthy appeal on the spirits of the unwary art public. He condemned the painter's approach in its entirety, for it obliged the spectator to restrict himself to an abstract, allegorical system arbitrarily "impressed" on to the natural forms. This, according to him, could only lead to confusion and a total impasse.

Other voices, however, took up Friedrich's defence, and in particular that of Ludwig Tieck, one of the greatest poets of the Romantic era. He pointed out the salient features of the artist's

Opposite

CASPAR DAVID FRIEDRICH
Winter Landscape with Church
Oil on canvas, 33 x 44 cm.
Private collection.

efforts, saying that he expressed not only a solemn melancholy, but also a world clearly defined in conceptual terms, and an approach which elevated landscape painting to heights of imagination and pictorial power seldom achieved before.

A better perspective on the discussion raised by the *Tetschen Altarpiece,* and greater insight into its originality, may be gained by comparing it with other religious subjects painted in Germany and France during this same period.

Especially revealing in this respect is a picture by Runge from 1806 representing the *Rest on the Flight into Egypt. Runge* at the time was twenty-nine years old, in full possession of his craft and determined to renew the Christian art in his land. The work he painted on this occasion was intended for the Marienkirche in Greifswald, the town of Friedrich's birth.

Runge executed this work according to his own theories of colour and in the spirit of an exercise in Christian painting. The subject was drawn from the Gospel of Matthew (2:13), and the composition was conceived in terms of the emotional value of the scene as expressed in the gestures of the figures and the light. In other words, the artist restricted himself to the clearly-defined elements of a traditional religious episode. The Christ Child is the dynamic focal point of the composition, his hands raised towards the spiritual light which dawns over a vast landscape supposed to be in the Valley of the Nile. A new day in the Orient, but also a luminous rebirth of humanity, as symbolized by the sudden blossoming of the tree and the presence of two angels. It is the beginning of a renewed salvation guaranteed by the cycles of nature, the rhythm of the days; all in all a masterful blend of Christianity and a cosmic sense of Creation.

Runge adapted this age-old subject by skilfully endowing the gestures and pictorial space with a thoroughly Germanic expressiveness in the tradition of Martin Schongauer. The *mise-en-scène* is Renaissance, with a slight tendency to Mannerism, and the importance of the human figure is in keeping with its traditional role, but the magic flowering of the tree and the symbolic value of the light are fully in keeping with the Romantic spirit.

This triumph of Christ over the forces of darkness in Runge signifies a subtle compromise, a major step on the way to Friedrich's *Tetschen Altarpiece.* What changed with the latter was that he unambiguously opted for a secularization of religious painting.

Overleaf (detail) and opposite

PHILIPP OTTO RUNGE
Rest on the Flight into Egypt
1805-1806, oil on canvas,
96.5 x 129.5 cm.
Hamburg, Kunsthalle.

Next pages (detail)

CASPAR DAVID FRIEDRICH
The Tetschen Altarpiece
1808, oil on canvas,
115 x 110.5 cm.
Dresden, Staatliche
Kunstsammlungen
Gemäldegalerie.

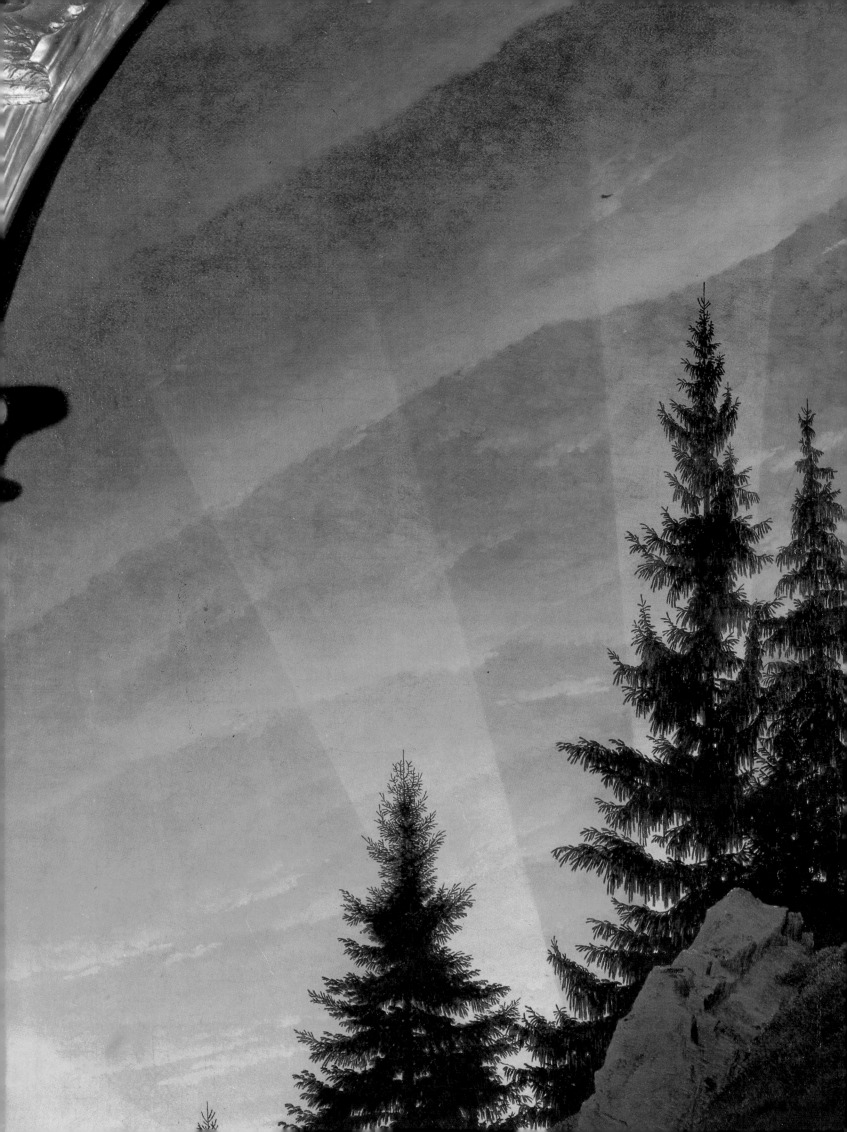

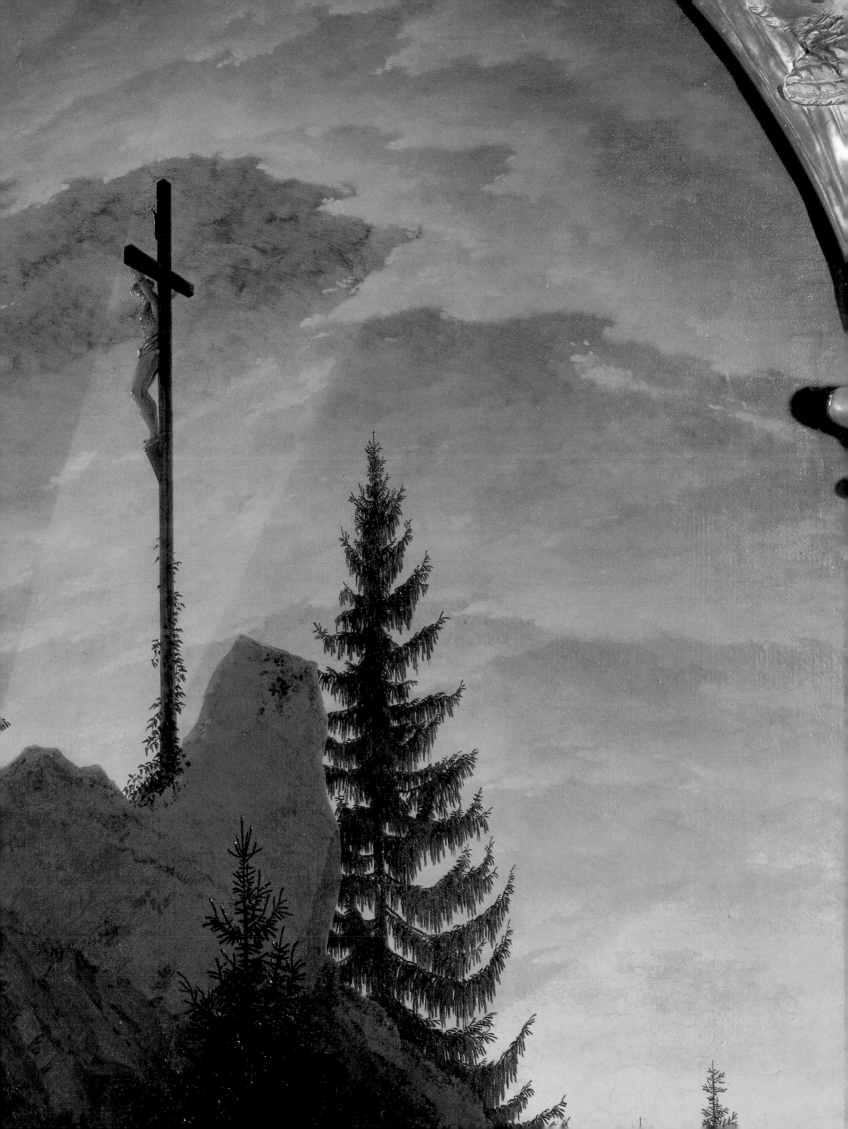

The differences between the religious conception of the *Tetschen Altarpiece* and the one that characterized the work of Delacroix are even more evident and fraught with artistic implications. To be sure, the French painter belonged to the generation of artists which followed that of Friedrich and also to a quite different pictorial culture. His work nonetheless included quite a few major religious paintings which he executed around 1820 (*The Virgin of the Harvest,* 1819).

Delacroix was not a believer in the traditional sense of the word. If he entertained a faith, or ethic, it was essentially a faith in the artistic entreprise, in the strictly individual coming to consciousness of the self, a cult of individuality over and against the forces of society, history and life itself. This did not prevent the great painter of French Romanticism from executing purely religious subjects, very often marked by the influence of the old masters; specifically, Raphael, Michelangelo and Rubens. The *Crucifixion* of 1835, for example, is definitely of a Rubenesque inspiration. The picture is organized according to a Baroque scheme, with a strong diagonal axis extending from left to right, grounded by the crosses. The emotional charge of the scene is reinforced by the almost arbitrary colour-scheme and the strong contrasts of light and shade, as well as by the rapid and nervous brushwork built up into a visible texture. The ominously dark sky, announcing the coming night, is a symbolic expression of the death of Christ.

Delacroix was to pursue this vein further towards the end of his career, as we can see by the *Crucifixion* from 1853, a mature work which accentuates the technique of elaborating the religious image by focusing the tragedy in the figure of Christ alone, as an individual faced with his mortal fate, faced with sacrifice. For Delacroix, the tragedy of the Crucifixion was a tragedy involving the human body, expressed by dynamic and contrasting forces that pulsed through the pictorial space. He brought the great history painting tradition of the 17th century up to date, all the while retaining its fundamental premises.

EUGÈNE DELACROIX
Christ on the Cross
1860, oil on canvas,
751 x 485 cm.
Vannes, musée des
Beaux-Arts.

MOVEMENT AND EXPANSION OF LIGHT

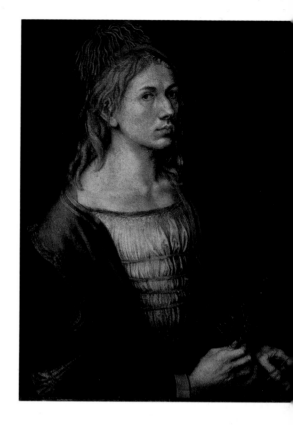

The self-portrait drawn in 1800 gives us an image of Friedrich that is clearly in line with the German tradition. The framing of the upper body, its bearing, the movement of the shoulder, as well as the expression of the face bring to mind the *Self-portrait* by Albrecht Dürer from 1493, which is today in the Louvre.

Later, in 1810, Friedrich painted his last known self-portrait. It gives a quite different image of him. The facial expression has changed, the gaze has become more steady, disquieting in its fixity, an almost inquisitorial stare. His ascetic face is framed by his hair and sideburns, and his upper body is locked in a garment reminiscent of the hair-shirt of a monk. The background is neutral and, unlike the other self-portraits that have come down to us, all tools or mention of the painter's craft have been left out. It is as if the individuality and powerful expressiveness of the gaze were all that mattered in the staging of the self.

The year 1810 was indeed a decisive one in the painter's career. Although still scrupulously keeping his distance from the world, Friedrich was accepted as a member of the Academy in Berlin; then he received a visit from Goethe, who had come to Dresden especially to see his studio. The great writer later expressed high praise for the *Monk by the Sea* and *Abbey in an Oak Forest* in his diary. The quality of these two pictures was so highly-esteemed that they were purchased by Frederick Wilhelm III, King of Prussia, on the advice of the young Crown Prince.

We know, however, that Goethe was somewhat hostile to the expression of mysticism in art, even if he admired Friedrich's technique and the moods which emanated from his landscapes.

On the other hand, what influence did Goethe himself have on Friedrich at the time? Did the painter look to the writings of the great poet and natural philosopher for suggestions or teachings? Goethe published his *Colour Theory* in 1810. This treatise, divided into four chapters, is articulate and profound, but

ALBRECHT DÜRER
Self-portrait
1493, oil on parchment
mounted on canvas,
56 x 44 cm.
Paris, musée du Louvre.

Opposite

CASPAR DAVID FRIEDRICH
Self-portrait, Head Resting on Hand,
1802, pencil, pen and ink,
26.7 x 21.5 cm.
Hamburg, Kunsthalle.

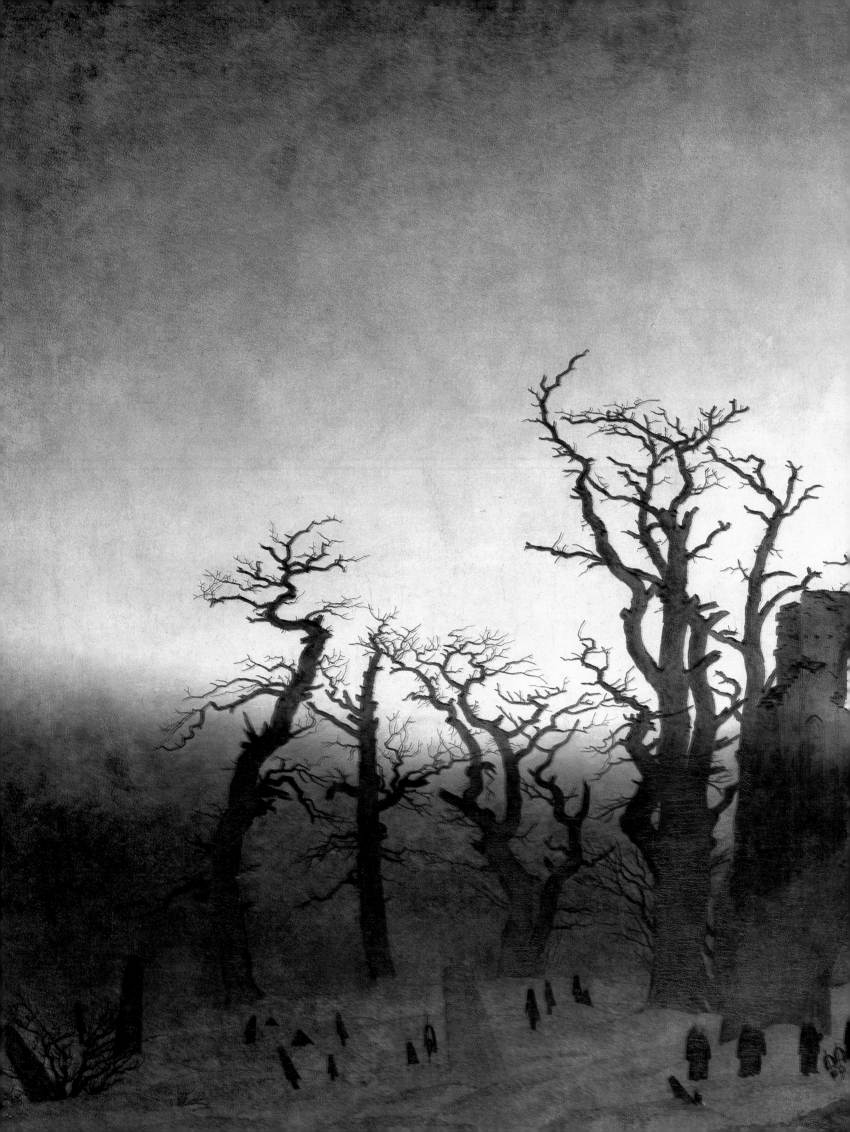

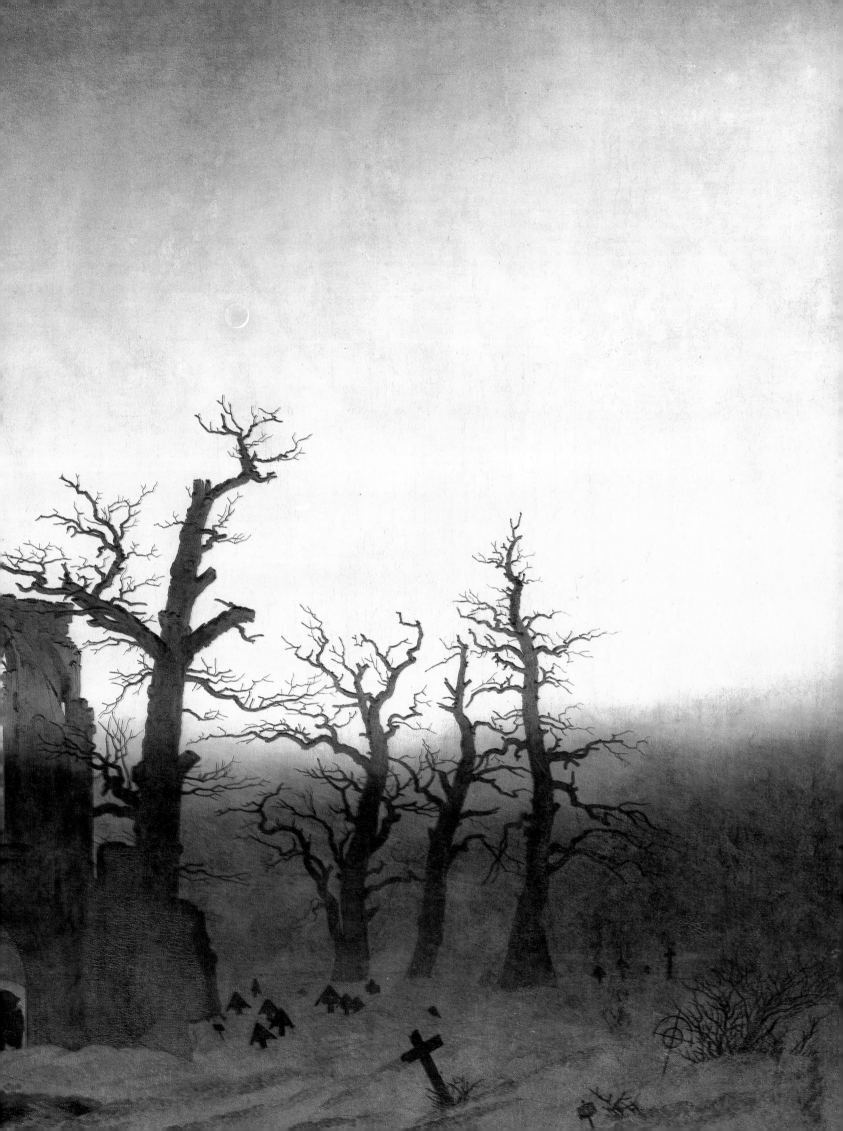

it seems unlikely that Friedrich could have been interested in its scientific, much less its didactic, aspects. Of course, the idea that colours speak less to the eye than to the soul must surely have appealed to the young artist. But it is a fact that Friedrich had already been applying this principle in landscapes in which the colour-schemes were evocative more of spiritual than of naturalistic intentions.

The painter was working at the time on several landmark works, all of oblong horizontal format to give the landscapes a lateral extension and, thanks to the symmetry of the design, somewhat the appearance of an icon.

Mountain Landscape with Rainbow (around 1810) was elaborated at the same time as another, very closely-related, composition, *Landscape with Rainbow,* which had probably been intended as a pendant, but has since been lost. In the foreground of the *Mountain Landscape* we see a brightly-lit clearing and rock. Posed against the outcropping is a solitary wanderer, dressed, strangely enough, in city clothes. The man seems completely out of place in this solemn, intimidating environment with its extremely contrasted and complex lighting. He leans half on his walking-stick, half on the rock, his hat deferentially removed and set beside him on the ground.

The figure is very likely a double of Friedrich, or at least a figure of man alone, far from the beaten tracks of city life, suddenly faced with the daunting immensity of the Cosmos. His isolation in the midst of this composition is striking, and there is no logical explanation for the aura of light which transfigures the small space in which he is confined. Beyond this figure, the eye is sucked into a sort of dark precipice traversed by a whitish glow, a sort of perceptual abyss. The picture is rebalanced visually by the centrally-placed mountain in the distance, a sort of dark "pyramid" crouched beneath a no-less gloomy sky full of dark clouds.

The mountain represented here is Mount Rosenberg in Northern Bohemia, which Friedrich visited to make on-site studies. The underlying idea is that the mountain is an allegory of God, an equivalent of God's presence, and that the valley, with its inevitable perils, is the locus of man's earthly journey, which always ends in death. This hypothesis is consistent with Christian symbolism, according to which the mountain is the place where heaven and earth meet, the goal of the mystic quest (St. John of the Cross, *Ascent of Mount Carmel*). Also, in the prophetic Book of Micah (4:1), it is written that at the end of Time, there will

Overleaf

CASPAR DAVID FRIEDRICH
Abbey in the Oak Forest
1809-1810, oil on canvas,
110.4 x 171 cm.
Berlin, Staatliche Schlösser
und Garten,
Schloss Charlottenburg.

Opposite

JOHN CONSTABLE
Landscape with Two Rainbows
1812, oil on paper,
34 x 38 cm.
London, Victoria and Albert Museum.

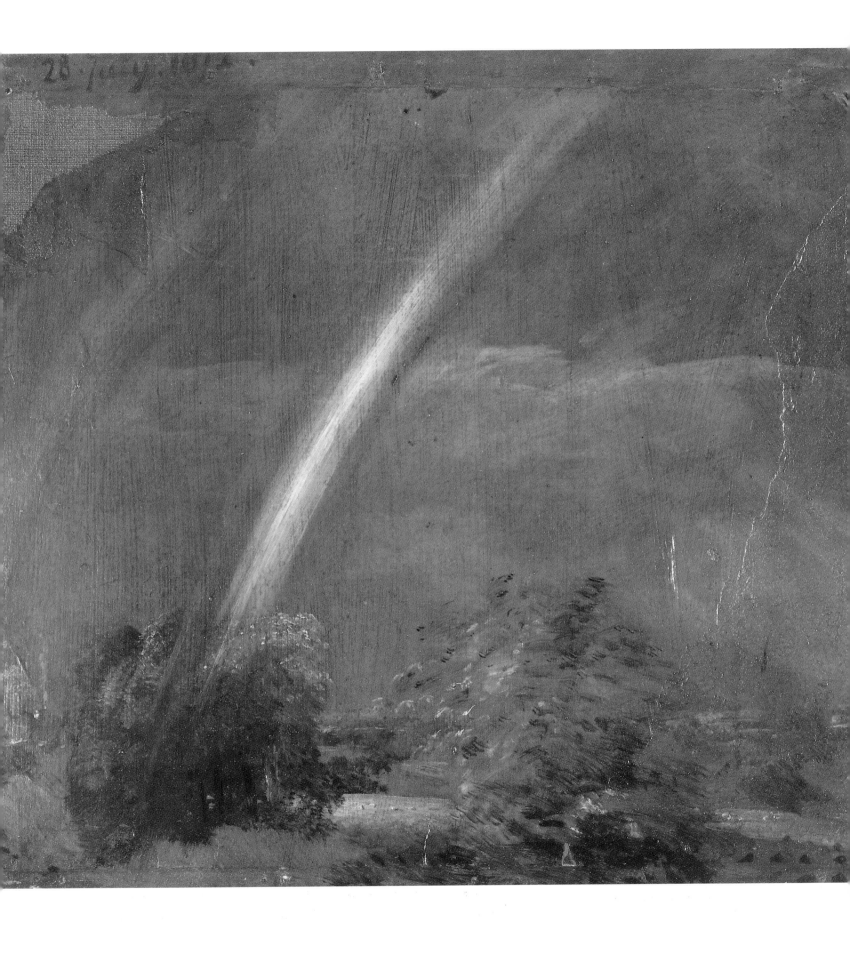

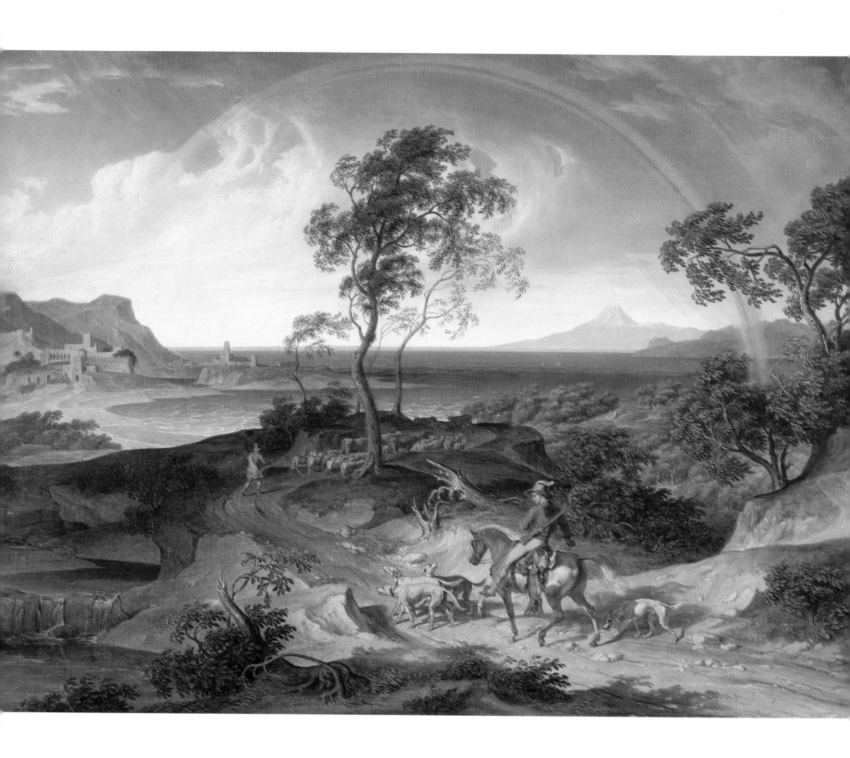

stand a Mountain of God, higher than any other mountain on earth.

The significance of the mountain is enhanced in Friedrich's painting by the presence of a broadly-arching rainbow. In the Christian tradition, the rainbow represents God or Christ in the iconography of the Last Judgment or of Christ in Majesty (Revelation 4:3, Ezechiel 1:28). It is furthermore the symbol of the new Covenant between Heaven and Earth after the Flood, such as it is shown in certain Late-Medieval German representations in which Christ appears seated on a rainbow, his feet resting on a second one below.

The internal tension of this picture is generated by the arbitrary combination of natural phenomena: a dark, looming sky, scarcely lightened by the rainbow, and an inexplicably brightly-lit foreground. The rainbow may have been included in a second phase of elaboration; that is, added to a night sky and moonlight landscape. In this way Friedrich integrated two mutually exclusive and contrasting natural phenomena. The resulting atmospheric paradox treats the spectator to the shock of a visual contradiction.

Unlike in certain painters like Turner (*Landscape with a Rainbow,* 1820) and even his compatriot Joseph Anton Koch (*Stormy Landscape with Returning Rider,* 1830), the rainbow in Friedrich is more than just a pleasant multicoloured mirage formed by the decomposition of light and served up to the aesthetic delectation of the spectator. His construction of the rainbow is precise and architectural; a depressed arch spanning the entire length of the composition, glowing with a cool and opaque luminosity.

This deliberate frontality, and this extension of the spectrum tend to subvert our confidence in a sheltering nature, for nature has been fixed into an unmoving, untouchable, somewhat aloof geometrical order. The artist pushed the aesthetics of awe and attraction to their extreme by underscoring the insuperable might of the natural sublime.

Nature in this landscape with a double lighting, both lunar and solar, with a pyramidal mountain and powerfully arching rainbow, seems to be in opposition to the man, who is calmly poised in contemplation. He is a wanderer who has reached a certain point in his life, far from his habitual haunts; a spiritual phase which confronts him with the problem of holding on to the light. The frail human form is exposed to multicoloured traps and mirages.

CASPAR DAVID FRIEDRICH
Mountain Landscape with Rainbow
Around 1810, oil on canvas, 70 x 102 cm.
Essen, Museum Folkwang.

Opposite

JOSEPH ANTON KOCH
Stormy Landscape with Returning Rider
1830.
Stuttgart, Staatsgalerie.

CASPAR DAVID FRIEDRICH
Monk by the Sea
1810, oil on canvas,
110 x 171.5 cm.
Berlin, Staatliche Schösser
und Garten,
Schloss Charlottenburg.

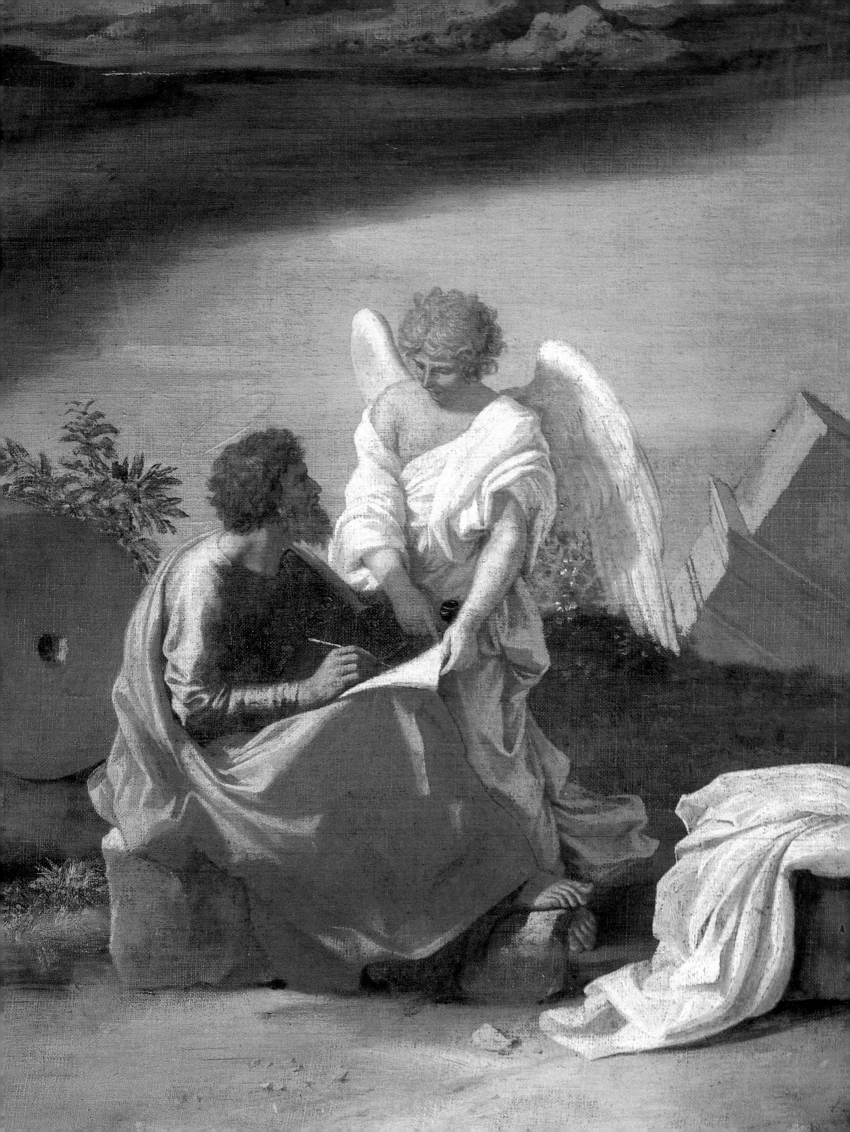

ABSTRACTIONS AND ALLEGORIAL VESTIGES

In the October 13, 1810, issue of the *Berliner Abendblätter*, the poet Heinrich von Kleist (who lived in Dresden from 1807 to 1809) wrote some very flattering comments on the *Monk by the Sea,* a picture which Goethe had described as "marvellous" when he saw it in Friedrich's studio that same year.

Indeed, the lapidary, almost "abstract" concision of this picture gives it a tremendous power. It accentuates and amplifies Friedrich's basic oppositions, achieving a perfect synthesis between physical form and spiritual content. Once again the painter opted for a simplified and elongated horizontal composition, a formal arrangement which fittingly expresses the dimensional qualities of land and sky: both juxtaposed and complementary. The complete elimination of the middle-ground emphasizes their opposition–the better to express the spiritual dialectic between man (painter-hermit-pilgrim) and God-in-Nature. The narrow strip of sand on which the monk stands is made to merge with the dark, wind-lashed waves. This band of foaming sea is like a rampart raised against the immensity of the sky, which here is inhabited only by a flight of three seagulls. On this strip of land, the solitary figure–a pilgrim, wanderer or "double" of the painter–advances, holding his head in his hands as if in great affliction.

Some historians think that Friedrich originally planned to depict a nocturnal scene and that he later changed it into a daylight one. Whatever the case may be, light in this picture does not seem to be a positive force. It draws the spectator's gaze with its contained intensity and absorbs that of the strolling monk with its immaterial immensity. One gets the feeling that this monk plays essentially the role of an intermediary; although small, he brings a sense of human scale, and so reduces the impact of the hostile sky. Like the lonely wanderer, the spectator experiences both fear and fascination in the face of this implied infinity. Finally, the *Monk by the Sea* presents a meditation on death in the tradition of the "Vanitas" pictures of the 17th century, a last resort against a powerful and distant divinized nature, felt ultimately to be indifferent.

Opposite (detail) and next pages

NICOLAS POUSSIN
Landscape with Saint Matthew and the Angel
Around 1644, oil on canvas, 99 x 135 cm.
Berlin, Dahlem Museum.

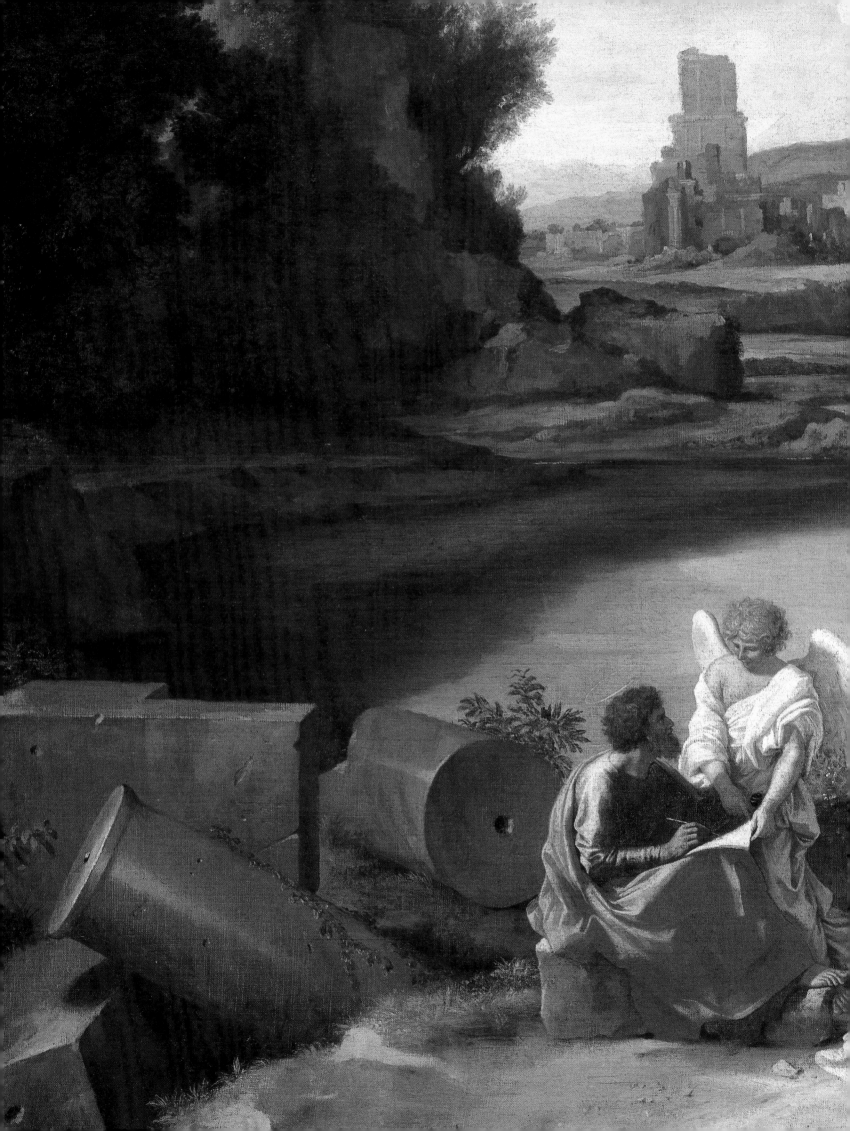

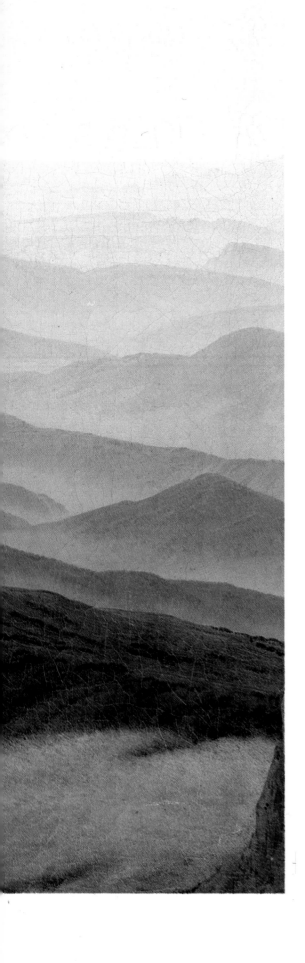

Friedrich expresses once more in this picture a new and original concept of the work of art. Indeed, this painting may be read on two levels: simply as a descriptive, highly contrasted, Romantic work in keeping with the European reaction against Neoclassicism; or as a secret and coded work, expressing a metaphysical attitude by means of natural symbolism. This approach, however, in which the spiritual message was often almost overshadowed by an evident naturalism, was still a novelty which Germans were not so ready and willing to approve. Friedrich's work was not automatically and necessarily greeted with laurels—far from it. Apart from a handful of admirers, there were many critics who expressed a more nuanced, if not downright disapproving, opinion.

In July 1810, Friedrich made a trip to the Riesengebirge (Mountains of the Giants), a mountainous region very much in fashion since the 18th century among artists and tourists in search of suggestive and impressive landscapes.

He was accompanied by the painter Kersting, who, like Friedrich, had studied at the Academy in Copenhagen and established himself in Dresden, becoming one of his faithful disciples. The drawings which Friedrich brought back with him from the Riesengebirge became the raw material for many mountainscapes, and in particular for the remarkable *Morning in the Riesengebirge* from that same year.

Friedrich exhibited this picture successively at the academies of Dresden in March 1811, of Weimar in November, and of Berlin in 1812. It was on this last occasion that it came to the attention of its future owner, King Frederick Wilhelm III.

At first glance, the pictorial space seems to be organized in a manner uncommon, almost unprecedented, in German painting. Mist, a major symbol for the painter, dominates the length and breadth of the composition, submerging the rolling terrain in wave-like bands, almost transforming the picture into a seascape. The whole is a classical allegory of our befogged terrestrial existence and the search for a spiritual light which is just about to break and spread throughout the world.

We see two figures at the foot of a Cross. The woman, lightly dressed in city clothes, holds on to the Cross. The figure of Christ is turned away from the dawning light, unlike in the *Tetschen Altarpiece*, as if here attending to the doings of humanity. A man, also in city dress, is being helped by the woman in his last steps to the summit. He seems equally out of

place in this splendid scene, almost unworthy of the luminous grace about to unfold. The painter has created a tension between the realism of the couple and the allegorical idealization of the landscape; between the all-too-human gestures and the majestic motionlessness of the natural spectacle.

This composition inaugurates a highly original iconography previously unknown in Germany. The theme of the Crucifixion is clearly stated, but it is subordinated, almost lost in the vast expanse of the landscape, just another object that is subject to the main theme of light and its action on the physical and spiritual aspects of things. The traditional religious theme is superseded here by a more profane vision, an approach which is not unrelated to that of Nicolas Poussin in the famous *Landscape with Matthew and the Angel* (1644), in which the religious subject of the apostle and the angel appears, but framed by a vast landscape bathed in the light of the Roman campagna.

The innovative and provocative feature of Friedrich's picture resides essentially in the relationship that has been created between the couple and the light-filled landscape, between the path of the personal self and that of Christian asceticism. There is the feeling here of being in the presence of two different, artificially juxtaposed, spaces, as in a dream: the realm of the ascetic-ascending couple standing on the rocky mass, and the realm of nature in the process of metamorphosis, fading into the distance, where the mountains lose both form and colour to be transubstantiated into pure light. Air has become a sacred element, and we move imperceptibly from the tangible and the visible toward formless transcendence.

Significantly enough, in this context, the woman is herself almost invisible; she is already a part of the luminous realm above, toward which she helps the darkly-clothed man still struggling in the shadow of the rock.

In 1805, Friedrich had drawn a very evocative scene representing a *Procession at Sunset,* which showed a long line of people advancing from the back towards a crucifix in the foreground. Later, between 1809 and 1810, he worked on *Abbey in an Oak Forest,* a picture which Carus called exceptional and of uncommon spiritual depth. There is a procession here too, but it is a funeral cortège in a winter landscape; the figures are crossing a cemetery toward the ruins of a Gothic arch, identifiable as the one at Eldena, near Greifswald, not far from the Baltic Sea. There is every reason to think that it represents the burial of a member

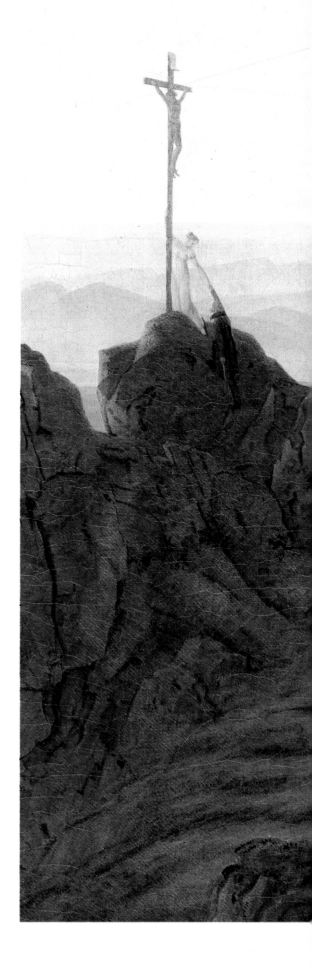

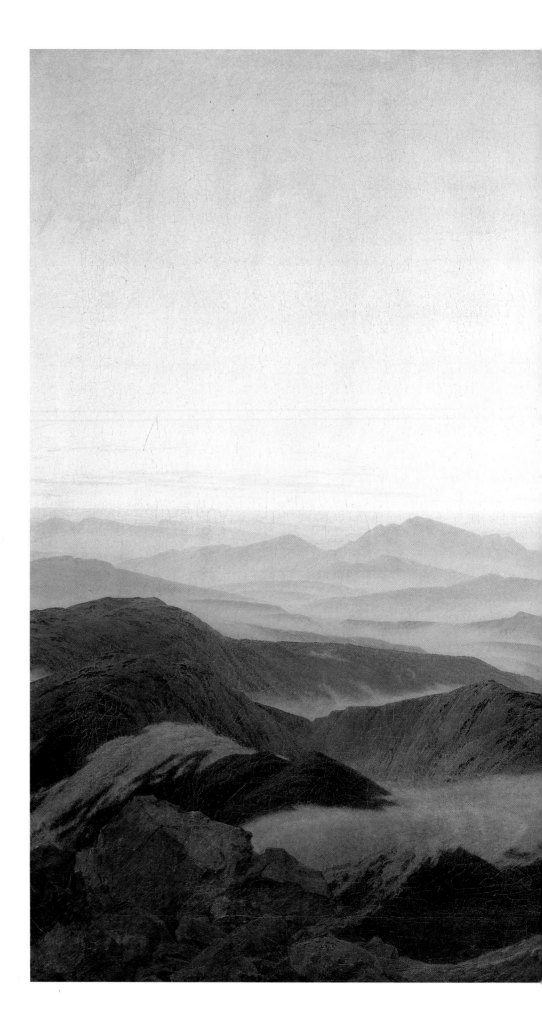

Overleaf (details) and opposite

CASPAR DAVID FRIEDRICH
Morning in the Riesengebirge
1811, oil on canvas,
108 x 170 cm.
Berlin, Staatliche Schlösser und Garten,
Schloss Charlottenburg.

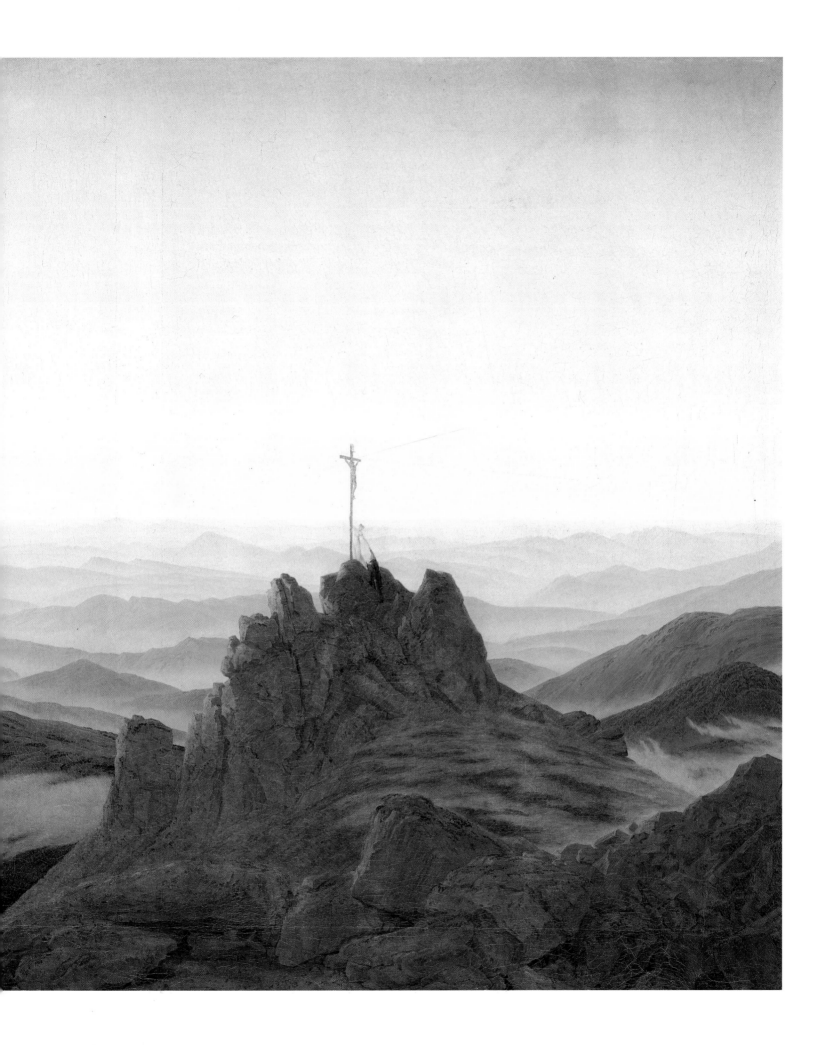

of the Church; unless it is the prefiguration of Friedrich's own burial, a theme which he had treated before in the past. The group of mourners–another image of our mortal journey–file past a recently-dug grave on their way to the two small lights and crucifix set up beneath the church portal.

The space in this work is particularly unusual, for it seems to be suspended, impalpable, bathed in evanescent wisps of mist. The middle-ground does not perform its ordinary function of leading the eye into the distance. On the contrary, Friedrich seems to have reverted here to the medieval system of representing space in superimposed registers, with a dark and apparently ambiguous middle zone. The upper zone, that of the celestial realm, is intensely luminous, and stretched out and rounded off at the bottom, as in the *Monk by the Sea*.

The painter has created an opposition between the strangely rigid architectural vestiges and the dynamic, biomorphic forms of the oak trees, with their contorted skyward-reaching branches. We know that the oak trees in Friedrich's paintings are symbols of German patriotism and heroism. This composition thus brings together the vitality of the trunks and branches and the rigid austerity of the graves and the church architecture. A crescent moon is visible at the top, but its brightness is dwarfed by the intense luminosity of the sky, which seems to be shot through with a life of its own.

The Gothic ruins may be interpreted as an allegory of the religion of the past, which is set in opposition to the organic vitality of the oaks and the light in the heavens. This confrontation creates a strong internal dynamic in the picture and inspires feelings of disquiet. Far from expressing a morbid fascination with death, as it has often been claimed, this painting is related to the traditional theme of *memento mori* (remember death); a meditation on the vanity of our mortal pleasures and a call to constant ascetic practice.

CASPAR DAVID FRIEDRICH
Cemetery in the Snow
1826, oil on canvas,
30 x 26 cm.
Leipzig, Museum der
Bildende Künste.

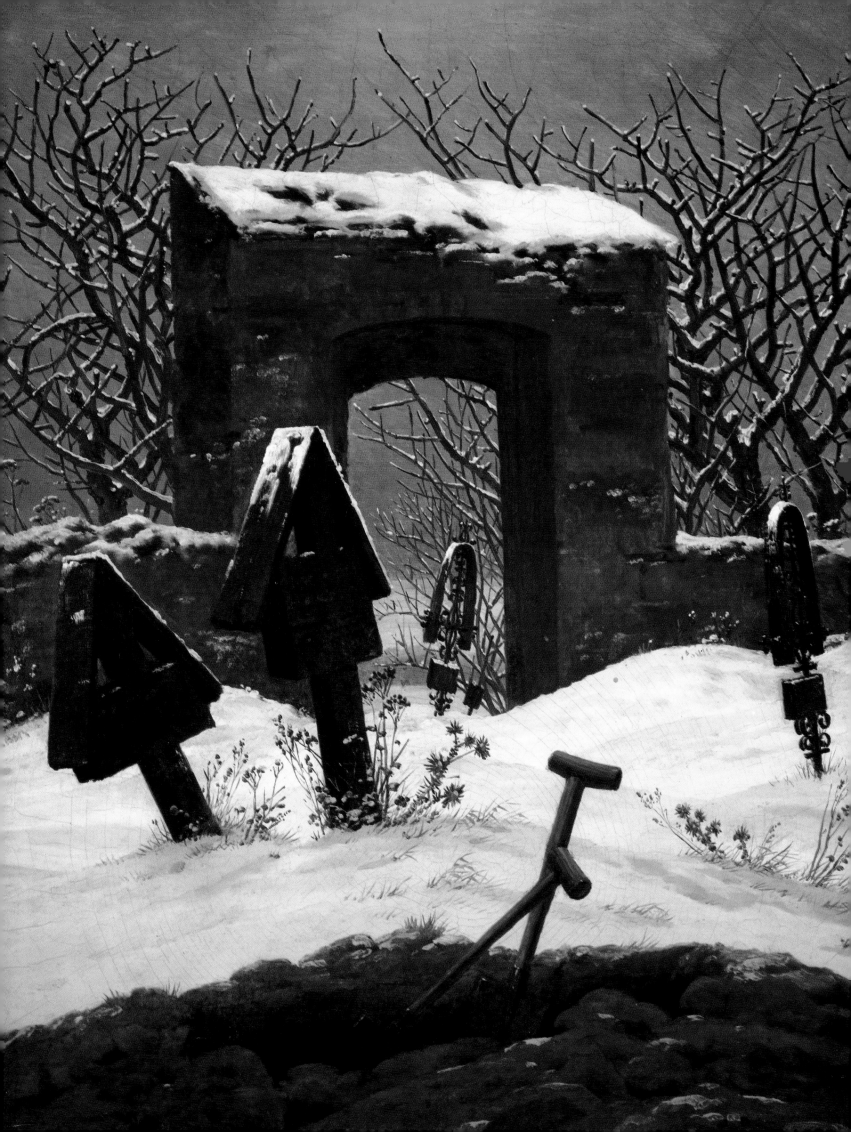

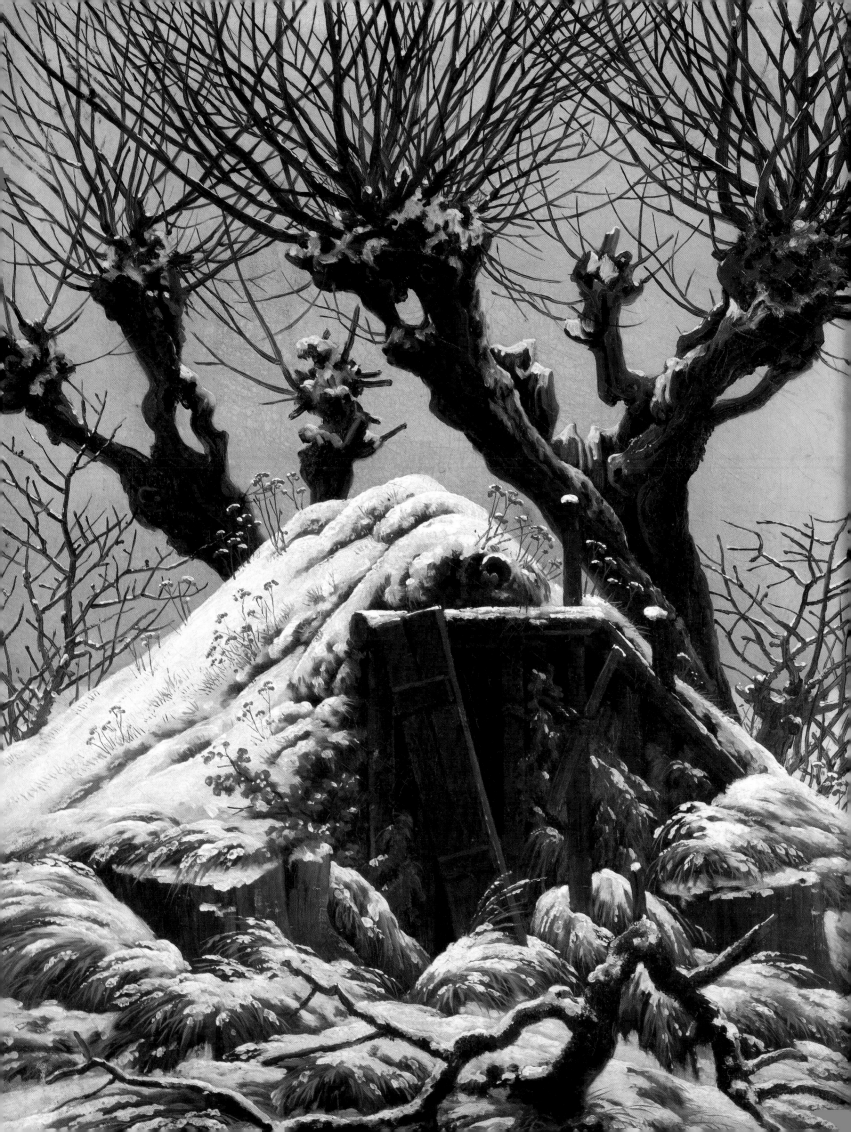

SNOW, FOG, WAITING

In the year 1811, Friedrich paid a visit to Goethe in Jena, and in November sent nine pictures to an exhibition in Weimar: this was the largest group of works shown by the artist so far.

Once again, his work was admired by a number of critics and poets, writers and famous figures like Goethe and Tieck; but others were clearly opposed to his way of treating religious subjects and landscapes, among them Gottfried Schadow, Vice-President of the Academy of Fine-Arts in Berlin, and of course also the Grand Chamberlain von Ramdohr.

This might seem paradoxical and almost incomprehensible to us today, for his painting in no way implied a formal rupture, as did Turner's, his contemporary in England. Nor did he seek to shock or bring about a radical break. He proposed instead a series of adaptations based on the use of landscape, which, to his mind, seemed a prime vehicle for spirituality. Yet its superficial conservativism notwithstanding, this painting must have contained a powerfully provocative charge, for it was judged to be outright misguided and artificial by a great number of art-lovers and specialists.

Several works from the years 1811-1812 seem to err on the "pathological" and excessively melancholic side for which Friedrich was reproached by some critics. One of these, a *Winter Landscape,* was painted in 1811, in the very tense atmosphere of a year that was to be followed by the French invasion. This picture seems less to propose a simple meditation on the vanity of the ways of the world, than to depict a particularly gloomy vision of man's mortal journey.

The subject of this pessimistic and hermetic canvas was developed however in a positive sense in other compositions of this period featuring the theme of snow, fog and man as a wayfarer in nature. Although painted only one year later, *Cross in the Mountains* (1812), seems to be the complete antithesis of the *Winter Landscape.* It would be difficicult to find, in Friedrich's work, a composition more dominated by geometry and symmetry, one with so rational and regular a construction. The

CASPAR DAVID FRIEDRICH
Hut in the Snow
1827, oil on canvas,
31 x 25 cm.
Berlin, Nationalgalerie.

CASPAR DAVID FRIEDRICH
Winter Landscape
1811, oil on canvas,
33 x 46 cm.
Schwerin, Staatliche
Museum.

pictorial space is basically articulated by two lozenges; one in the foreground, formed by rocks, and the other, emerging in the distance like an apparition, formed by pine trees and a Gothic church surrounded by fog, the whole being flanked by two triangular masses of ground.

At the bottom of the composition one can see tufts of grass and dead trees with sinuous branches; symbols, in the Christian tradition, of humanity before the coming of the Messiah. At the foot of the great Cross is a spring, an evident symbol of purification and baptism, even if it does not seem yet to have spiritually fertilized the dark and cold earth.

The pine trees create a linear rhythm that is echoed by the spires of the church (clearly inspired by the Marienkirche in Brandenburg). The juxtaposition of these trees, symbols of German patriotism, and this church, was a way of underscoring in formal terms the unity of the cults of the Fatherland and of Christ, a necessary reminder in those troubled times. The top of the picture is dominated in the centre by the solar disk, which radiates with an intense light that attracts the gaze and dissipates the fog of earthly ignorance.

Friedrich, as usual, was working on two different levels. First, there was the symbolic dimension, incorporated in the meticulously described natural motifs; and second, a purely retinal dimension which invited the spectator to enjoy the pictorial and emotionally suggestive elements without having to refer to any allegorical keys.

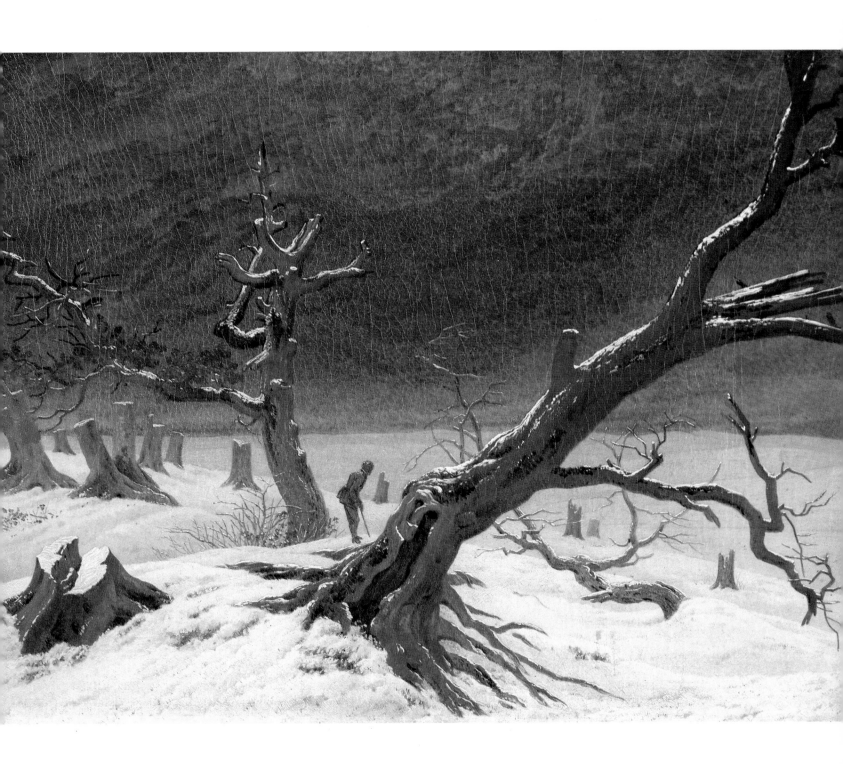

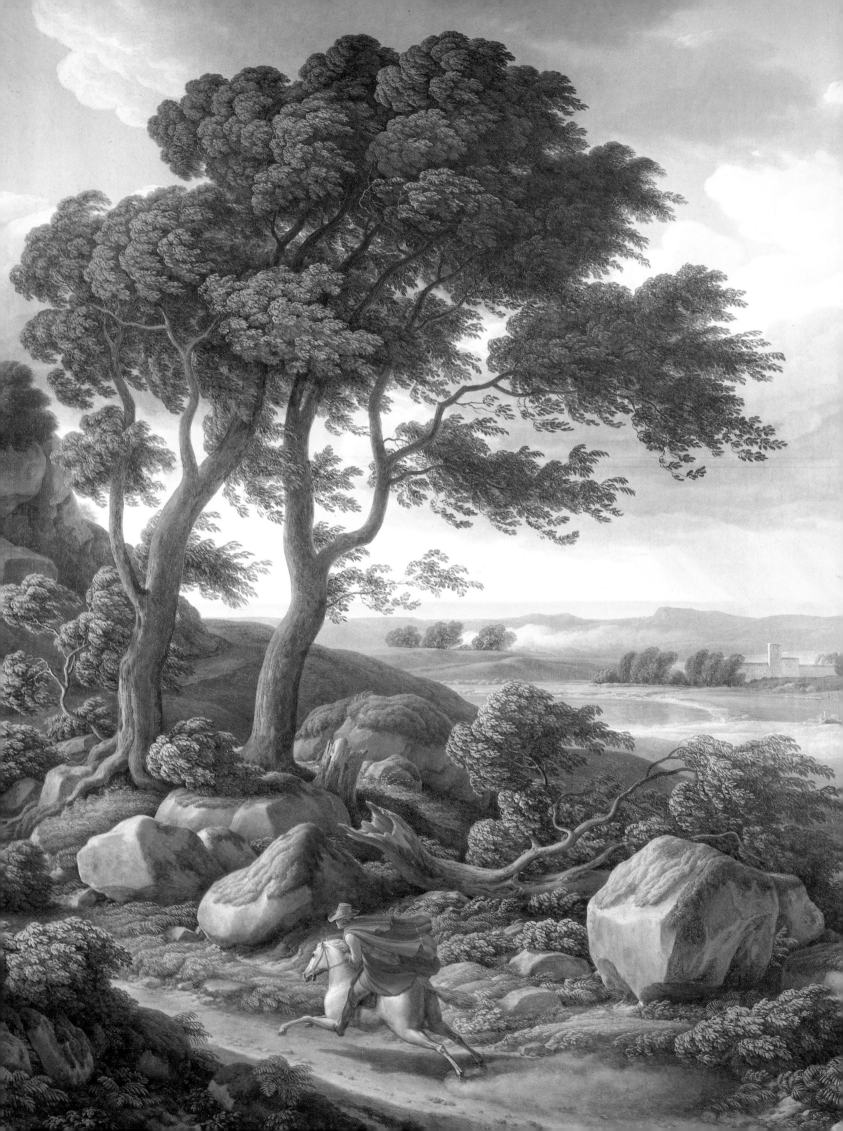

THE INVASION OF NAPOLEON
AND THE ICONOGRAPHY OF "RÉSISTANCE "

In 1813, Friedrich met the poet and patriot Ernst Moritz Arndt on the occasion of his visit to Dresden. This encounter can only have strengthened the painter's nationalistic sentiment at a time when he feared the worst for his homeland. Because of the state of war, these were also financially very difficult times for the artist. In that year, when Napoleon's army entered Dresden, Friedrich sought refuge and consolation in nature by fleeing to the Elbsandsteingebirge, where he stayed from June 1 until July 20.

Friedrich's anti-French sentiments were so strong that he felt the need to create a patriotic iconography based on his usual blend of nature and architectural monuments.

On 27 and 28 August the Battle of Dresden was fought, but the French occupants did not leave the city before 12 November. At the beginning of 1814, the painter worked on several compositions to commemorate the heroic dead of the resistance against the French. To this period also belong a number of drawings of war monuments linked to the resistance and destined for his paintings.

At the patriotic exhibition held in March and April 1814, Friedrich presented two works: *Graves of Ancient Heroes* and *Chasseur in the Forest*. This last picture, painted between the summer of 1813 and March 1814, is especially noteworthy, for it repeats the spatial construction of the *Cross in the Mountains* from 1812 and transposes it into a patriotic context.

The composition is once again based on a rhythm of alternating triangles and lozenges formed by the pine trees and the snow-covered ground. At the bottom of the picture, squarely in the middle, stands a French cavalryman, lost in the midst of a natural cathedral, oppressed by the gothic forest. The painter leaves us in no doubt as to his personal feelings in the matter. The *Vossische Zeitung* interpreted this work as an obvious profession of patriotism, according to which the invading foe was to be overwhelmed in advance by the menacing phalanx of trees. The crow perched on a tree-stump reinforces the feeling of imminent

JOHANN CHRISTIAN REINHART
Stormy Landscape with Rider
1824, oil on canvas,
75 x 63 cm.
Leipzig, Museum der Bildende Künste.

THÉODORE GÉRICAULT
**Chasseur of the Imperial
Guard, Charging**
Around 1812, oil on paper
mounted on canvas,
43 x 35.5 cm.
Rouen, musée des
Beaux-Arts.

THÉODORE GÉRICAULT
**Chasseur of the Imperial
Guard, Charging**
Sketch
1812, paper on canvas
52.5 x 40 cm.
Paris, musée du Louvre.

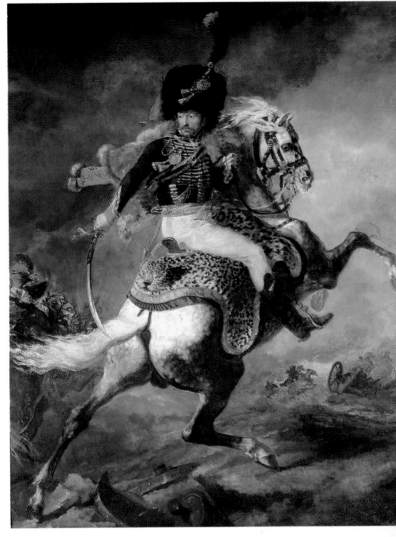

THÉODORE GÉRICAULT
**Chasseur of the Imperial
Guard, Charging**
1812, oil on canvas,
28 x 23 cm.
Bayonne, musée Bonnat.

THÉODORE GÉRICAULT
**Chasseur of the Imperial
Guard, Charging**
1812, oil on canvas,
292 x 194 cm.
Paris, musée du Louvre.

doom, but is also a quotation from Flemish paintings of the past (Breugel, *Hunters in the Snow,* 1565).

At the same time, the soldier's dignified bearing, his abstractly upright stance, caught as he is in a moment of philosophical contemplation, seems to accord the enemy a modicum of human respect. The dismounted rider can therefore be seen as yet another version of the solitary wanderer, a symbol of the human condition, faced with the sublimity of nature. This neutrality, or distance from representing the deeds of war, was expressed by Géricault in a different way during this same period. In his *Chasseur of the Imperial Guard* (1812), and in his preliminary oil sketches, he isolated the rider from the battle, focussing on his loneliness and fatigue, avoiding the traditional subject of clashing armies.

Although the subject is the monologue of the hero faced with the awareness of death, there is an evident difference in approach between the French and the German artists. Friedrich created a hermetic form, replacing action with a situation in which the symbolic mode prevails. Géricault retained the action and dynamic forms, but isolated the figure from the engagement. He created a new type of figure, the "philosophic" officer, who is

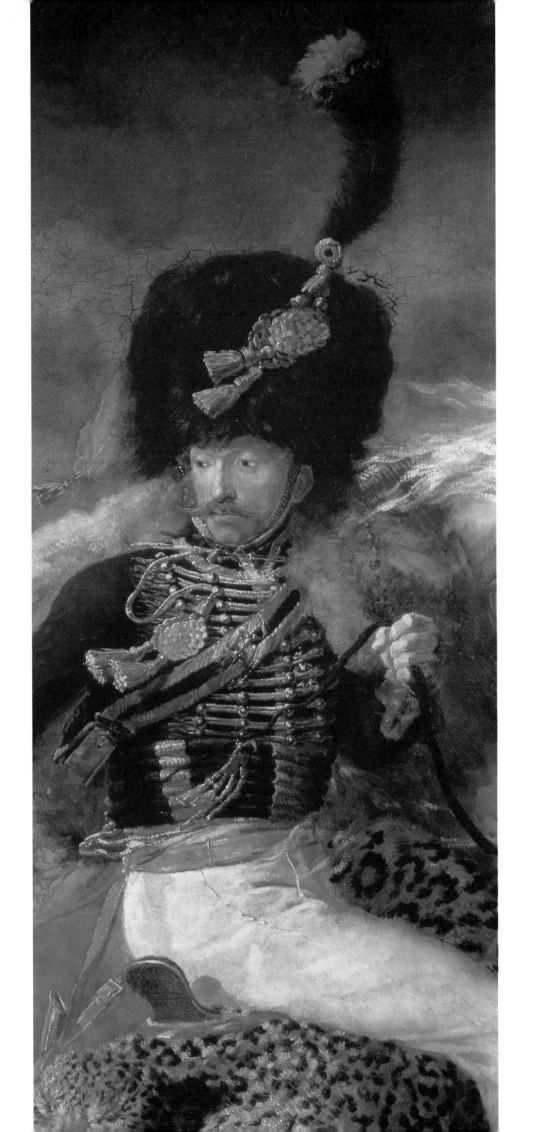

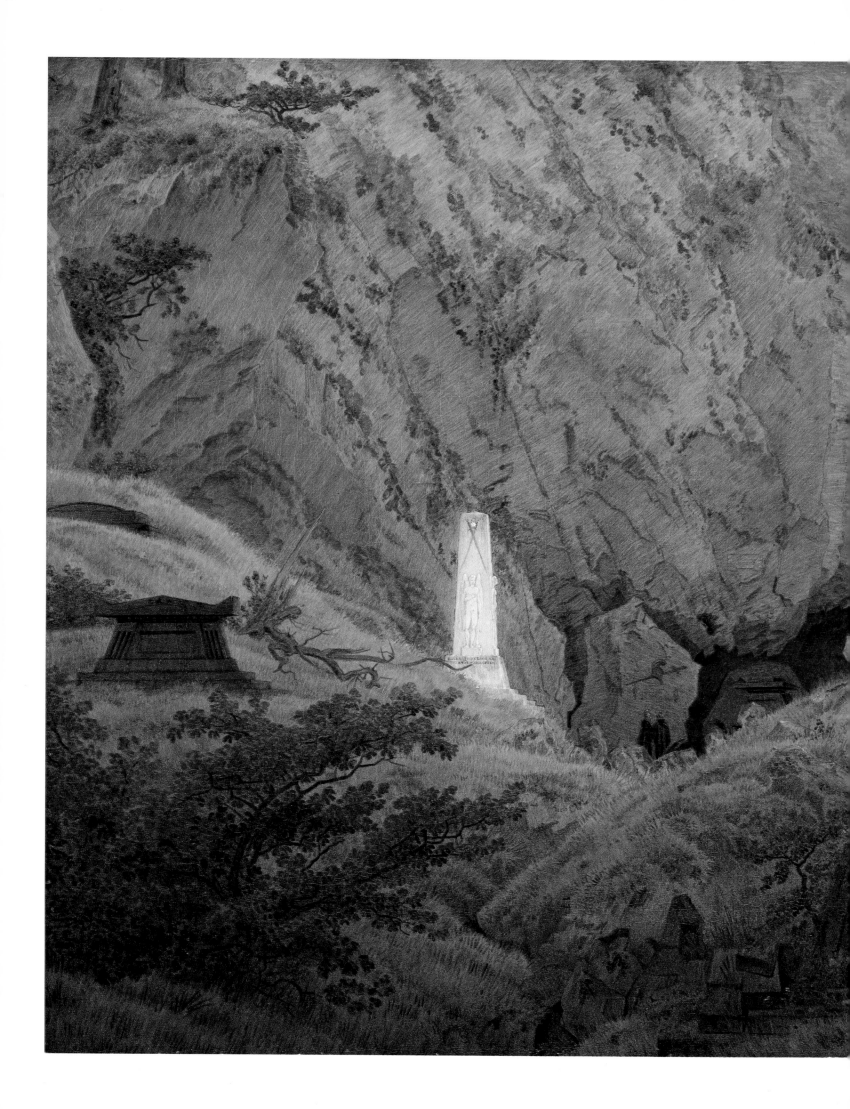

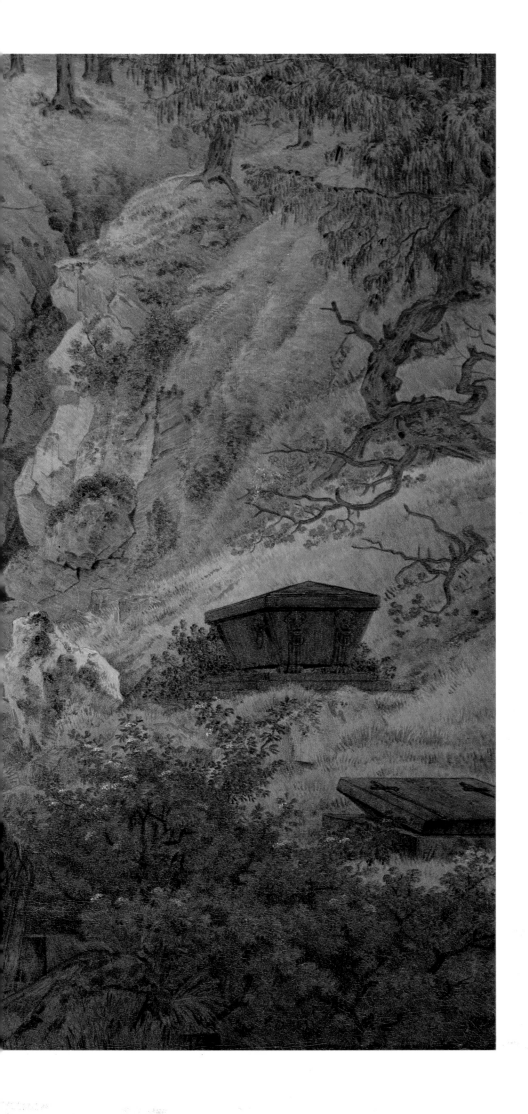

CASPAR DAVID FRIEDRICH
Graves of Ancient Heroes
1812, oil on canvas,
49.5 x 70.5 cm.
Hamburg, Kunsthalle.

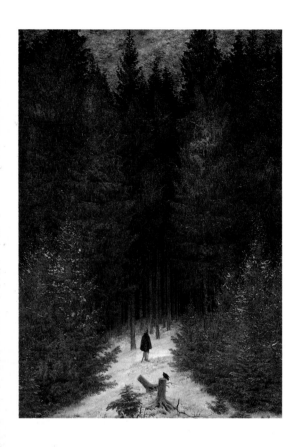

CASPAR DAVID FRIEDRICH
Chasseur in the Forest
1813, oil on canvas,
65.7 x 46.7 cm.
Private collection

Opposite

CASPAR DAVID FRIEDRICH
Cave and Funerary Monument
1813, oil on canvas,
49 x 70 cm.
Bremen, Kunsthalle.

martial only because of his military uniform, and who expresses his vulnerability through his wounds (*Wounded Cavalryman Leaving the Battle,* 1814), and even more deeply, through a sort of moral fatigue. Alexandre Dieudonné, the officer in Géricault's first painting, was portrayed against a disheartening background of flames and smoke. It was painted in the year in which the Empire seemed to be crumbling under the overwhelming weight of its casualties and problems. The man is alone, tight-lipped, his gaze inexpressive. He seems to be lost in thought, probably about death, like the French cavalryman lost in the immensity of the German forest, crushed by nature itself.

Among the patriotic works painted by Friedrich between 1812 and 1814, *Graves of the Ancient Heroes* stands on its own. For this picture, the painter used drawings done in the Harz mountains, modifying and adapting them for the purposes of the subject. The framing itself is unusual, and may be compared to the compositions of Wolf and English landscape painters of the late 18th century. There is no sky at all, and the eye is led along the line of a crevice down to a cave.

Some of the tombs in the foreground have inscriptions that may be read, including the name of Arminius, leader of the Cherusci who first fought in the Roman army, then returned to Germania and revolted against and destroyed the legions of Varus in 9 A.D. The clearest and visibly most recent monument is in the form of an obelisk decorated with a winged figure, two crossed swords, the initials "G.A.F." and an inscription which reads: "To the Youth Fallen for the Fatherland." This tomb seems to have been dedicated to a specific individual whose identity remains, as yet, unknown. In the background are the figures of two French soldiers contemplating a vast open tomb, clearly dwarfed by the majesty of the place. A red, white and blue snake–symbol of Evil–winds around the tomb of Arminius, leaving no doubt as to the patriotic import of this scene.

The oppressive structure of this work, with its insistent two-dimensionality and gaping cavern, is attenuated somewhat in the *Cave with a Funerary Monument* from 1813, which represents a related subject. Here again, the sky is conspicuously absent, and a long diagonal fissure leads the eye to a centrally-placed opening. But here, instead of graves, there are ferns and pine trees, dual symbols of patriotism and eternal life. The grass, foliage and light colour-scheme give this scene a positive, springtime atmosphere. The rebirth of nature is thus associated with a spiritual and nationalistic renewal.

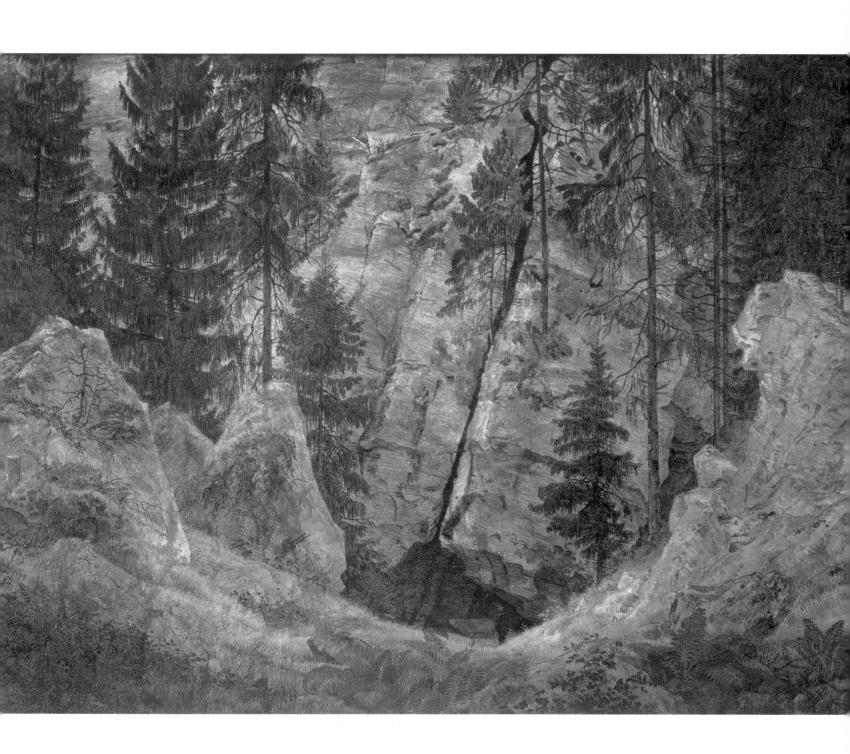

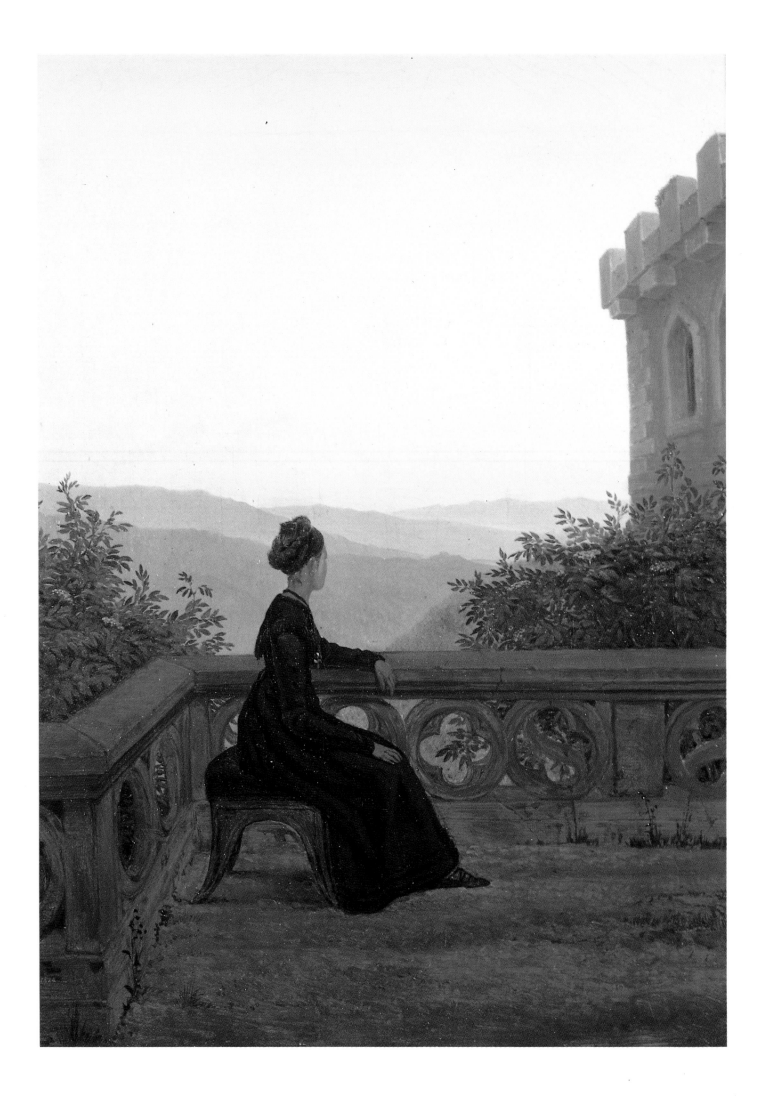

A NEW INTERMEDIARY:
THE WOMAN IN THE LIGHT

In 1816, Friedrich, having become famous and recognized by the majority of the critics, was invited to go to Rome. If he ultimately turned the invitation down, it was probably because–and he said as much–the Italian pictorial culture was too preponderant, and it was better to draw on the resources of the old Germanic tradition, which even Dürer and Altdorfer had never really abandoned.

The painter led a modest existence, far from the tumult of the world and the artistic agitation that he considered harmful to the unfolding of his pictorial personality. His was an inward life, ever turned toward trancendence of the transient.

His contemporaries described him as a loner, living under very spare, not to say spartan, conditions. Yet his fame had spread far and wide just the same. Among his many visitors were the German writer Heinrich de la Motte-Fouqué and the French sculptor David d'Angers, who described him as an affable and sensitive man who was at times of a surprisingly merry disposition. In 1816 also, he was elected member to the Academy of Dresden, with an annual salary of one hundred and fifty thalers, a promotion which considerably improved his material circumstances.

Until then, Friedrich had led an almost monk-like existence. He was not known to have had any love relationships, and one of his intimates, Helen von Kügelgen, called him "the most bachelor of the bachelors." It was therefore a cause of general surprise when, on January 21, 1818, he wed the still quite young Caroline Bommer, the daughter of a modest storekeeper. They spent their honeymoon at Greifswald and on the island of Rügen, in the midst of the landscapes he had known in his youth and which had brought him so much consolation and inspiration.

As Carus pointed out, these new circumstances did not change Friedrich's life in depth, but they did bring about a new feature in his imagery–the female figure–bringing with it new formal and affective resonances. Shortly after their return to Dresden, Friedrich executed *On the Sailboat* (1818-1819), a

CARL GUSTAV CARUS
Woman on a Terrace
1824, oil on canvas,
42 x 33 cm.
Dresden, Staatliche
Kunstsammlungen
Gemäldegalerie.

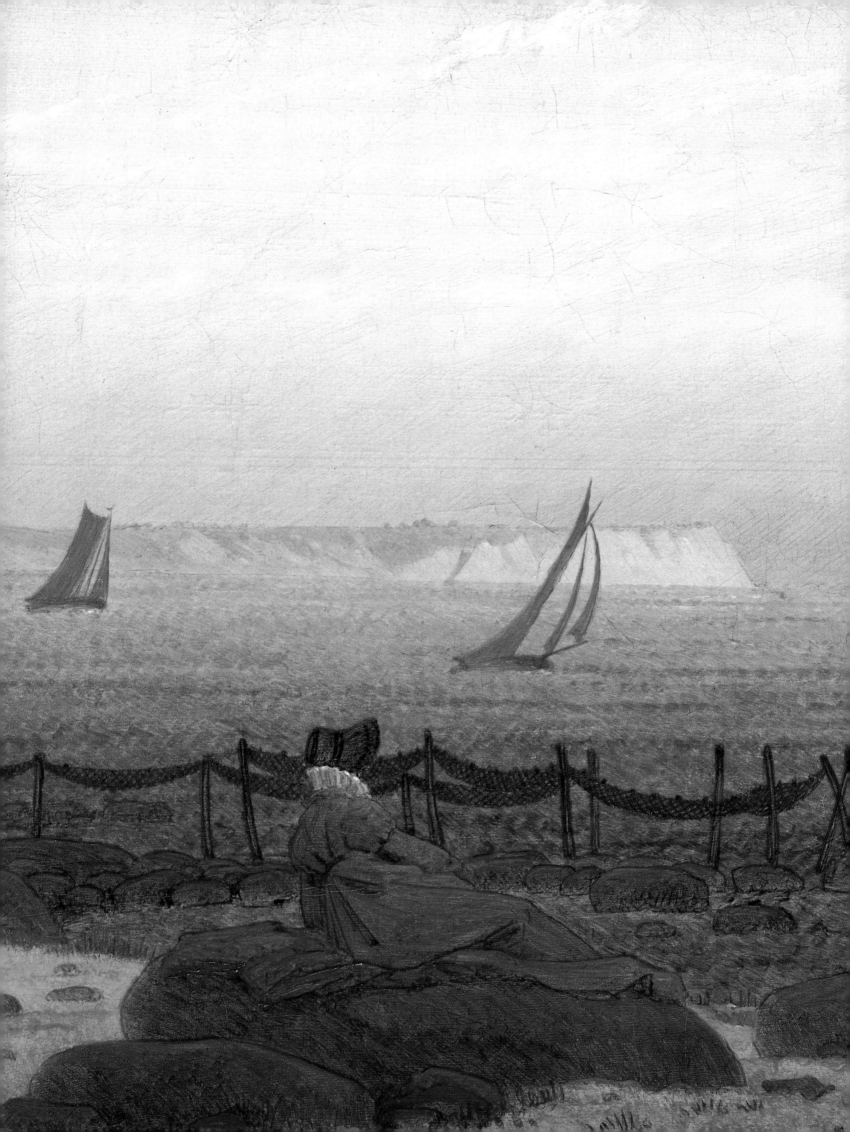

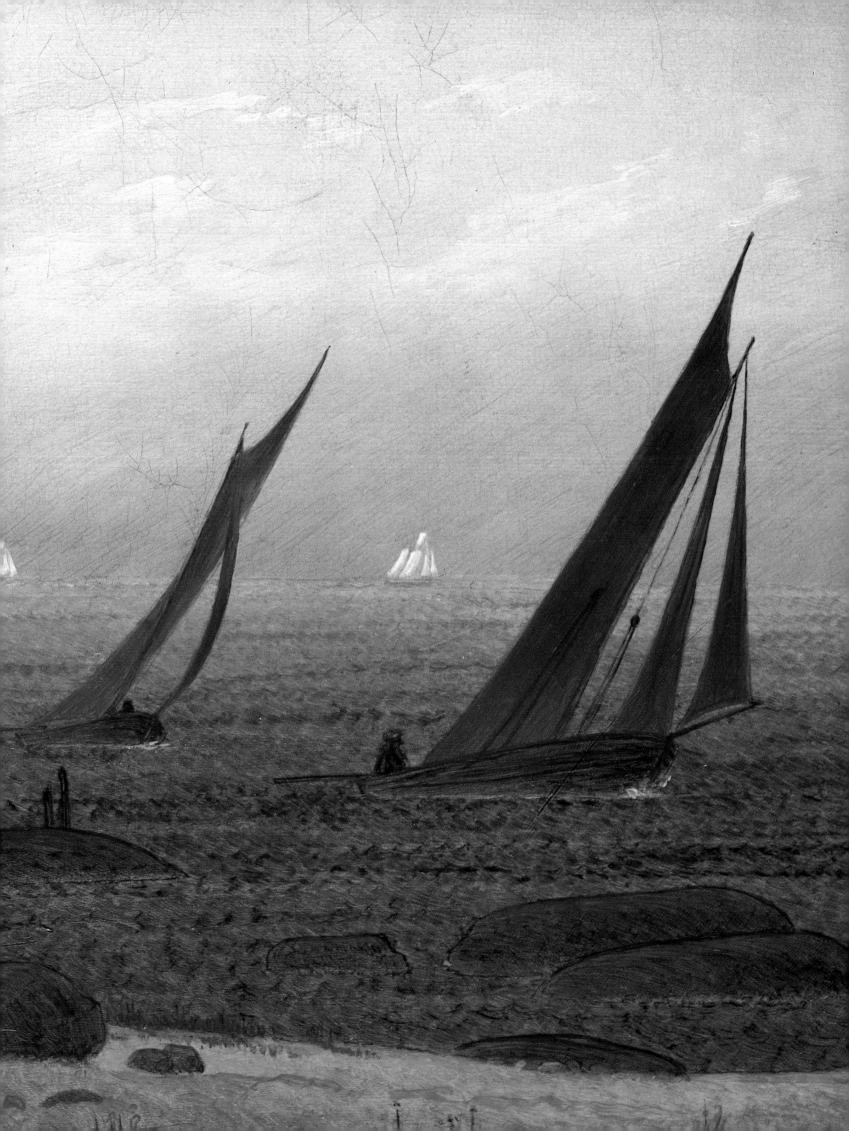

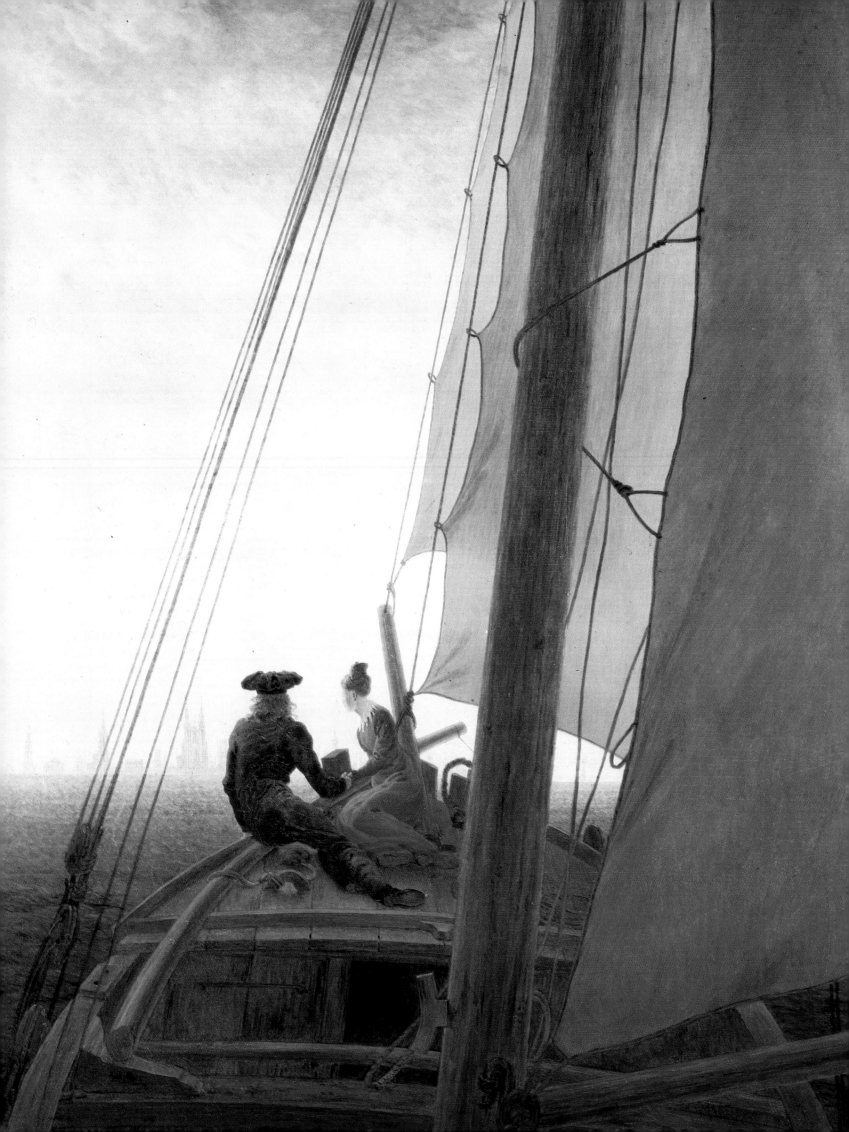

singular and luminous composition which he built up out of sketches he had made during his travels.

In this breezy idyll, poised on the prow of a sloop, we see two figures from the back: the painter and his young wife, dressed in the modern, form-revealing fashion of the day and affectionately holding his hand.

The sloop which carries them under full sail is heading toward a light-filled horizon, on which we can just make out the skyline of an imaginary city full of Gothic spires and bell-towers. Hovering fantastically above the water like a Celestial Jerusalem or a dream of serenity, it captivates the attention of the newlyweds. The theme is the sentimental journey across the waters of life, a symbol of the spiritual dimensions towards which all should strive. The Gothic city is protected by the diaphanous sky, which clothes the religious buildings and monumental cathedral in a veil of light.

The appearance of Caroline in the painter's work is a significant development, for now the wanderer is no longer alone: between him and the promising light there is a woman who can bring him comfort or act as an intermediary.

In formal terms, his colour-schemes become lighter, and his compositions seem to be less dominated by the intransigent rules of a strict symmetry and geometry. His work accordingly gains in diversity of composition and subject-matter. Alongside his classic subjects, we see the appearance of the theme of the owl, of strollers in the moonlight, the chalk cliffs of Rügen, as well as the polar scenes described at the beginning of this book.

Friedrich seems to have gone over to a more direct manner of dealing with the complexity of landscape. At any rate, he seems to be working ever more on a dual register; giving the spectator the choice between pure aesthetic contemplation and the suggestion of a hidden spirituality. He was nonetheless aware of the dangers inherent in his deliberately limited iconographic repertoire. In 1822, in a conversation with the writer de la Motte-Fouqué, the painter is reported to have asked: "Do you find me so monotonous, then?"–to which the author of *Undine* replied–in somewhat sybilline fashion–that his approach allowed him to handle a vast spectrum of meanings by continually using the same vocabulary of situations and motifs.

Friedrich's *On the Sailboat* inspired Carus for the subject of a later painting, *Rowing on the Elbe near Dresden* (1827), which is composed of two distinct registers differentiated by their construction and colour-scheme.

Above and pages 154-155 (detail)

CASPAR DAVID FRIEDRICH
Woman on the Beach at Rügen
1818, oil on canvas, 21.5 x 30 cm.
Winterthur, Museum Stiftung Oskar Reinhart.

Opposite

CASPAR DAVID FRIEDRICH
On the Sail-boat
1819, oil on canvas, 71 x 56 cm.
St. Petersburg, Hermitage Museum.

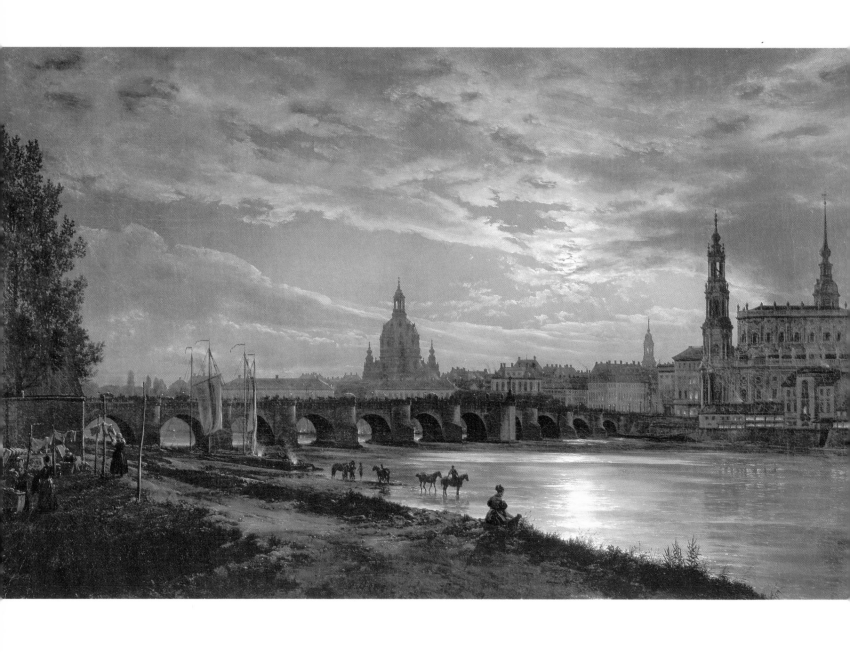

It is clear, however, that Carus was on a different tack than his friend and master, for there is no hint of a hidden meaning, nor of any kind of transcendence, whether apparent or only suggested. With its fashionably-dressed figures, the man straining at the oars and the woman absorbed in her contemplation of the scenery, this picture is oriented more towards everyday concerns, like the pleasures of pleasant company, than towards any metaphysical meditations. The purpose of the boat-ride is to admire the splendid sights of Dresden–the belfry of the Kreuzkirche, the dome of the Frauenkirche, the towers of the Hofkirche, or the arches of the Augustbröcke, all monuments built in the 18th century.

Another pupil of Friedrich, Christian Dahl, also depicted the port and monuments of Dresden in a composition titled *View of Dresden in the Moonlight* (1839) which is even more traditional than those of his master or of Carus, and quite foreign to the intentions of Romanticism. With its precise description and emphasis on the picturesque, it is definitely more in the *vedute* genre of Bellotto.

Around 1820, the female presence appeared in several of Friedrich's pictures, either alone, in a couple, or as a group of women. As we have seen, this woman was not necessarily the painter's wife, but rather his walking source of inspiration; the motivating element of the couple tending toward the contemplation of nature and its sublimity.

Few works, however, match the pictorial and affective intensity of the small painting representing a *Woman before the Setting Sun,* from 1818. In this highly original composition, the woman stands out as the central element around which the rest of the scene is organized. This time Friedrich did not eliminate the middle-ground, but adopted a classic construction with a succession of receding planes. The female figure is shown strictly from the back, dressed in elegant town-fashions, standing at the end of a path and in front of an agricultural landscape with rocks, fields, and a minuscule church on the left to lend a religious note to the scene. She is standing facing the sun, her arms slightly outspread, on the verge of another world, far from her everyday cares, like a figure in a dream or sudden vision. Her identity is not specified, but the importance of her function is made apparent by her size: inordinately large for a painter who usually represented only quite small figures.

Her gesture could have a double meaning: it is a gesture of opening, of offering the body almost sensually to the

JOHAN CHRISTIAN CLAUSEN DAHL
View of Dresden in the Moonlight
1839, oil on canvas, 78 x 130 cm. Dresden, Staatliche Kunstsammlungen Gemäldegalerie.

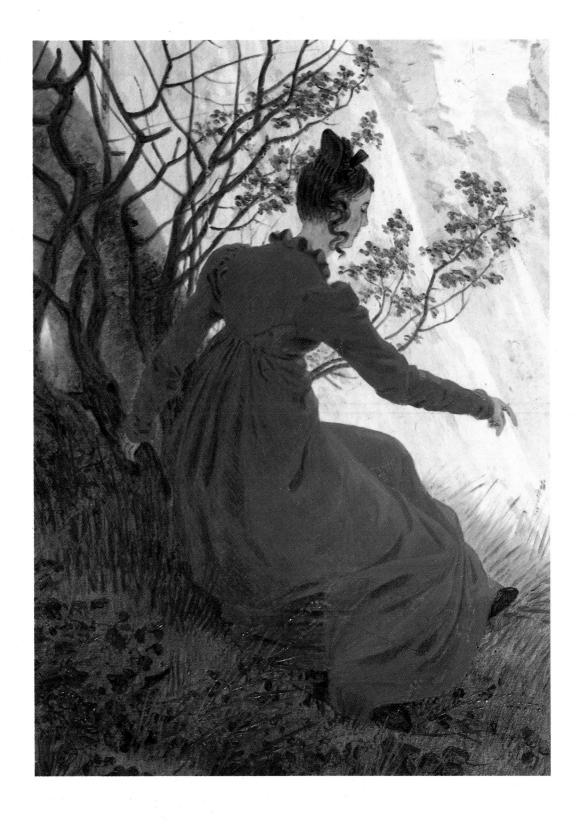

CASPAR DAVID FRIEDRICH
Chalk Cliffs of Rügen
1818, oil on canvas,
90 x 70 cm.
Winterthur, Museum
Stiftung Oskar Reinhart.

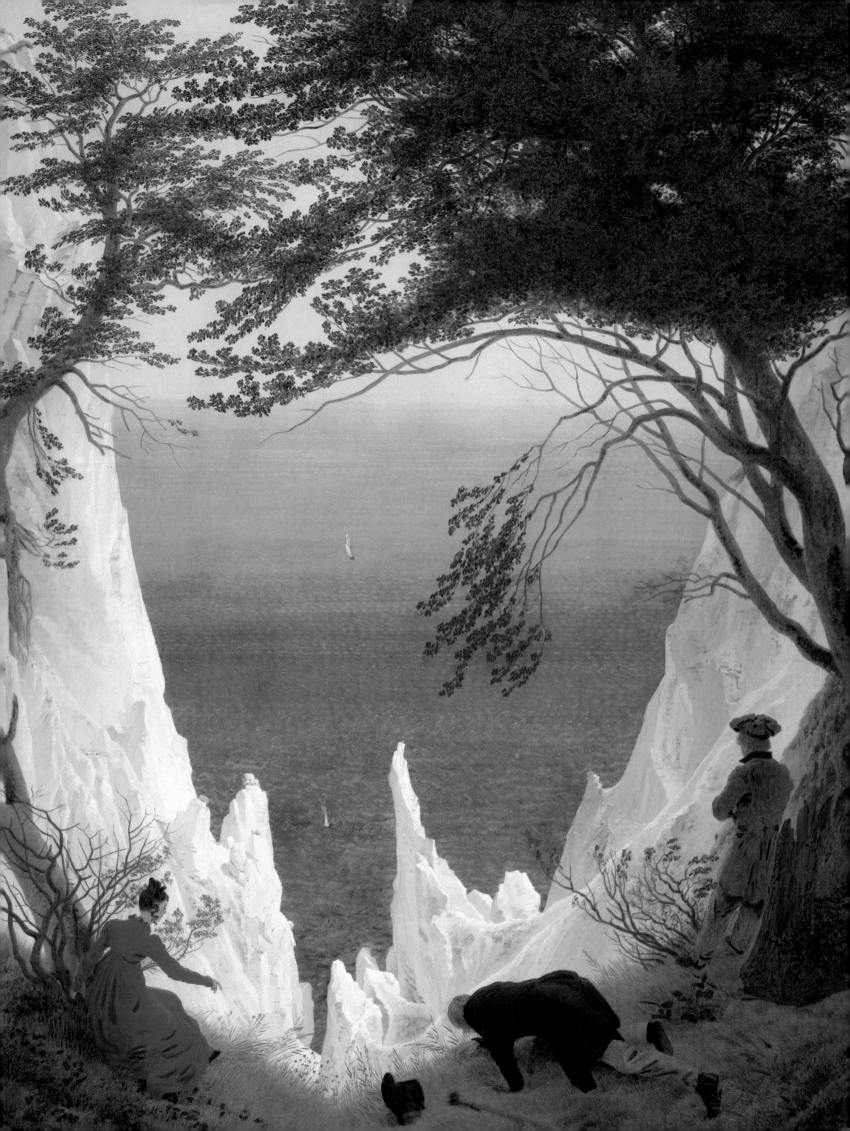

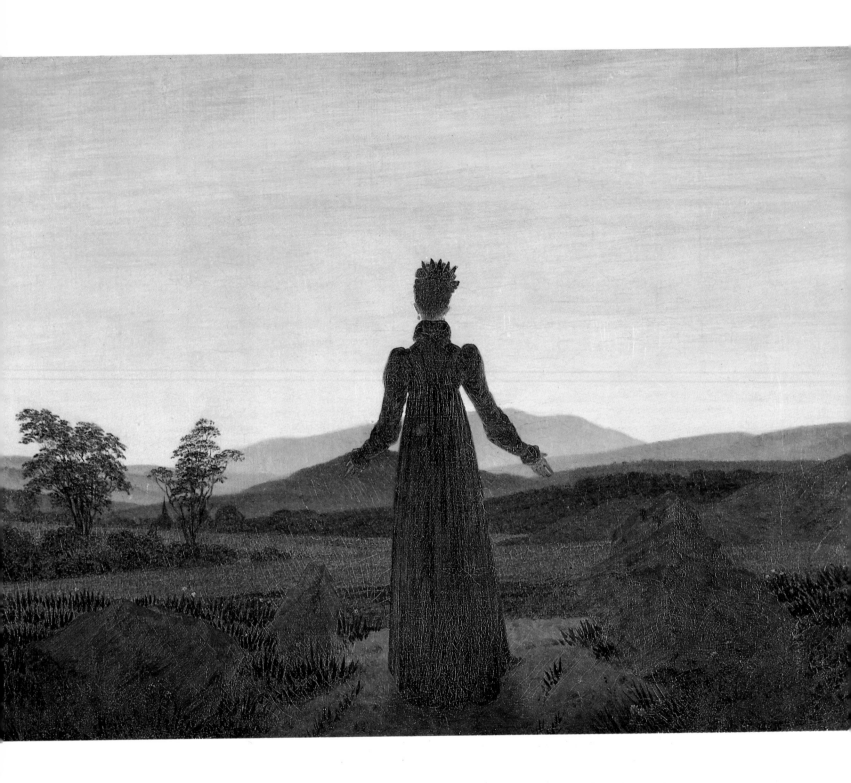

light; and it is also a reminiscence of the female praying figures of the Early Christian era.

The time of day is not easy to determine. It could be dawn or dusk. Be that as it may, everything suggests that this picture represents a spiritual landscape in which the woman indicates the way toward the light, the mountains, and God. The whole is bathed in a limpid, transparent light, in which there is no longer any obstacle, whether rocks, snow or fog, between humanity and the divine presence.

Other concerns seem to have been portrayed in a picture from the same year showing the *Chalk Cliffs on Rügen,* a very modern and bold composition which depicts the pleasures of contemplative excursions, and the city-dwellers' amazement at the blue vastness of the sea and the steepness of the white cliffs. Friedrich had long explored the island–since his youth–taking the time to experience the charms of life under Northern skies. He filled his sketchbooks with details that served for the elaboration of future works in the solitude of his studio, for he was convinced that only under these conditions could any spiritual fruit come into being.

The site chosen by the artist for this canvas was a ravine on the east end of the island, which is dominated by the famous chalk cliffs. The composition is structured in somewhat of a circular scheme, or rather an irregular oval framed below by the grassy ground and above by the branches of a tree. Through this opening the gaze plunges towards the open sea–punctuated only by two tiny white sails–which almost fills the pictorial space vertically in a succession of blues, yellows, greys and pinks, laid down on the canvas with an evident visual delight.

Caroline Bommer, fashionably dressed, as usual, is seated on the lefthand side: with one hand she wisely steadies herself by holding on to a small tree trunk, and with the other she points downward at some red flowers and the precipice beyond. Friedrich himself, having set his hat and walking-stick beside him on the grass, has crept up to the edge on all fours, irresistibly drawn to the sight of the chalky white rocks below. The other figure, standing on the right, has not been identified, seems to be in intense contemplation, his arms crossed and his feet poised on the edge of the cliff. This figure directs our gaze into the distance, toward the departing boats, which, in Friedrich's work, symbolize the voyage of the soul after death. This significant detail introduces an incongruous note in this idyllic scene, a hint of contradiction in an otherwise harmonious whole.

CASPAR DAVID FRIEDRICH
Woman Before the Setting Sun
1818, oil on canvas,
22 x 30 cm.
Essen, Museum Folkwang.

This picture, more than most of the others, was entirely in keeping with the pure Romantic esthetics as elaborated by great writers and philosophers like the Schlegel brothers, Schelling, Hölderlin, and especially Novalis. In his works, the latter advocated the cult of the ineffable fear that lies hidden beneath the surface appearance of things.

The reminder of death in the midst of happiness, the melancholic aftertaste of the discovery of nature, this was the principle of internal contradiction so often encountered in the writings of Friedrich von Hardenberg, better known as Novalis, and to which Friedrich gave a pictorial expression. Novalis wrote that in the union of contraries, in the reconciliation of their internal duality, resides the essence of what can be conceived of as the

most sublime. Accordingly, Friedrich created contrasting
intellectual and pictorial spaces, uniting contradictory emotions
through the internal dialectic of the landscape and its chromatic
transposition. This was a form of *concordia discors,* and it found a
perfect expression in the Romantic *Stimmung;* a state in which the
mind, functioning like a musical instrument, was in tune with the
vibrations of the world, even if they happened to clash–as they
sometimes do.

 The eye is seized by a sort of vertigo at the sight of
Chalk Cliffs on the Island of Rügen. Like the bold tourists skirting
the abyss in the picture, we experience a vital shock that induces
a state of contemplative transport, even if it is mixed with a
sudden, subtle hint of melancholy.

JOHAN CHRISTIAN CLAUSEN
DAHL
**View of Dresden in the
Moonlight**
(detail)
1839, oil on canvas,
78 x 130 cm.
Dresden, Staatliche
Kunstsammlungen
Gemäldegalerie.

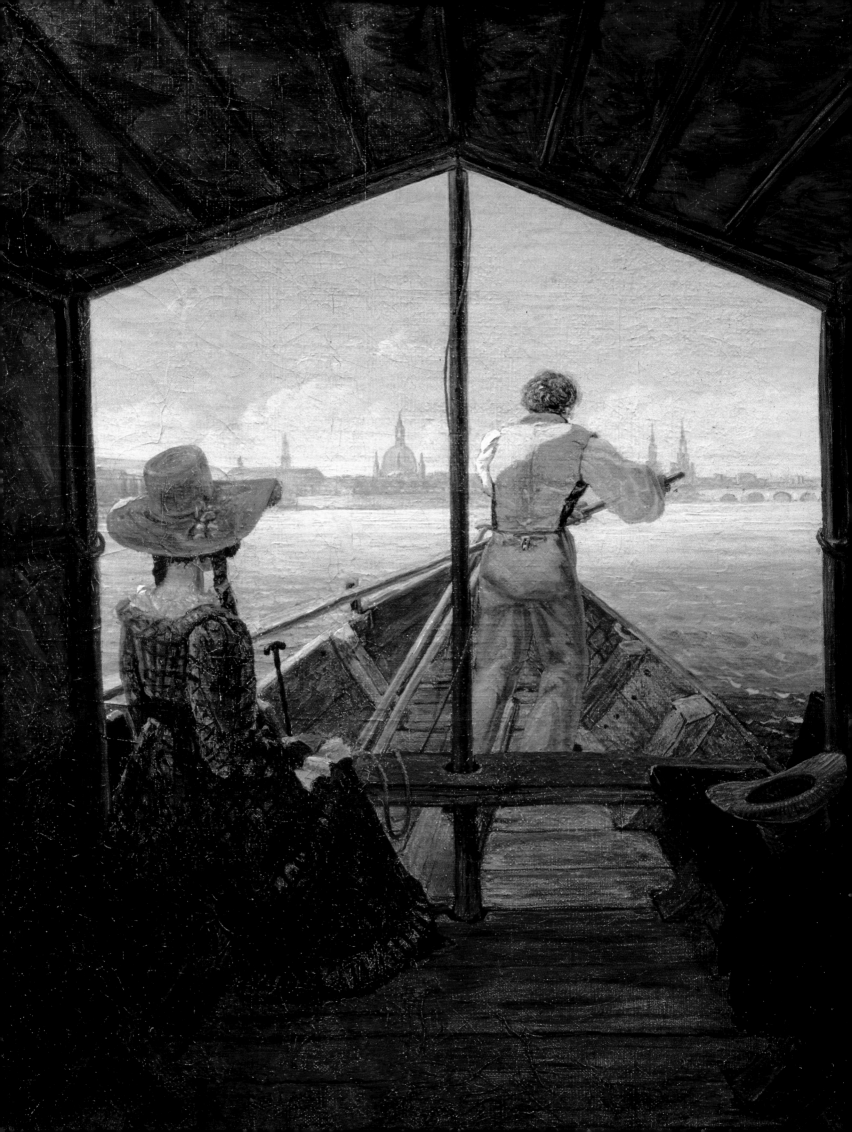

Although Friedrich's art calls upon spiritual, and often unconscious, resources it does not result from a purely visionary stance, no more than from an irrational practice of painting. To be sure, the painter found inspiration in Schelling's philosophy and strove to free his work from all binding rules, practices or traditional themes, in favour of a sort of internal "dictation" which was unquestionably profound, but certainly not out of his control. His very work methods; studies painstakingly set down from life and later used as raw material; his questioning of the natural motifs and sensitivity to their suggestions; the long periods of work, stretching out over weeks and months, if not years; seem to belie the all-too Romantic myth of momentary illumination, of sudden epiphany and action.

Friedrich noted in 1821 that some of his ideas came to him when he was in a semi-conscious state, between waking and sleep. Such affirmations, however, must be seen in light of the polemic context in which they were expressed. The artist was proclaiming an idealist stance as opposed to the naturalistic and realistic tendency that was beginning to take hold in Germany at the time. If anything, his paintings were the product of prolonged premeditation; a process involving making graphic studies in a variety of media, of selecting figurative elements, and of profound reflection. This enabled him to elaborate the subject primarily in his studio and in the interests of a maximum simplification of the subject. Moreover, his modifications of pictorial space were never extreme. He used spectacular natural phenomena like mist, fog, or twilight, and deployed them in a suggestive manner to inspire a diffuse, discreet and uncanny spirituality; yet never beyond the bounds of what could be experienced among men and their environment. His painting contains no prefabricated message, but creates instead an intellectual climate, so to speak, which gradually enables nature to be divinized and a mystic light to be cast on external particulars in a Pantheistic spirit, but without disturbing the coherence of perception.

CARL GUSTAV CARUS
**Boat Ride on the Elbe,
near Dresden**
1827, oil on canvas,
29 x 21.5 cm.
Düsseldorf, Kunstmuseum.

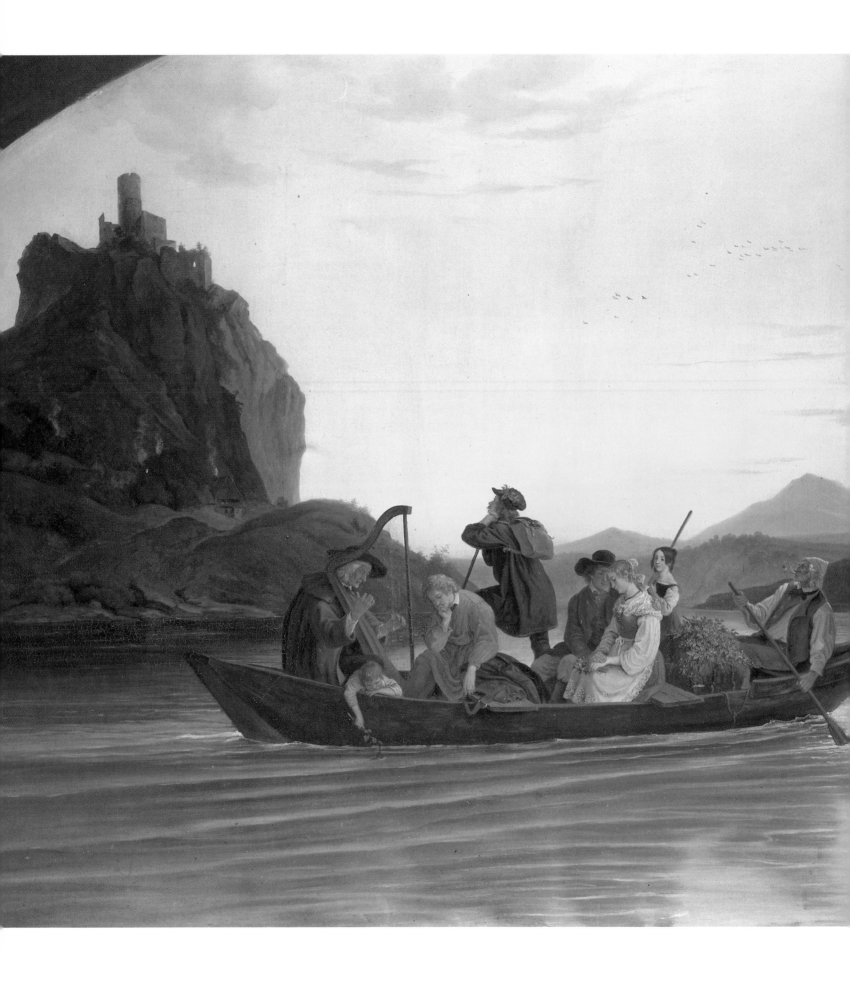

Certain orientations and working methods seem to have prevailed in the works of the period around 1820. As we have already noted, there was the elimination of the middle-ground to create the effect of a sudden emergence. Then, in some cases, there was the elimination of the foreground, a pictorial ploy that tended to destabilize the gaze, to create an uncertainty due to the absence of cues as to the point of view adopted in the composition.

Another technique was the "montage" and joining of natural elements which did not usually coexist in the same space and which created an effect of atmospheric paradox conducive to mystical experience. Last but not least, there was his tendency to use a peculiar perspective in which there was either an excess of definition in the background area, or sharp precision in the foreground accompanied by a pronounced dematerialization of objects in the distance.

Despite all his originality and strong personality, however, Friedrich did not stray far from the mainstream of the great Germanic tradition. He admired Albrecht Dürer's great precision in rendering natural details with a graphic technique that was both incisive and nervous. We could cite as examples any number of landscapes with majestic pines, misty mountains, water surfaces, gaping tree stumps, and rock formations on the brink of some metamorphosis. Altdorfer may have given him the example of the loss of self in a fearsome natural environment in works like his Munich *Saint George*. Elsheimer, with his complex and intense nocturnal effects, must also surely have appealed to him.

As it was, nighttime must have been one of Friedrich's favourite subjects, judging by how consistently he depicted it throughout his career. This particular theme inspired him to create a type of image for which he became famous and which shows figures contemplating the moon–a Romantic icon, if ever there was one.

LUDWIG RICHTER
Crossing the Elbe in front of the Schreckenstein
1837, oil on canvas,
116.5 x 156.3 cm.
Dresden, Staatliche
Kunstsammlungen
Gemäldegalerie.

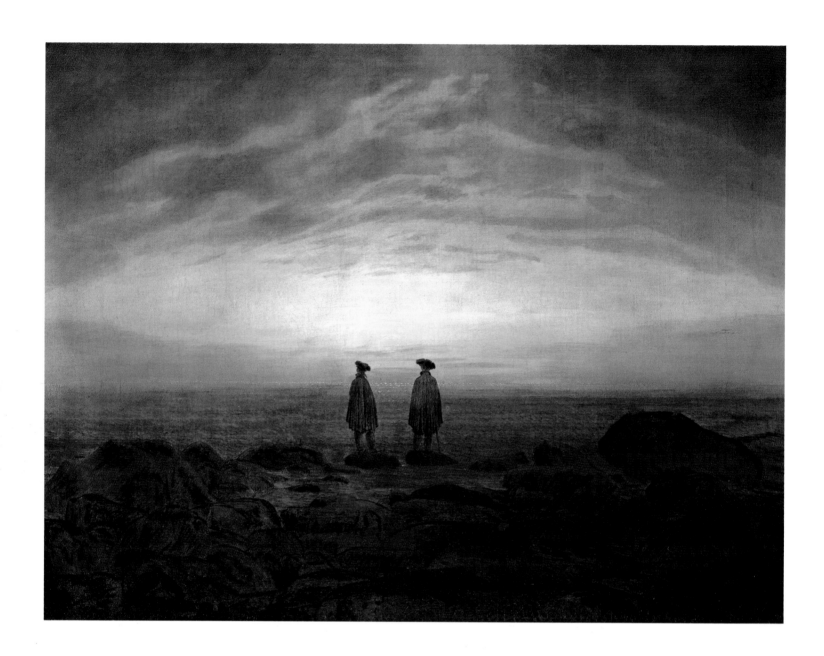

NOCTURAL SPACE
AND THE MELANCOLIC FAULT

The basic theme in this famous series of works is the relationship between a foreground which is firm, structured and inhabited by human figures, and the luminosity of the moon, which some authors interpret as a symbol of Christ, and others as a symptom of Romantic nostalgia. It should be remembered that there is a Christian iconographic tradition in which the Crucifixion is simultaneously flanked by representations of the sun and the moon. The moon can also symbolize biological rhythms, growth, death, and the transience of time.

Two Men by the Moonlit Sea (1817) is one of Friedrich's first and most interesting "sublunar" landscapes. In it, he depicted two figures seen from the back and dressed in the old German fashion; a costume which the artist began to use in 1815 for patriotic and nationalistic purposes. The two men contemplating the moon have stepped away from the shore to stand each on a rock. The moon is positioned exactly in the middle of the space above and between their heads.

As in Claude's nightscapes, the light of the moon is reflected on the waves, and so brought into the foreground. In this way, Friedrich establishes a path of light which bridges the space between the land and the sky, between the foreground and the immensity of the sea, which is filled from horizon to horizon by a dazzling luminous ellipse.

This arrangement also appears in *Harbour in the Moonlight* (1811) and in *Night* (1818), and was used by his pupil Carus in his *Night Scene on Rügen* (1820).

Friedrich once wrote: "The truly authentic work is conceived in a sacred hour, born in a blessèd hour." The hours of the night seem to have been a particularly fertile source of emotional experience for him. One might think that the forms seen in the dark by the painter would lose in precision, but the opposite is the case. Curiously enough, the nocturnal lighting brings out the contours, which are sharp and well-defined, if

CASPAR DAVID FRIEDRICH
Two Men at Twilight
1830-1835, oil on canvas,
25 x 31 cm.
St. Petersburg, Hermitage
Museum.

Opposite

CASPAR DAVID FRIEDRICH
Two Men on the Beach in Moonlight
1817, oil on canvas,
51 x 66 cm.
Berlin, Nationalgalerie.

Next pages

CASPAR DAVID FRIEDRICH
Seascape in the Moonlight
Around 1835, oil on canvas,
25 x 31 cm.
Leipzig, Museum der
Bildenden Künste.

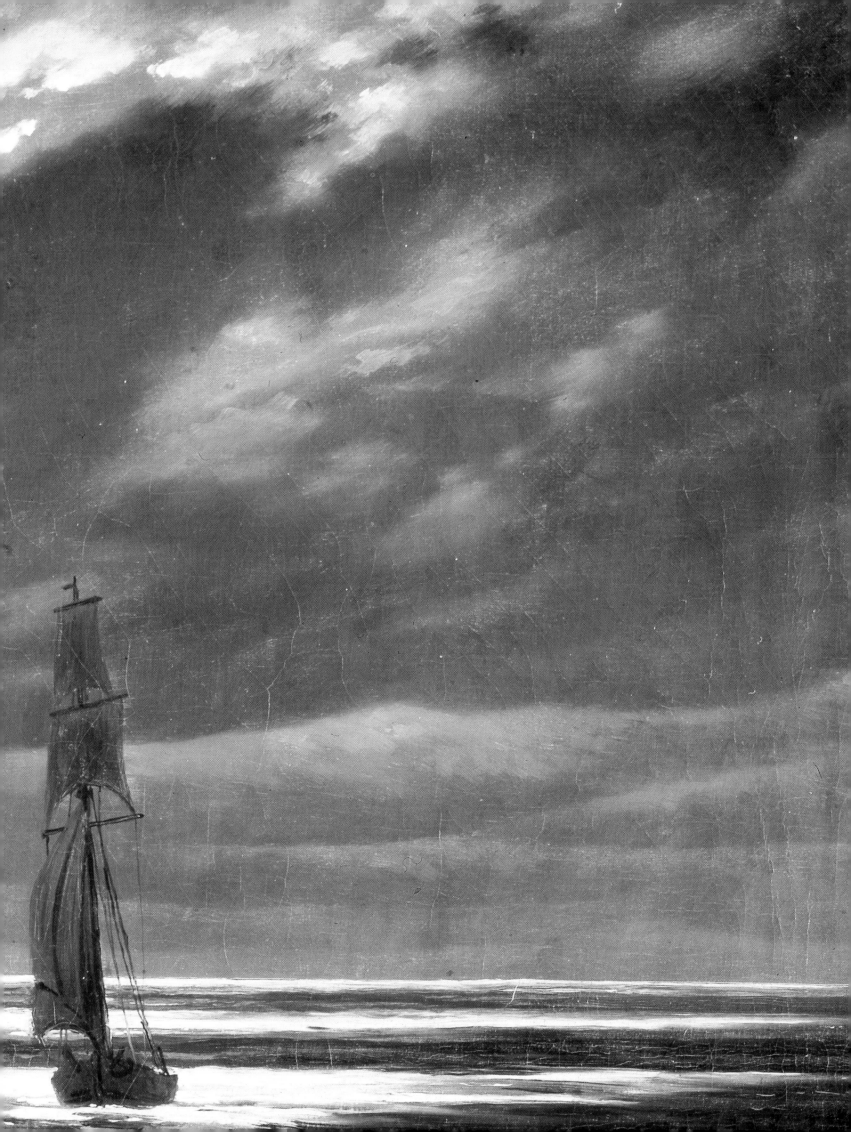

dark, causing the image to shift into a form of magic realism, a transporting crispness of detail which is the hallmark of Friedrich's œuvre.

We know that his habits led him to haunt the late hours of the day, twilight and night. He would take long walks at daybreak, but also at sundown, and even into the night. Alone, he strove to penetrate the suggestive surface appearance of things, scrutinize the hidden aspects of nature, pausing to contemplate a special rock on the shore, a blackened stump toppled by lightning, or an uprooted tree still green with leaves.

Moonlight in any case was a leitmotiv of the entire Romantic generation. For writers like Jean-Paul and Tieck it was an extraordinary and magical experience. The moon was a pervasive theme in poetry, music and philosophy. Von Schubert obstinately studied the "nocturnal aspects" of the natural sciences. Schelling declared that night was not the realm of pernicious forces, but a great source of energy in need of liberation. As for Novalis, he composed his eerie and otherworldly *Hymns to Night*. Decades later, in *Zarathustra's Nachtlied,* Nietszche described the night journey not as a mere eccentricity, but as an initiatory passage through the interior and to the centre of the world and of the self. All in all, what is confronted and conquered at night are the deeply submerged parts of the self.

The time of twilight so dear to Friedrich, a time which is neither of day nor of night, but a synthesis of two worlds, also fascinated the German Romantic poets and philosophers. It was a double-edged attraction, a combination of enchantment and fear, the call of unknown limits, of uncertainty, of the metamorphosis of appearances.

Friedrich's relationship to the moon was not devoid of ambiguity, however. It dazzled him on the one hand, but there was also something melancholic about its appeal. It drew him into depths of intense contemplation, as if he were searching for another dimension of being. He considered the moon to be an emanation of the World-Soul, a luminous bridge between heaven and earth, between the mortal world and the afterlife to which the souls of the dead repaired. Friedrich was far from being alone in his cult of the orb of the night; all the "pre-Romantics" in Europe had celebrated it before him. We need only mention the importance of the moon in the work of Füssli, certain paintings of François Gérard (*Ossian Summoning the Ghosts,* 1801), the Ossian pictures by Ingres, and of course the works of Goya.

Ossian, a nocturnal figure styled as the "Homer of the North," was in fact almost the pure invention of a Scottish schoolteacher, Macpherson, who served up some very ancient Gaelic poems under the name of this mythic bard in 1773. Napoleon was so taken by these poems that he took the book along with him on his military campaigns, along with Goethe's *The Sorrows of Young Werther*, a novel steeped in Ossianism. The Emperor even commissioned Ingres to paint *The Dream of Ossian* (1813-1815)on the ceiling of his bedchamber at the Quirinal Palace in Rome. This picture (originally of oval format, before it was cut down to a rectangle when the painter bought it back in 1815) shows the old bard asleep against his harp, surrounded by the souls of dead warriors "in their aery palaces." This nocturnal incursion into the realm of the imagination is unique in Ingres' production, and has all the melancholic and dreamlike qualities of a Romantic work. In Germany, Ossianic themes were representedby Castens in 1788, Koch in 1800, and Runge in 1804.

Evocative ruins and vestiges bathed in a silvery light, dramas and tragedies presided by the moon, fairies, elves, ghosts and phantoms, all these motifs belonged to a vast repertory in general use throughout Europe–especially in England and the North Countries–and of which Friedrich was certainly aware.

The theme of nocturnal contemplation, of the attempt to establish a connection between the terrestrial and the lunar realms, was treated with unusual pictorial force in Friedrich's *Two Men Contemplating the Moon* from 1819.

Two figures dressed in the old-fashioned costume watch the moon rising, spreading its light over the steeply sloping mountainside. The two men are probably Friedrich and August Heinrich, one of his pupils. The young man indeed seems to be leaning against the older man, who is himself leaning on his walking stick. The scene suggests a transmission of the contemplative ritual from generation to generation. The location has been identified as the cliffs of Rügen, but the presence of pine trees and rocks would indicate a mountainous area. The most reasonable guess would be somewhere in the Harz region, which Friedrich knew very well.

This remarkable composition presents the anticlimactic image of a journey through rough terrain to reach an ideal vantage point to observe the moon, to experience a special connection with an infinite and otherworldy cosmos which, alas,

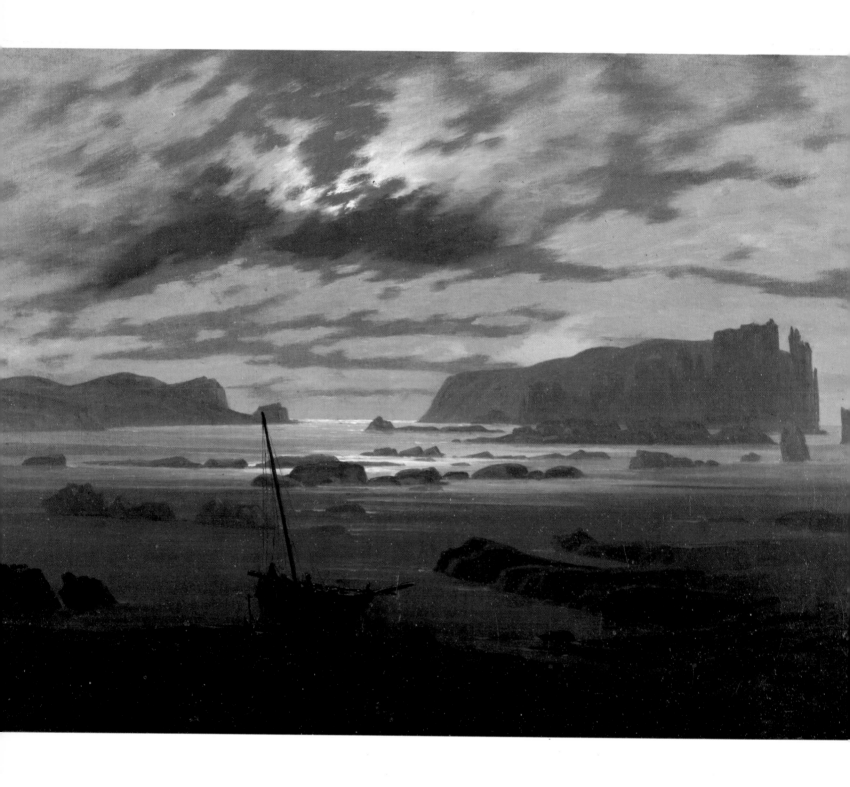

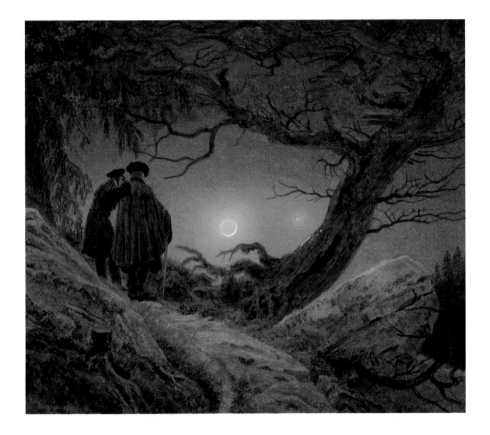

is not devoid of melancholy. For the two men, as for the spectator, the moon represents the inaccessible goal of Romantic nostalgia. This constant return of seduction and of melancholy gives the work not only a realistic character, but, even more, a metaphysical tension above and beyond any specific symbolic interpretation.

Many years later, Friedrich again took up the subject of nocturnal strollers contemplating the moon in a significant variation: *Man and Woman Contemplating the Moon* (1830-1835). The man and the woman are in the same plane and shown from the back, absorbed in their contemplation of the sickle moon filled out with earthlight. The woman–presumably Caroline Friedrich–leans on the shoulder of the painter in a gesture suggesting alternately a need for protection and for intimacy.

The serene and contemplative pose of the couple contrasts sharply with the contorsions of the half-uprooted oak tree, which is itself in opposition with the verticality of the lush pine tree on the left. This irregular and asymmetrical pictorial construction–one linked with the post-Baroque aesthetic of the previous century–was fairly rare in Friedrich's work, characterized rather by regular geometric arrangements.

CASPAR DAVID FRIEDRICH
Two Men Contemplating the Moon
1819, oil on canvas,
35 x 44 cm.
Dresden, Staatliche Kunstsammlungen Gemäldegalerie.

Opposite

CASPAR DAVID FRIEDRICH
The Baltic Sea in the Moonlight
1824, oil on canvas,
22 x 30.5 cm.
Prague, Narodni Galerie.

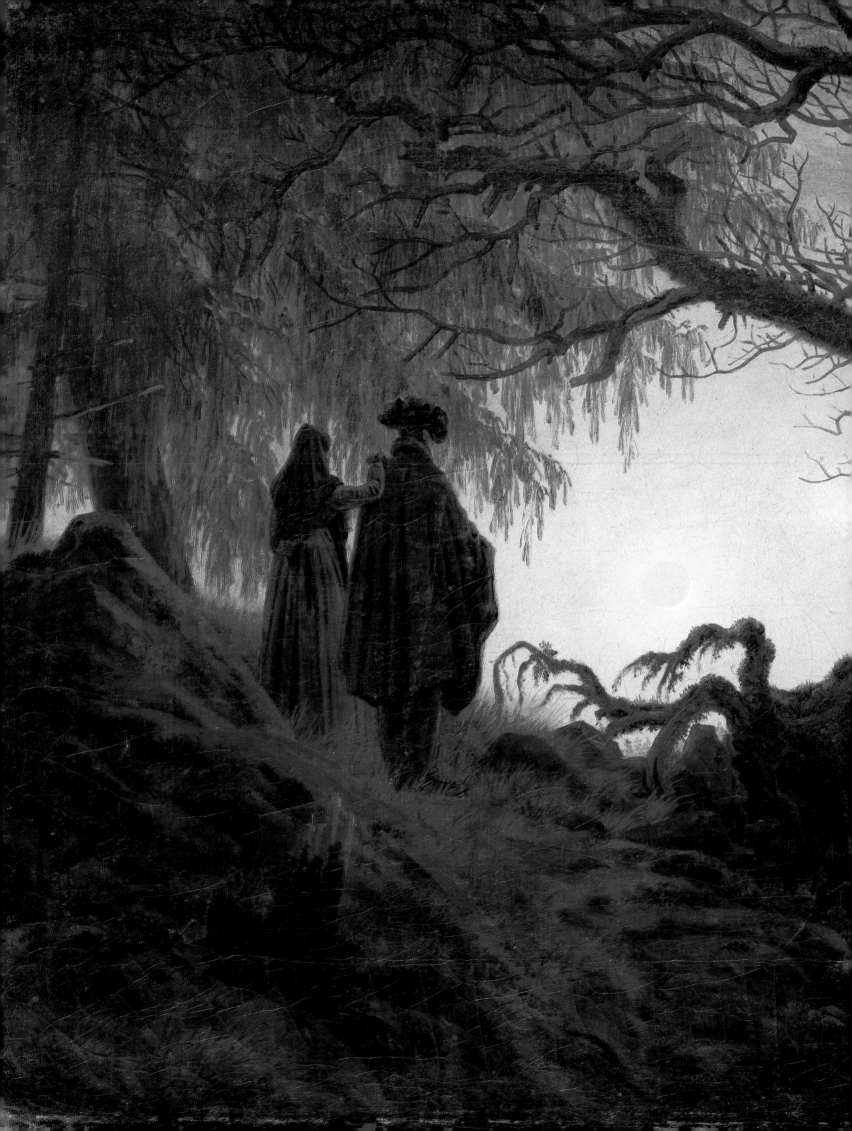

Caspar David Friedrich
**Man and Woman
Contemplating the Moon**
Around 1830-1835,
oil on canvas,
34 x 44 cm.
Berlin, Nationalgalerie.

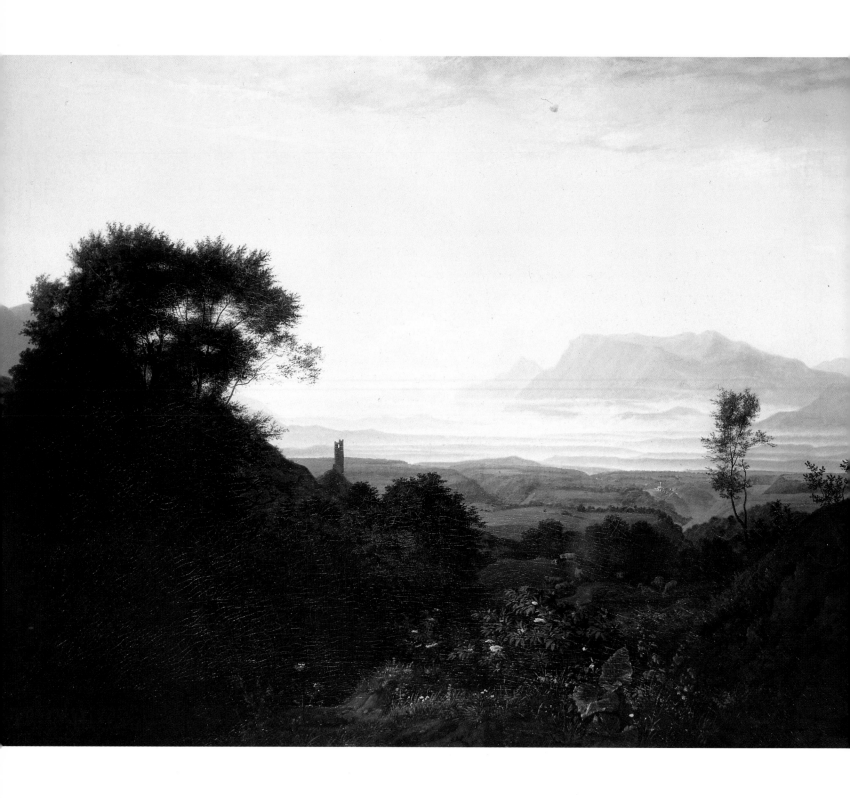

On April 19, 1820, Friedrich received the visit of Peter Cornelius and Friedrich Overbeck, two of the most important representatives of the Nazarene Movement, so-called because its adepts wore their long hair parted in the middle, *alla nazzareno.* At the beginning of the 19th century, a group of painters from the southern Germanic countries left the Vienna Academy for Rome to found the Brotherhood of St. Luke with the intent of revitalizing the German pictorial culture. This regeneration was to be effected on the basis of the Christian faith and according to the methods of the artists of the Middle Ages. Their choice of establishing themselves in the abandoned convent of Sant'Isidoro testified to their will to put their artistic theories directly into practice.

In 1820, Cornelius was appointed director of the Academy in Düsseldorf, and in 1822, Overbeck executed *Christ's Entry in Jerusalem,* one of his most important works. Friedrich's cordial reception notwithstanding, it is difficult to imagine a type of painting more different from his own as that of the Nazarenes. A decade later, he would note in his *Aphorisms* that, in seeking to resurrect the medieval forms of Italy, the Nazarene movement had set itself the wrong objectives and adopted the wrong methods.

Indeed, where the Nazarene movement advocated history painting on a large scale—and even a return to fresco—Friedrich sought to eliminate superfluous figuration and to reduce nature to elementary signs, in a sort of basic symbolic vocabulary. The Nazarenes filled their compositions with references to the past, highlighting the traditional subject-matter and staging the historical action with large figures replete with the necessary accessories, relegating landscape to a secondary role.

The only Nazarene painter to have had any affinity with Friedrich's ideas was Josef Anton Koch, who achieved in his works an expressive vision of nature in keeping with a certain heroic romanticism reminiscent of Poussin and Rubens. Ludwig Richter, on the other hand, seems to have come closer to Friedrich's manner in a work like *Morning in Palestrina, in the Appenines* (1829), but it must be said that his landscape displays neither the spiritual density, nor the symbolic scope of the Dresden master's compositions.

CASPAR DAVID FRIEDRICH
Memory of the Riesengebirge
1820, oil on canvas,
54.9 x 70.3 cm.
Munich, Neue Pinakothek.

Opposite

LUDWIG RICHTER
Morning in Palestrina
1829, oil on canvas,
77.5 x 100 cm.
Dresden, Staatliche Kunstsamlungen Gemäldegalerie.

CASPAR DAVID FRIEDRICH
The Watzmann
1825, oil on canvas,
133 x 170 cm.
Berlin, Nationalgalerie.

LAST EFFORTS

THE INFINITE BEYOND THE IMAGE

In 1823, Friedrich's life seems momentarily to have been lightened through the birth of a second daughter, Agnes. Then, on September 20, his pupil and friend, Christian Dahl moved into the painter's household at "32 an der Elbe", bringing him considerable moral and artistic support. The critics of the day considered Friedrich and Dahl as the most outstanding representatives of the Dresden School. At the same time, in the course of the last few years, the attention of the critics had turned elsewhere, especially toward the Düsseldorf School. On January 19, 1824, Friedrich, already a member of the Dresden Academy since 1816, was appointed to a professorship without the obligation to teach. As usual, he continued not to sign or date his works, making the work of his future biographers and historians that much more difficult. This attitude was not due to any negligence, but rather to a deliberate modesty; the painter wanted to forego his identity for the sake of an anonymity that would let his spiritual landscape speak for themselves, like the painters of icons or the masters of the Western Medieval tradition.

This academic appointment changed little in Friedrich's life; he continued working in the tranquillity of his studio, which commanded a splendid view of the Elbe and its plains. His character, however, already strongly given to meditation, began to darken, and his melancholy–that saturnian trait so common to artists–grew daily more pronounced and worrisome. In 1824, he lapsed into a severe bout of illness following a period of excessive work. Between 1824 and 1826, he restricted himself essentially to painting in watercolour.

After 1826, he resumed his oil painting with a vengeance, but his illness had had a lasting effect on his moods and his perception of the world. His character, already peculiar enough, further congealed; he withdrew into an unwholesome isolation and became prey to fixations that left him little peace. Even his friend Carus, who was a physician, could no longer reach him in the depths of his mental journey toward the shadowy parts of his personality. His family life was also adversely affected, and his fits of jealousy poisoned his relationship with his wife. Strangely enough, the works painted in the years immediately preceding this period contained no signs of the tragedy to come. Far from it. A painting like *Meadows near Greifswald* from 1822 seems to introduce a new, completely positive dimension, presenting the viewer with a meticulously rendered and surprising landscape.

CORNELIUS OVERBECK
Germania and Italia
1811-1828, oil on canvas,
94.4 x 104.7 cm.
Munich, Neue Pinakothek.

Opposite

JOHAN CHRISTIAN CLAUSEN DAHL
Window with a View of Pillnitz Castle
1823, oil on canvas,
Essen, Museum Folkwang.

Overleaf

CASPAR DAVID FRIEDRICH
Meadows near Greifswald
1821, oil on canvas,
35 x 48.9 cm.
Hamburg, Kunsthalle.

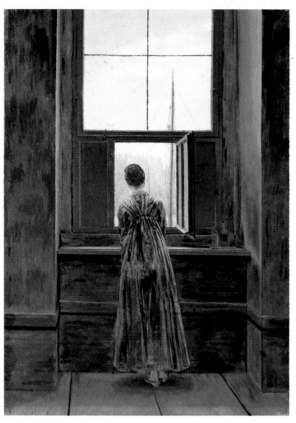

CASPAR DAVID FRIEDRICH
Woman at the Window
1822, oil on canvas,
44 x 37 cm.
Berlin, Nationalgalerie.

Opposite

GEORG FRIEDRICH KERSTING
Woman before a Mirror
1827, oil on canvas,
46 x 35 cm.
Kiel, Kunsthalle.

The viewpoint from which the painter chose to depict his subject was to the west of the town; the green fields extend to the line of horizon, above which rise the silhouettes of the windmills and churches. Two ponds are visible: one in the middle distance, and the other at the foot of the churches of St. Jacob and St. Nicholas. The topographical features have been depicted with such precision that it would be tempting to compare this work with the *vedute* of Canaletto or Bellotto, or of their contemporary German equivalents, Karl Blechen and Edward Gaertner.

One could interpret the passage from the shaded foreground to the light-filled prairie as a symbol of the journey towards an ideal city, which, in this case, happened to be the painter's beloved birthplace.

Because of its broad expanse, the landscape in this composition has a positive function; it is ideal in spite of the realism, an image of Arcadian peace (the prancing foals) tending toward a spiritual serenity (the diaphanous architecture). The contemplation of this picture induces a tranquillity which transmutes this ordinary view of a town into a vision of the Celestial Jerusalem.

An ideal Jerusalem, yet still depicted in purely material terms, shrouded in a palpable veil of luminosity for the greater retinal delight of the spectator. Perhaps also a composite of the painter's childhood memories, developed by meditation, experience and pictorial practice. A dream translated into pictorial signs, or a realistic vision which gradually shifts into irreality by dint of luminous clarity.

Light, Friedrich's main vehicle for spirituality, suffuses the atmosphere, clarifying it to the point of unknowing. Nearly one half of the pictorial space is taken up by a seamless, crystalline sky. The eye is therefore drawn to the cityscape below, which becomes at once a frame of reference and the threshold of a transformation. This is where Friedrich sets the boundary of the unbounded, the infinity hidden in the grain of sand, the mystical dimension of everyday life.

The iconography of the window as an independent subject dates from the 19th century, even though its development may be followed through Flemish and Tuscan painting from as early as the 15th century (among others: Van Eyck, Mantegna, Dürer).

Friedrich had already shown his interest in this particular motif in 1805 in the views he drew respectively from the left and right windows of his studio overlooking the Elbe.

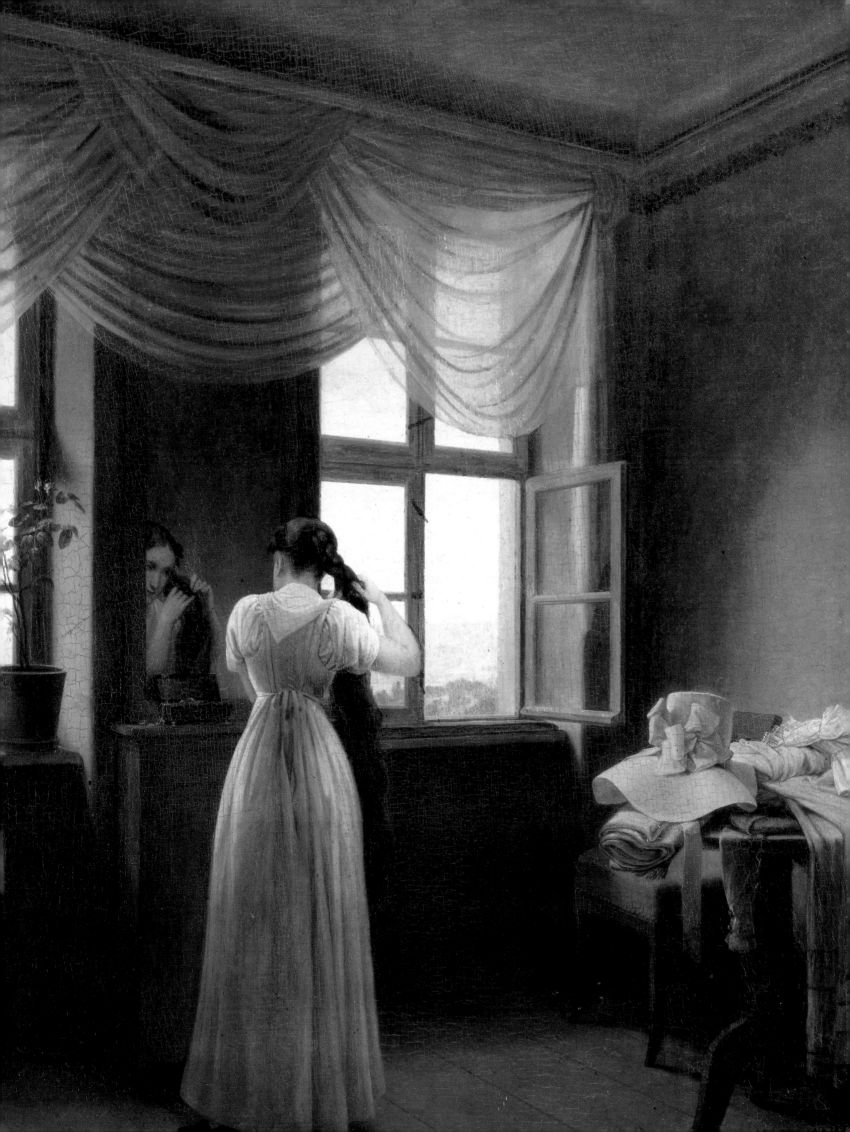

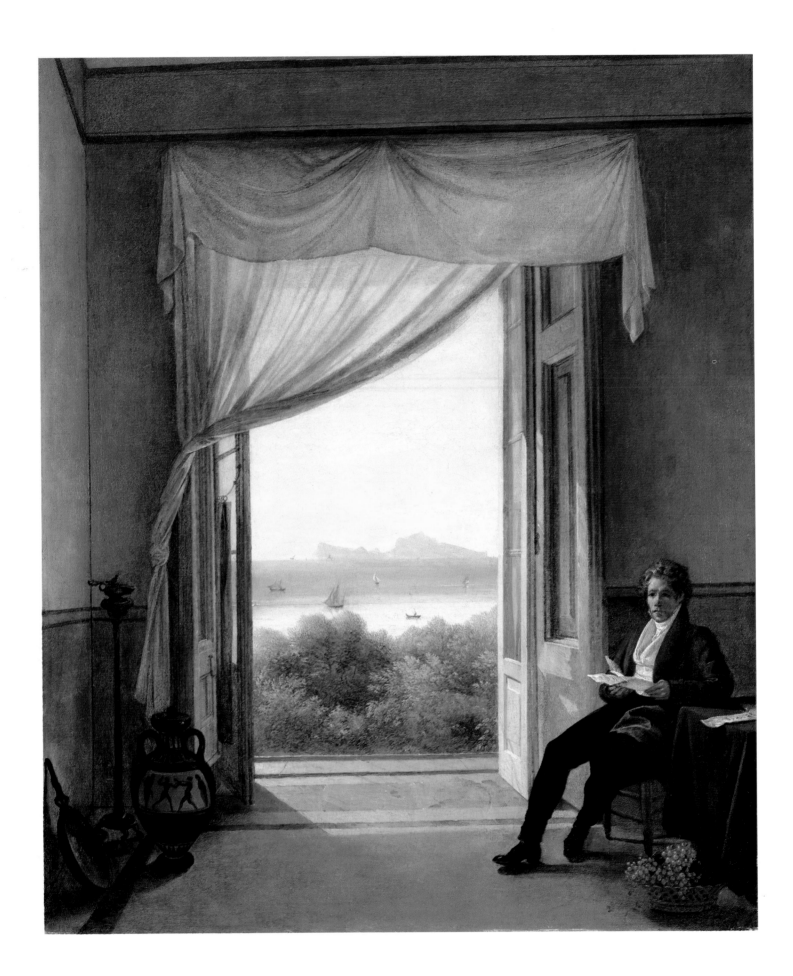

In 1822, the painter turned to this motif again in *Woman at the Window*, a picture destined to become the archetype of Romantic representations of this subject. The floorboards create a perspective effect that ends at the figure of the woman–Caroline Friedrich–seen from the back. On the window ledge stand two flasks and a stick (brush?). The window itself is divided into two halves: a lower half occupied by the head and shoulders of Caroline Friedrich, and an upper half consisting of window panes looking out on to a clear sky and joined by an intersecting frame that evidently suggests a Christian cross. The room shown is the studio which Friedrich had been using since 1820, and, in accordance with the painter's wishes, it is bare of the usual paraphernalia that crowded artists' studios.

In this composition, Friedrich created an impressive encounter between the interior and the exterior; the window stands out in backlighting against a dematerialized space punctuated only by boat masts and a row of poplars.

The woman stands motionless, leaning against the window ledge, an ideal intermediary between the dark recesses of the inner world and the tonic vision of light and nature outside. It is clearly more than just an image of physical fact, but a spiritual vision. She is contemplating this splendid view with intense concentration, doubling the gaze of the painter behind her, who is himself doubled by the spectator. It is difficult not to project oneself mentally towards the view beyond the window, even if the gaze is insistently drawn back to the sombre and sober confines of the interior.

The view of the landscape beyond the window is evidently not just intended for aesthetic delectation: it opens out on to a spiritual dimension. The poplars on the opposite bank are not just anecdotal details, but surely refer to their ancient symbolism associated with the underworld, suffering and sacrifice. They are a symbol of the regressive forces in nature, reminders of time past. The masts of the boats, one near and one far, seem to indicate the passage from one bank to another, as in the passage from life to death. Be that as it may, the composition as a whole gives an impression of warmth and life; it is almost picturesque. It is ultimately linked to the tradition of Dutch genre painting of the 17th century, reminding us of the peaceful interiors of Vermeer, with figures of women pensively staring out of a window (*Woman with a Pitcher*, around 1660).

CASPAR DAVID FRIEDRICH
Hills and Ploughed Fields near Dresden
1824, oil on canvas,
22.2 x 30.5 cm.
Hamburg, Kunsthalle.

Opposite

FRANZ LUDWIG CATEL
Portrait of Schinkel in Naples
1824, oil on canvas,
62 x 49 cm.
Berlin, Nationalgalerie.

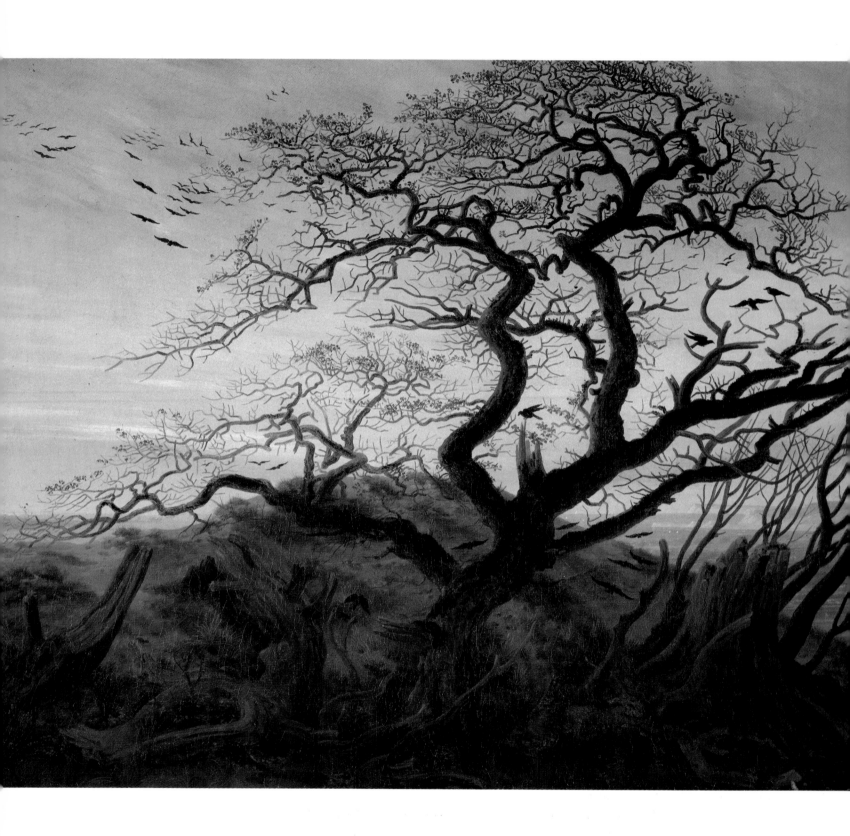

Curiously enough, Salvador Dali happened to paint a *Young Girl at a Window* (1925) which–purely by chance?–bears a striking resemblance to Friedrich's composition.

Closer in time to our painter, Christian Dahl, his pupil and friend, executed a *Window with a View of Pillnitz Castle, on the Elbe* (1823), but in a much larger format than Friedrich's picture. This is a typical *Fensterbild,* or window picture, but it concentrates more on the relationship between two terms: the darkness of the interior and the exceptional clarity of the landscape visible outside.

The recessed window takes up almost the entire breadth of the composition, and the absence of a floor or figure brings the eye–which is level with the midpoint of the lower panes–that much closer to the opening. In this way, we are visually forced to look beyond the window, which acts as a kind of frame, and to focus on the landscape as if it were an independent scene.

The winding road outside therefore leads the eye gradually and gracefully to the river and to the summer palace of Frederick-Augustus of Saxony, beyond which rise the hills of Swiss Saxony. The landscape is aglow with a late afternoon light, reinforcing the effect of a picture-within-a-picture. This coloured light is repeated in a more subdued range as a reflection on the open windowpanes, which, thanks to this device, act as a perfect interface between the two worlds. Unlike Friedrich, Dahl depicts all sorts of anecdotal details, making the composition more lively and realistic.

At the other extreme from both Friedrich and Dahl, another German painter, Franz Ludwig Catel painted a similar scene in a composition portraying *Schinkel in Naples*. The subject stated in very general terms is similar to Friedrich's: a room with a French-window overlooking a light-filled view of the Bay of Naples with boats and the Isle of Capri on the horizon. Indoors, on the left, tulle curtains grace the wide-open window, while on the right, formally posed with sheets of paper in his hand, sits the painter and architect Karl Friedrich Schinkel, a professor at the Berlin Academy.

Schinkel, a painter of gigantic panoramas and dioramas, and a great admirer of Friedrich's work, is surrounded by a variety of attributes: a basket of grapes, symbol of the abundance of nature outside, counterbalanced on the left by a Greek amphora, a bronze offering-cup and a lamp on a tripod; allusions to the painter's own antiquarian tastes and to the sitter's cultural pursuits.

Despite the intense Romantic atmosphere created by the relationship between the figure and the space, and despite Schinkel's absorbed, meditative gaze as he faces the painter, Catel's composition cannot be said to belong to the same line of inspiration as Friedrich's *Woman at a Window.* The view shown outside the window records and exalts a specific Italian landscape, and the motifs inside commemorate the classical sources so important to the painter and his sitter.

Friedrich, faithful to the Nordic spirit, abandoned all reference to the Neoclassical or even to the anecdotal, going beyond the purely descriptive dimension to create a passage between the inner and the outer, between the things of the world and a luminous revelation.

THE LIMITLESS POWER OF LANDSCAPE

If the *Sea of Ice* from 1824 was the cold and geometric, if not monumental, metaphor of death, a sort of terminal phase of the *navigatio vitae, the Tree with Crows* from 1822 may be called the sinuously dynamic and curiously "alive" version of this dark metaphor. This lone tree, spreading its complex and insinuating tendrils in all directions, stands as a reminder of death.

The central motif is a gnarled old oak tree with many dead or broken branches dominating the pictorial space and silhouetted against an intensely luminous sunset. The sky itself seems to be locked in the twisting, biomorphic net of branches. In the background, on the right, is a realistic notation: the cliffs of Arkona on the island of Rügen, so dear to the painter. An inscription on the back of the canvas points out that the hillock on which the tree stands could be a prehistoric tumulus, or *Hünengrab,* a so-called Hun grave mound.

The leafless tree is the main subject of the composition, which it both structures and charges with its graphic energy. It

may be interpreted as a classic Christian symbol, but turned in a negative sense. In the Epistle of Judas (5:12), those who are guilty of sin are likened to "trees in the late season, bare of fruit, twice dead and uprooted." Christ also once used the simile of a sterile fig tree (Luke 13:6). These traditional references aside, it is clear that Friedrich conceived this oak as a sinister and negative image, an impression which can only be reinforced by the presence of crows, considered everywhere as birds of ill-omen.

The image of a tree with crows reappeared two years later in *Hills and Ploughed Fields near Dresden* (1824), which features an opposition between a dark foreground and a luminous background punctuated by the hazy silhouettes of buildings. Once again, we see expressed the theme of the Romantic duality between light and dark: here between the darkness of the earth and a luminous architecture, between the simple earthly life and a metaphysical yearning for hope.

In 1890, Vincent van Gogh painted his famous and poignant *Wheatfield with Crows,* an intense and disquieting work which seems to have been his last desperate attempt to ward off his death: only hours later he committed suicide.

When Friedrich painted *The Great Enclosure* in 1832, his life continued to follow the usual routine of work, proceeding according to established rituals, but the progress of his illness continued to feed his penchant for melancholy. Only his intense study and contemplation of the Elbe landscape brought him a momentary respite from his existential anguish.

Interest in his work had gradually waned over the years, and only his most faithful followers brought him the assurance of their respect and affection. Yet even these marks of support did not seem to dispel the obscure depression into which he had fallen. In 1830, he wrote a series of *Aphorisms* in which he expressed his pessimistic view of the role of art in German society, but also formulated important comments on his own work. Carus remained at his side during this period of ever greater solitude, but whatever it was that had broken inside him refused to heal.

The Great Enclosure, however, betrays nothing of the painter's troubled inner life, nor does it indicate the degeneration that would steadily rob the artist of his visionary faculties and of his technical ability. Rather, this serene composition opens out on to a vast and majestic prospect, like the passage from a sonata to a grand natural symphony. The canvas depicts a section of the

great reserve of Ostra on the south bank of the Elbe, near Dresden, an area which the Romantic painters, and particularly Oehme, were fond of representing at the time. The river at this point is just a shallow watercourse meandering among scattered rivulets–almost the image of a peaceful, long-drawn-out death. On the left, in the middle distance, a line of trees suddenly stops, to be engulfed by the vast plain: the end of the mortal journey. The boat moving from left to right on the vanishing river even seems to be in danger of being grounded on a sand bank. As usual with Friedrich, behind the seamless realism of the external motifs lies an allegorical dimension, a more or less subtle allusion to his melancholic state. But all symbols aside, there is an evident sensual delight in his exercise in realism, in the chromatic play of contrasts between land, sky and water, and in the pellucid atmosphere of this autumn evening. The picture stands on its own in purely pictorial terms as well.

In a letter to a friend, Friedrich wrote: "I must be alone, and I must know that I am alone in order to see and hear nature fully. I must be in a state of osmosis with my environment. I must become of the same material as the clouds and mountains of my land in order to be who I am."

Yet, around 1835, this pantheistic attitude began to break down, and his communion with nature became ever more tenuous under the repeated blows of fatigue and illness. His faculties suffered a decline, like the intensity of light after sunset, a fading warmth, withdrawing behind the opaque mask of his personality.

On November 7, 1834, he was visited by the sculptor David d'Angers in his studio overlooking the Elbe. It was on this occasion that the notion that Friedrich was introducing "the tragedy of landscape" into painting was coined; a rather limiting definition, but one which gained a wide currency. The French sculptor carved for posterity a medallion portrait of Friedrich which shows a man with a very willful, almost classical profile, and very definitely idealized.

A portrait painted by Caroline Bardua in 1839 shows us a likeness of the artist that was closer to the physical and moral facts. Friedrich's gaze is obstinately vacant, his eyes seem to be scrutinizing some far-off place, which may be a sereneplace, but an ever-receding one, far beyond the plains of the Elbe. The artist seems to have come to the end of his mortal journey, he is only a shadow–however respected–of his former self. He had never quite recovered from his stroke in 1835.

BRUEGEL PIETER LE VIEUX
Hunters in the Snow
1565, oil on canvas,
117 x 162 cm.
Vienna, Kunsthistorisches Museum.

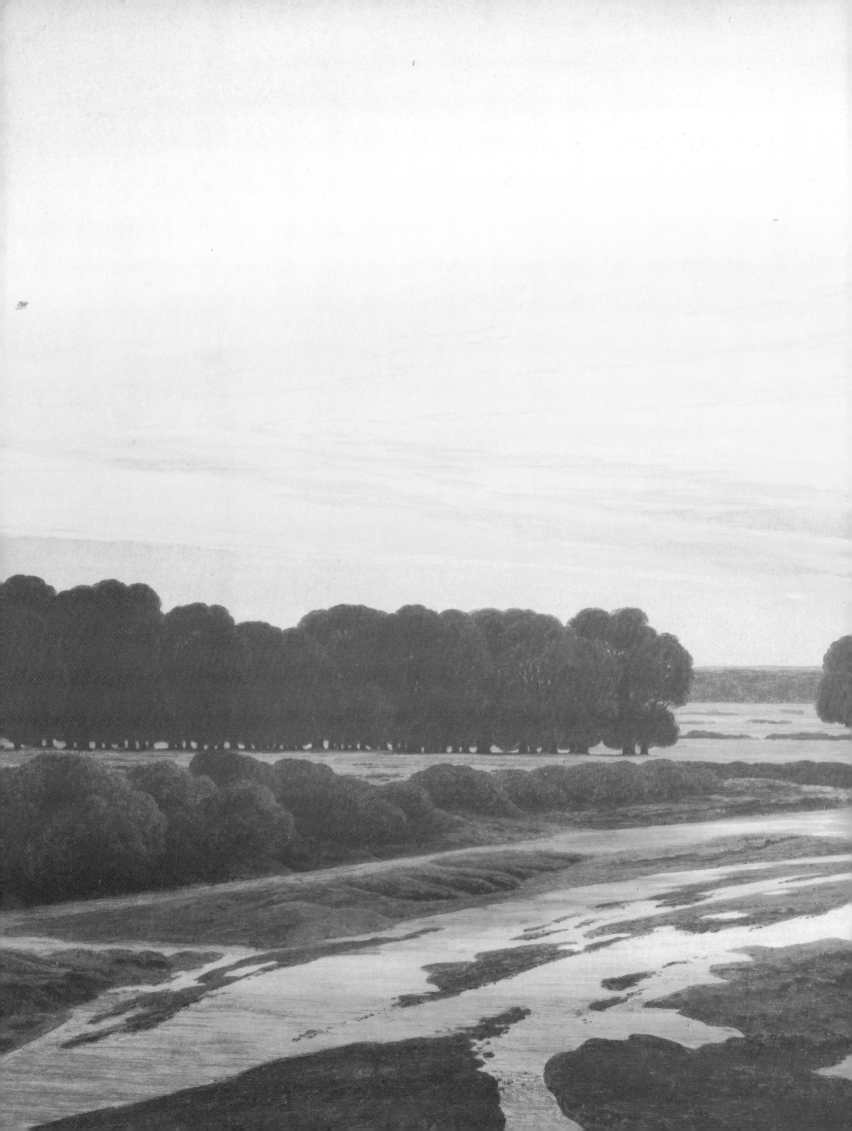

CONCLUSION

THE STAGES OF LIFE

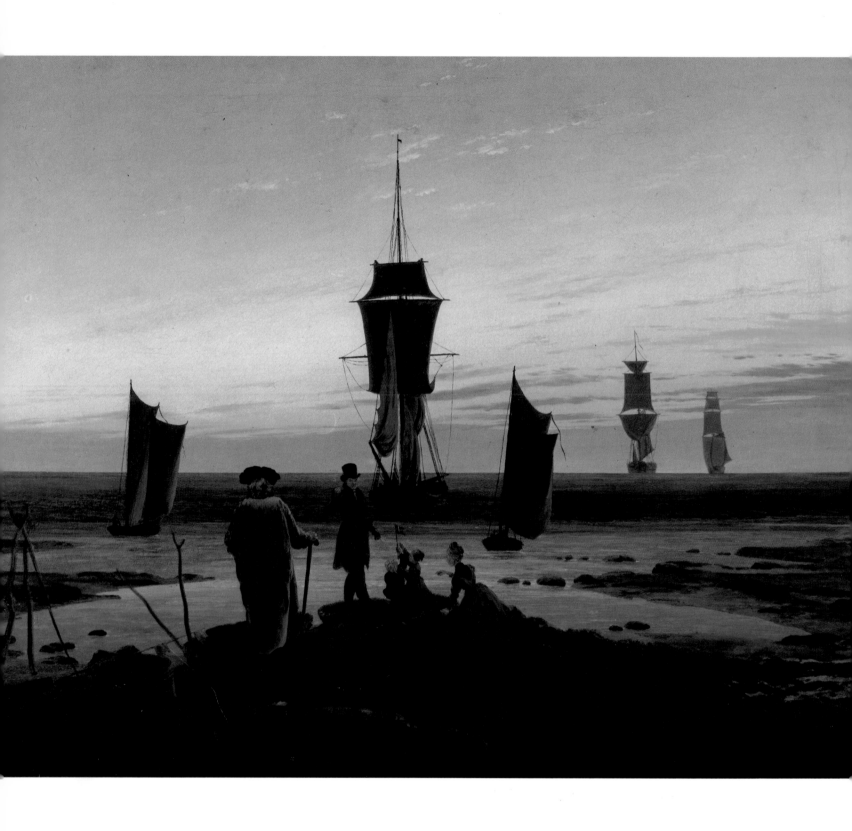

The years preceding 1835 were still rich in highly mature compositions, several of which remain as outstanding examples of his late work. A picture like *The Stages of Life,* done around 1835, testifies to the ambitions and concerns that still governed Friedrich.

We have become accustomed, in Friedrich's paintings, to see his figures with their backs turned, both in outdoor or indoor settings. These figures are often anonymous, watching a moonrise over the Baltic Sea, reaching the top of a mountain in the Harz, seemingly lost at the edge of a forest, or silhouetted against the radiant light of the sun. They are strollers absorbed in their thoughts, wayfarers singlemindedly pursuing their paths, through ever responsive to spiritual concerns. They seem somehow not to belong to the earthly realm any more.

The Stages of Life reiterated and brilliantly summarized this imagery, endowing it with a powerful scope and a premonitory note. The composition opens out in the foreground on a narrow, raised spit of land at the seashore occupied by five figures. In the immediate foreground we can make out an empty wooden barrel, an overturned skiff, and some fishing materials. The first figure which catches the eye is that of an old man leaning on a walking stick with his back turned to the spectator. This figure is the initial term of a chain of figures which is prolonged in the distance by a series of boats and ships of all sizes. The eye is thus led inexorably towards the horizon, which is the stage of a majestic sunset sky with just the barest wisp of a crescent moon.

At the edge of the spit of land stands a young man in frock coat and top hat who turns to face the old man, mirroring the spectator's gaze. Crouched or sitting next to him at the water's edge are two children—one holding a Swedish flag, the dominant power in the region at the time—and a young girl who introduces a sensual and emotional touch.

Five boats plot the course of an imaginary path that extends to the horizon, indicating the journey to be made, the depths of the sea and sky, or possibly the mortal and spiritual transformations that await the five figures. Their identity is not easy to ascertain, but one might think that they represent Friedrich himself in the company of his three children—Gustav Adolf, Agnes and Emma—and his nephew, wearing the top hat.

The image is explicit enough this time to speak to us without recourse to a code. The spectator is summoned to an

Overleaf

CASPAR DAVID FRIEDRICH
The Large Enclosure (details)
1832, oil on canvas,
73.5 x 102.5 cm.
Dresden, Staatliche
Kunstsammlungen
Gemäldegalerie.

*Opposite and next page
(detail)*

CASPAR DAVID FRIEDRICH
The Stages of Life
1834-1835, oil on canvas,
72.5 x 94 cm.
Leipzig, Museum der
Bildenden Künste.

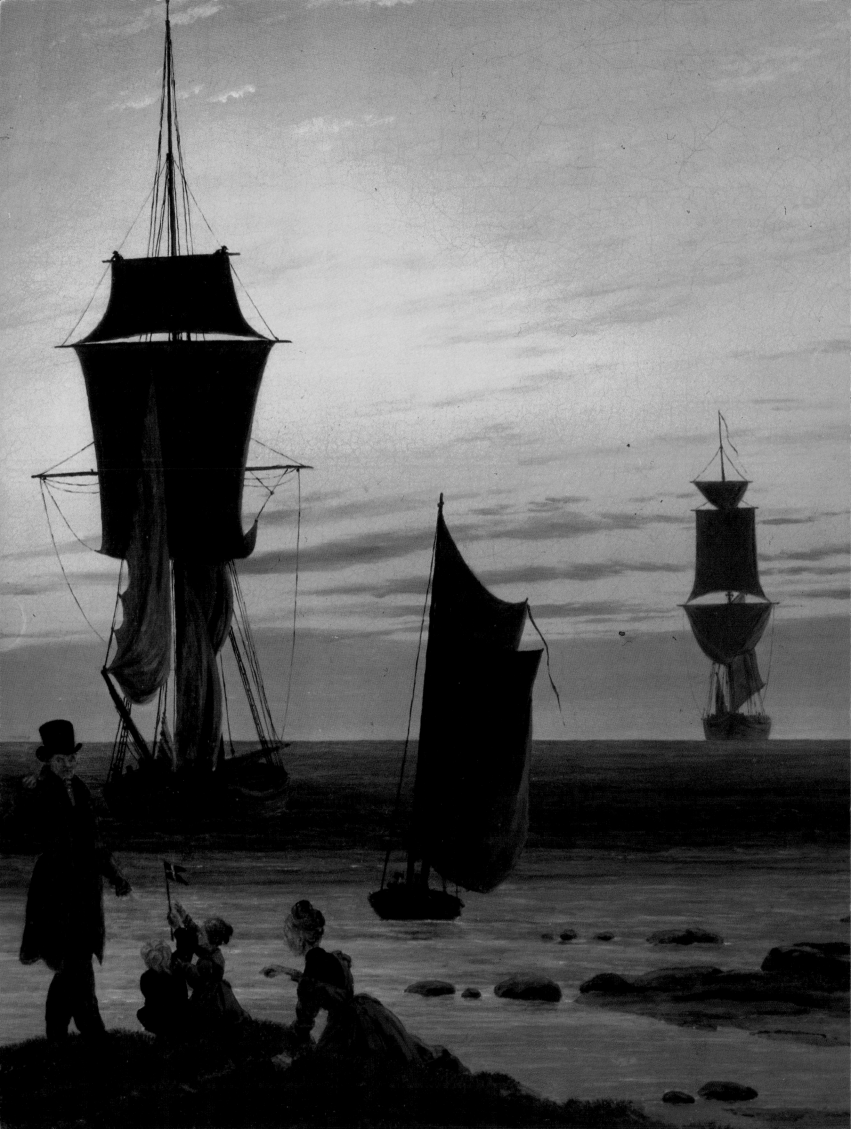

ultimate journey, in a Nordic setting which both summarizes and transcends the human condition. The part of the day is sunset, a moment associated with the end of Time since the Middle Ages. The question now is: does the day's end in this picture mean the end of life or a spark of hope?

The generations march toward the light, toward the transcendence of conditioned existence, a melancholic path, but one that was shared by an entire generation inspired by the symphonies of Schumann, the poems of Hölderlin and Novalis, or the plays of Kleist. For the last time in Friedrich's work we get an idea of the sense of infinity by which the painter measured–in terms of space and figures–the limits of human existence and sketched the contours of his metaphysical quest. This is also an example of *Stimmung* in the fullest German Romantic sense of the word.

After his stroke in 1835, Friedrich no longer painted in oils. In 1837, his condition worsened, yet he still executed watercolours and was drawings with a sure hand; but his ideas and concepts had deserted him, leaving only the outward, formal appearances. By 1839 his hand had lost its steadiness: motifs such as the owl, tombs and graves now replaced his formerly crystalline visions. He was either no longer capable of thought, or else his thinking had changed altogether. His hand was blocked. The rest of the tale is silence, or perhaps the end of the struggle between Jacob and the Angel. Long forgotten by the art public, he passed away on May 7, 1840–one hopes, just before dawn.

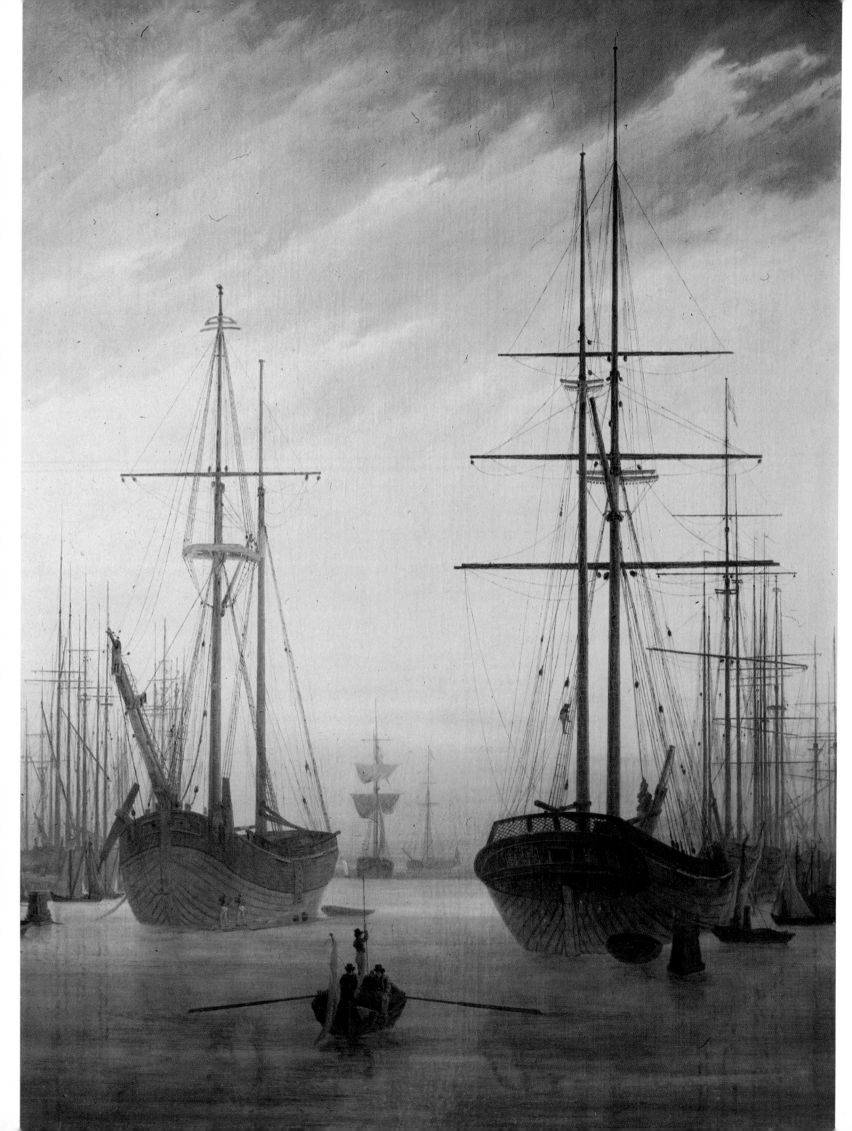